D1506021

SCULPTURE OF THE TWENTIETH CENTURY

BY ANDREW CARNDUFF RITCHIE

Including the exhibition catalogue,
Sculpture of the Twentieth Century
with an introduction by Andrew Carnduff Ritchie

THE MUSEUM OF MODERN ART NEW YORK
Reprint Edition 1972 Published for The Museum of Modern Art by Arno Press

Library of Congress Catalog Card No. 78-169311
ISBN 0-405-01570-4
Exhibition catalogue, Sculpture of the Twentieth Century
Copyright © 1952 by The Museum of Modern Art, New York
All Rights Reserved.
Printed in the United States of America

SCULPTURE OF THE TWENTIETH CENTURY

BY ANDREW CARNDUFF RITCHIE

THE MUSEUM OF MODERN ART NEW YORK

CONTENTS

ACKNOWLEDGMENTS

In the preparation of a survey such as this I have received invaluable assistance from many people—more, unfortunately, than I can mention here by name.

First, I would like to thank members of the staff of the Museum of Modern Art for their assistance in a number of ways; Miss Margaret Miller; Miss Alice Bacon, who translated many of the quotations and checked a great body of factual details; Miss Alicia Legg, who typed the manuscript and helped with some translations; Miss Jane Sabersky for assistance in German translations.

I am grateful to my colleagues, Alfred H. Barr, Jr., René d'Harnoncourt, Miss Dorothy C. Miller and Monroe Wheeler for their advice and encouragement.

I wish also to thank all collectors, public and private, who have permitted me to reproduce works of art in their possession. To the following persons who have provided me with photographs or information I am particularly indebted: Miss Lilian Somerville, Director, Fine Arts Department, British Council; Philip James, Director of Art, The Arts Council of Great Britain; Trenchard Cox, Director, City Museum and Art Gallery, Birmingham, England; Mr. and Mrs. Lawrence P. Roberts, American Academy in Rome; Sig. and Sig.ra Afro Basaldella, Rome; Romeo Toninelli, Milan; Professor Gino Ghiringhelli, Milan; Juan Ainaud, Director, Museo de Arte Moderno, Barcelona; José Mario Gudiol, Director, Instituto Amatller, Barcelona; Juan Antonio Gaya Nuño, Ediciones Sagitario, Barcelona; Siegfried Rosengart, Lucerne; Dr. Georg Schmidt, Director, Kunstmuseum, Basel; W. J. H. B. Sandberg, Director, Stedelijk Museum, Amsterdam; Mme Roberta Gonzalez-Hartung, Paris; Jean Cassou, Director, Musée National d'Art Moderne, Paris; Daniel Henry Kahnweiler, Galerie Louise Leiris, Paris; Louis Carré, Galerie Louis Carré, Paris; Stefan P. Munsing, Director, U.S. Information Center, Munich; Edgar Breitenbach, U.S. Cultural Affairs Advisor, Office of Public Affairs, HICOG, Frankfurt; Dr. Walter Passarge, Director, Städtlische Kunsthalle, Mannheim; Dr. Alfred Hentzen, Director, Kestner-Gesellschaft, Hanover; Mateo Lettunich, Cultural Affairs Advisor, Office of Public Affairs, HICOG, Berlin; Mme Gaston Lachaise, Lexington, Conn.; Marcel Duchamp, New York; Pierre Bourdelle, New York; Alfredo Segre, New York.

I also wish to thank the following for their permission to reprint quotations, either in the original or in translation: Albright Art Gallery, Buffalo, N.Y.; Arts and Architecture, Los Angeles, Calif.; Officina Bodoni, Verona; British Broadcasting Corporation, London; K. Lemmer Verlag, Berlin; Pierre Matisse Gallery, New York; Oxford University Press; Partisan Review, New York; Réalités Nouvelles, Paris; XXᵉ Siècle, Paris; Wittenborn, Schultz, Inc., New York.

Finally, I should like to thank Curt Valentin and the staff of his gallery, Miss Jane Wade and John Hohnsbeen, for their extraordinary help in securing photographs and information and for their limitless patience.

A. C. R.

FOR JANE

FOREWORD

In surveying such a complex period as the past fifty years I have of necessity, for space and other reasons, composed an anthology of sculptors. This anthology is, I hope, sufficiently extensive to give a fair picture of the diverse directions sculpture has taken in our century. A systematic history would take volumes, and no one as yet has had the courage or the industry to attempt it. Failing such an all-inclusive history, I have chosen to outline the general stylistic currents leading up to the present and to illustrate them with major and less major sculptors who seem to me to have made a definite contribution to the art. This is a subjective choice, as all such choices must be. My choice of younger sculptors who have only become known in the past decade is undoubtedly the most subjective of all. Even so, I have tried here to avoid nationalistic bias as much as possible and have included only work that I have personally seen and consider to have unusual merit. There is undoubtedly work by younger men that I have not seen that is of equal merit. The limitations of one pair of eyes must serve as my apology to them for my neglect.

A word about the arrangement of the plates. They follow the progression of leading sculptors or movements discussed in the text. An alphabetical arrangement would be useful for quick reference but would make no other sense. (Sculptors will be found listed alphabetically in the Biographical Notes, pp. 225–232, and under each entry reference is made to the illustrations devoted to each artist.) A strictly chronological succession presents serious mechanical difficulties as between the text and the plates. I have chosen rather a loosely chronological arrangement of works that seem to derive more from one movement than another or that show the direct or indirect influence of one or other of such great masters as Rodin, Maillol or Brancusi. Sculptors, like Picasso, who have worked in different modes appear under several groupings. Works of the past decade, of whatever tendency, I have grouped together, at the end, the older giants with the younger protagonists. The reader then may compare the vitality of the one with the other and perhaps gain a more dynamic idea of the intensity of flow, the coalescence or divergence of the various stylistic streams that continue to have a vigorous existence at mid-century.

A. C. R.

8

SCULPTURE OF THE TWENTIETH CENTURY

SCULPTURE'S POSITION TODAY

The art of sculpture, which held a predominant place in all the ancient cultures and in medieval and renaissance Europe, fell to a position of relative unimportance after the seventeenth century. The decline began during the renaissance. Leonardo, if subsequent history is to be believed, won his famous argument with Michelangelo as to the superiority of painting over sculpture. This is more or less true today, although there are encouraging signs that sculpture is beginning again to take on a less subsidiary role.

The public, high, middle and low in brow, is notoriously disinterested in the architectural and sculptural monuments that have risen or are rising about it. One seldom hears a public outcry over any new building, however atrocious it may be in design. Whatever criticism there is of sculptural monuments is seldom of an aesthetic kind. The public figure is not sufficiently life-like perhaps for the public taste; the nudity of a statue is too disturbing to those who set themselves up as the protectors of public morals; deviations from, or distortions of, accepted canons of realism on occasion produce violent resentment. Official sculptors, usually called academic, have long since learned to make the necessary compromises with their artistic consciences and consequently have received most of the commissions for public monuments or architectural sculpture. The insipid and therefore undisturbing results are all about us, in parks and on public buildings of all kinds. They do not deserve and seldom receive a second look. However technically expert they may be in execution, and no one can gainsay the academician's technical ability, the temperature of his imagination is so low he usually cannot give to the content of his work more than a pallid, sentimental expression. Sculpture of this kind is not our province here. It will be with us no doubt for many years to come, or just so long as official taste continues to be phlegmatic and timid.

Perhaps the speed and fluidity of the industrial age and particularly our own century are responsible for a confused and, it would almost seem, atrophied sense of form and space. The man who walks is in a position to view and to appreciate the form and colour of things about him. Life in trains, automobiles and planes tends to produce a never ending series of two-dimensional images. We see only the façades of buildings, and often only a fraction of these, or a fleeting glimpse of a piece of sculpture. These unsubstantial impressions are in turn documented and re-emphasized by the moving picture and journalistic photography to a point where an appreciation of volume and space, the basic considerations of architecture and sculpture, becomes almost impossible.

To be sure, our motor-driven age may be said to enjoy a new sense of space, due to speed of travel. And something of the fusion of fast moving images is reflected in the

work of many modern painters and sculptors. But however revolutionary our new experiences of space and time may be, we tend to sacrifice many of those visual experiences that are only possible at a leisurely, pedestrian pace. Under the strain of high speed pressures then, it becomes necessary to make a conscious effort to do more than give sculpture or architecture a superficial glance.

There are, of course, well-known economic reasons for the general lack of appreciation of sculpture. Its cost in effort and materials is usually much greater than painting. Consequently there are fewer sculptors than painters. Paintings are relatively easy and cheap to transport and exhibitions are therefore frequent. Most sculpture is expensive to move, and its exhibition is fairly infrequent.

Furthermore, the separation or compartmentalizing of architecture, sculpture and painting since the renaissance, a condition which has become even more exaggerated in our time, has had a deleterious effect on the first two. The separation of artist and patron, which has been growing during the past one hundred and fifty years, has reacted often in a perverse way to the advantage of the painter. The freedom of individual expression which has become a cardinal artistic principle in our time is obviously more possible of realization by writers and painters than by architects and sculptors. The one needs only in physical terms a typewriter and paper or paint and canvas, while the other demands either a willing client of considerable means or, in the case of the sculptor, more or less costly or intractable materials or relatively expensive castings in bronze. The writer may spend years on a book and never find a publisher, and painters may paint for years and never sell a canvas. Nevertheless, the minimum physical requirements of their respective crafts are far and away simpler than those of sculptors and architects.

And as between architect and sculptor the latter is probably worse off. The architect, either alone or in company with others, may find a client. Until he does, planning and construction do not take place. When they do they may, but more often do not, include a sculpture commission. The sculptor is then in the terribly exposed position of having, like the painter, to produce first, then attempt to sell, but at considerably greater expense in time and materials.

Despite sculpture's many disadvantages today, and its decline between the seventeenth and nineteenth centuries, it has always been a force in all the visual arts. In our time it has once more become a vital force.

SCULPTURE AND PAINTERS

Sculpture is probably the oldest of the arts. Its technical beginnings go back to the first prehistoric man who chipped an arrow head or carved a club or spear. And from the dawn of history the sculpture and pottery (a form of applied sculpture) of all the ancient civilizations have been the chief clues to our understanding of them. The relative permanence of stone, baked clay or metal is, of course, a major factor in our dependence upon sculpture and inscriptions upon stone or clay as conveyors of

historical record. By comparison, writing upon more perishable materials such as papyrus, vellum and paper is a relatively recent source of information. In the long run, however, such written records, and accompanying or derived pictorial illustration, finally undermined sculpture's supremacy and made painting of all kinds, at least in the West, the art having the widest use and popular appeal.

I think it is not too much to say, then, that the book has been the greatest enemy of sculpture and that, concomitantly, as literacy progressed, sculpture declined in value and eventually in quality. From embodying the gods and heroes of Greece and Rome in ancient and renaissance art, and the whole dramatis personae of Holy Writ in medieval Europe, it began to lose ground in the renaissance, and in the seventeenth, eighteenth and nineteenth centuries it was finally relegated, for the most part, to portrait busts and insipid garden and pottery statuary. Despite this decline, it was still possible for a Bernini and a Houdon to produce great works of art. At a lower level of accomplishment Rude, Barye and Carpeaux in the nineteenth century were not undistinguished in their efforts to revitalize sculpture. But they are lonely exceptions. The stellar lights during these three centuries were painters.

Now no one can say that the tables have been turned in our century. But three very significant things have happened in the past hundred years. Painters have become less and less dependent upon literature for the content of their paintings. The horizons of art have been greatly enlarged to include the whole world and the dependence upon the classical and renaissance traditions to the exclusion of all others has been broken. And finally, many of our most important painters, searching for new sources of stylistic inspiration have turned to sculpture and in a remarkable number of instances have actually produced sculpture themselves.

The most significant factor, I presume, in the revival of sculpture in the twentieth century (and there has been a revival beyond doubt) is the diversion of the painter's interest from problems of literary illustration or interpretation to the more fundamental problems of form, space and light. The exploration of these problems has characterized in varying degrees the great revolutionary movements of our time. With the return of painting to plastic first principles, partly under the inspiration of new discoveries in the physical and biological sciences, the ground was prepared for a reunification of the three visual arts of painting, sculpture and architecture. When painting ceased being the handmaiden of literature it led the way for all the visual arts to establish a working relationship, one which had existed previously in the renaissance, with revolutionary discoveries in science. Thus impressionism is unthinkable without the investigations of Helmholtz and other physicists into the properties of light. The post-impressionists, symbolists and fauves, like Gauguin and Matisse, could not have investigated or been influenced by the primitive arts of Africa and Oceania without the previous researches and collections of nineteenth-century ethnologists and anthropologists. And cubism, likewise, was dependent upon ethnographic discoveries of primitive sculpture as well as new concepts in physics concerning the interdependence of space and time.

The extraordinary development of archaeological and anthropological studies in the nineteenth and twentieth centuries has tremendously expanded our knowledge of all people both inside and outside the Western world. The artist seeking to break the stranglehold of academic canons based on a limited renaissance conception of the arts of Greece and Rome, found ready to his hand and eye the revelation of many other traditions, primitive, prehistoric, pre-Columbian, Oriental, together with a better understanding of the relation of ancient Near-Eastern and Egyptian art to archaic Greece. (The violent and often eclectic absorption of non-Western art, represented largely, it must be repeated, by sculpture is one of the tremendous factors underlying the artistic revolutions of the past fifty or sixty years.)

The role of the painter as an absorber of non-Western traditions has been, and to some extent still continues to be, a dominant one. Largely dependent as he has been upon the sculpture of non-Western peoples for inspiration, it is not surprising that as he has experimented with new forms of expression he has often been tempted to work out some of his ideas by actual modeling or, more rarely, carving.

Among the painters who have made significant contributions to twentieth-century sculpture are Matisse, Picasso, Modigliani, Renoir, Braque and Degas (although most of the latter's sculpture was originally executed in wax in the late nineteenth century and cast in bronze after his death). With the exception of Modigliani, all of these painters have been, in the main, modelers in plaster or wax. (The unpredictable Picasso, it is true, has made some carvings and constructions in metal and wood and has combined *objets trouvés* with plaster modeling, a process related to the cubist collage.) This emphasis by painters upon modeling in a soft material rather than carving in stone or wood has several obvious explanations. Accustomed as the painter is to working in tractable pigments, the "adding on" process, as Michelangelo called it, of clay or plaster modeling comes more naturally to a painter than the laborious use of the mallet and chisel. The experimental freedom of expression which has been a characteristic of all the great modern painters must surely have been inhibited by time-consuming stone carving. The example of Rodin, the modeler, under whose influence Matisse and Picasso did their first sculptures, undoubtedly helped determine their choice of method and materials. But above all, Rodin's nervous experimental energy, which could only find immediate release in modeling, must have impressed itself most on such younger painter-sculptors. Paradoxically, given his extraordinarily high-strung temperament, Modigliani studied sculpture first with Brancusi, who in partial opposition to Rodin, early turned to direct carving. The linear tradition in which Modigliani worked, a tradition in opposition to the formal analyses of his cubist contemporaries, undoubtedly had something to do with his admiration and emulation of Brancusi's immaculately finished carvings and the inevitable linearity of their subtle contours. At the same time, his cubist contemporaries, Lipchitz and Laurens, for example, were carvers and only later turned to modeling. Their early example undoubtedly reinforced his own predilection for the chisel.

12

There is one significant feature which most of the great twentieth-century painter-sculptors have in common: a considerable preoccupation with the human figure. Matisse, probably the greatest painter-sculptor of our time, says in his *Notes of a Painter*: "What interests me most is neither still life nor landscape but the human figure. It is through it that I best succeed in expressing the nearly religious feeling that I have towards life." Degas, Renoir, Picasso, Modigliani have all given a greater emphasis to the human figure than to any other motif, and much of their interest in sculpture may well derive from this predominant interest.

All other questions aside, however, the principal contribution of the painter-sculptor in the twentieth century has been to explore and expand the whole field of formal imagery under the impact of new concepts of space, time and psychology. The great movements of modern art—expressionism, cubism, surrealism—have all originated with painters, and whether they practiced sculpture or no, they have left their mark on all modern sculptors. That two of the greatest painters of the century, Matisse and Picasso, are sculptors also has acted simply as a tremendous reinforcement of a general influence.

Having said as much, I hasten to recall once again how much the modern painter has taken from sculpture of all periods. Matisse and Picasso's debt to Rodin; Cézanne's to Michelangelo, Houdon and others; Gauguin's to the folk carvings of Brittany and Oceania; the expressionists and the cubists to African sculpture—all these and many more instances of the vitalizing effect of one art on the other go far to balance any debt that exists from one to the other. The important fact is the interaction of sculpture and painting, a healthy fusion that today, in America at least, is having important results. When modern architecture loses some of her virginal fears and reticence and joins the company of painting and sculpture, a further enrichment of all three will surely result.

FORM AND CONTENT

The extraordinary variety and complexity of styles in twentieth-century art is a characteristic of the period. All these styles have their origin in painting and their counterpart in sculpture. They may be classified for purposes of definition by various ways of treating the object, whether it is the human or animal figure, or constructions of an organic or geometric kind. Stated very simply and in the chronological order of their appearance, these treatments may be described as follows: the object in relation to light; the object idealized; the object purified; the object dissected, at rest and in motion; the object constructed on geometric principles; the object and the subconscious.

In only one of these classifications, the object constructed on geometric principles, is the motif of the human or animal figure, in whole or in part, completely forsaken. In all others, organic or animate forms are the basis of the sculptor's creations. With the significant exception of Rodin, the isolated human figure, unrelated to any particular interior, during the first decade of the century at least, dominates the scene.

13

The portrait bust or figure is a relatively rare phenomenon and becomes increasingly uncommon as the century advances, except in academic circles. Compositions of more than one figure are also uncommon, possibly as a consequence of the more or less general abandonment of "literary" or anecdotal references in sculpture and painting and the relatively rare use of sculpture in an architectural or monumental connection. (Again we must except academic sculpture from this generalization.) During the second decade the figurative tradition continues dominant, however altered it may be by cubist and futurist dissection. The cubist sculptors, perhaps because they were more closely identified with painting than any other group in this century, revived an interest in relief sculpture, using the still-life compositions and constructions of their fellow painters as a point of departure. The third and fourth decades saw the high-water-mark of the geometrically minded constructivists, a movement stemming directly from the cubists. As a point of doctrine, they gave up all reference to animate nature in order to construct a new imagery related to architectural and technological forms. During the same period the surrealists countered the constructivists' geometry with a return to organic forms and a revival of the human figure, however metamorphosed by the sub-conscious vision. Finally, in the last decade a sort of fusion of the surrealist and con-structivist imaginations has produced a new sculpture whose real potential is still unexplored. Unlike the constructivists, but like the surrealists, its forms are organic rather than geometric in derivation. Unlike the surrealists, but like the constructivists, it seeks to direct the attention of the observer to the form or forms themselves without direct reference to nature but allied to it in conception and structure.

However diverse the form and content of twentieth-century sculpture may be, it is well to remember that in all its manifestations the basic preoccupation of all great sculptors of all periods of history has been adhered to—the relation of mass to space. The material of the mass may be stone, wood, bronze, iron, steel, aluminum, plastic, wire or glass—the interaction of volume on space is the sculptor's primary considera-tion. The mass may be solid, the internal rhythm of the parts describing a closed unity, the better to displace and resist the surrounding space. Or by interior perforations and irregularity of contour, the mass may capture space and hold it in weighty or delicate tension. At the other extreme, in transparent or wire constructions, space becomes a dominant factor, the slight material of the sculpture serving only to define it.

THE OBJECT IN RELATION TO LIGHT: RODIN AND HIS INFLUENCE

Rodin is the father of modern sculpture, and probably the greatest sculptor of our day. While his principal work was done in the last quarter of the nineteenth century his influence on modern sculpture has probably been more profound than any other.

Rodin is both an impressionist and an expressionist sculptor. In his beginnings he may owe a partial debt to his lesser nineteenth-century predecessors Rude and Barye.

14

His greatest debt is to the impressionist painters and their preoccupation with objects under the transitory impact of light. Much of the vitality of surface which his sculptures possess is the result of the breaking up of planes to achieve flickering effects of light and shadow, comparable to the broken facets of color of the impressionists. However, as we are learning to understand him better, we can now appreciate that he was much more than a mere sculptural reflection of a technique of painting. His Italian opposite, Medardo Rosso, who may well have influenced him and been influenced by him, is more of an impressionist painter in wax. Rodin, more than Rosso, had a profound sense of mass and space, of "the hole and the lump," as he called the art of sculpture. And no matter how much the excrescence of his rhetorical, even melodramatic posturings in, for example, his *Gate of Hell* or *The Defense* (pp. 49, 51) may disturb our inhibited emotions and sceptical minds today, his passionate and monumental concern with the everlasting sculptural relationships of volumes and voids, particularly with reference to the single figure, has had an increasingly fruitful influence on much modern sculpture.

The *St. John the Baptist Preaching* (p. 53) is one of his greatest sculptures. The first plaster version, and a drawing, showed St. John with a cross over the left shoulder. The same figure appears again in the headless and armless *Walking Man* (p. 52). Rodin's inspiration for these studies and the final piece were probably derived in part from Michelangelo's *David* and Donatello's *St. John* in the Sienna Cathedral. Three years before his *St. John* was modeled, Rodin had spent considerable time in Italy and was filled with enthusiasm for the work of both these masters.

These passing references are made to two of Rodin's greatest progenitors to emphasize the renaissance tradition within which he worked and which he revitalized after it had almost died at the hands of academic formularizers. The religious associations called up by this *St. John* may be disregarded for a moment and the sculpture looked upon simply as a figure walking—Rodin did dissociate the religious implications himself by striking off the head and arms. The power and vitality of the sculpture is achieved through the interplay of the vast number of surface planes, describing the musculature and flesh of the body, set off against the basically simple pyramidal mass of the body itself. The stark angularity of the spaces contained by the spread of the striding legs, between the body and the uplifted arm, and by the uplifted arm itself, is given added force and dynamic complexity by the spiral movement of the figure, described by the curvature of the left arm (pointing spatially to the right foot), flowing upwards through the shoulders and head and extending finally through the right arm. To see and feel this magnificent complex of formal and spatial rhythms is to experience the deepest pleasure that great sculpture of all ages and countries can produce.

The *St. John* is monumental in scale and in heroic grandeur of conception. However, in a small plaster sketch such as the *Jugglers* (p. 50) one can as fully appreciate the extraordinary vitality and richness of Rodin's formal and spatial invention, his method of attacking and dominating his material to express himself most forcefully. He said at one time, "First I made close studies after nature, like *The Bronze Age* [his first sculpture to become widely known]. Later I understood that art required more breadth—

15

exaggeration, in fact, and my aim was then, after *The Burghers of Calais*, to find ways of exaggerating logically—that is to say, by reasonable amplification of the modeling. . . . In sculpture everything depends on the way modeling is carried out, and the active line of the plane found, the hollows and projections rendered, and their connections." Here one can see in this small plaster, as we have already seen in the *St. John* bronze, the exaggeration and amplitude of form and space, "the active line of the plane found, the hollows and projections rendered, and their connections," all of which are the essence of Rodin's expressionistic power.

Both these sculptures by Rodin are of the figure or figures in movement. Forms in spiraling twisting movement, such as the portrait of *Balzac* (p. 54) and *The Defense* (p. 51) are a characteristic of all his work. The sculptural problems he set himself all had to do, as did Michelangelo before him, with the composition or containment, the definition and resolution of the thrust and tension of forms, the expansion and contraction of space and the dynamic interplay of the two. To quote him again, "the public," he said, "which has been perverted by academical prejudices, confounds art with neatness or spruceness. Molding from nature is copying of the most exact kind, and yet it has neither movement nor eloquence." Rodin's best sculpture has both.

However great the debt of the twentieth-century sculptor to the painter, his greatest single debt is to Rodin. Whether they were his studio assistants like Bourdelle and Despiau, or came under his direct influence like Brancusi, Matisse and Picasso, or derived from the same impressionist and expressionist traditions like Degas, Renoir, Rosso, Martini and Epstein, the power of his genius can be perceived in practically all the sculpture of our time. More specifically, however, his influence or stylistic association can more clearly be recognized in those sculptors and painter-sculptors mentioned above.

Bourdelle was perhaps a greater teacher than a sculptor. He generally lacks the emotional drive and energy of his master. But in the monumental *Head of a Man* (p. 56) and his *Self Portrait* (p. 57) his more relaxed talent is seen at its greatest extension. His craftsmanship is superior to his imagination, one feels. The rhetoric of his forms is more studied than felt. Matisse, who came under Bourdelle's as well as Rodin's influence, as a comparison of his *Slave* (p. 58) with Bourdelle's *Self Portrait* and Rodin's *Walking Man* clearly shows, brought to his sculpture the emotional fervor and the formal power which were soon to find full expression in his fauve paintings. His *Reclining Nude, I* (p. 59), so explosive yet so controlled in its dynamic formal structure, which he used in many of his later paintings, became a sort of model of rhythmic organization through which he could measure and adjust the development of his pictorial ideas.

Brancusi's *Boy* (p. 60) and Picasso's *Jester* (p. 61), the one sensitively refining Rodin's surface planes and twisting rhythms, the other sentimentalizing to some degree his expressive characterization of the human head, are significant early essays in the tradition of the master by two artists who were to leave in their different ways the greatest single imprints upon the art of this century.

16

Degas, like Matisse, used sculpture to explore more fully the formal principles he was striving to resolve in his paintings. His work in one medium is therefore best understood in relation to the other. Even so, his impressionistic capture of the delicate balance of forms in the pose of a dancer (p. 62), or the arrested movement of a race horse, or the complex gestures of his female models, are all indicative of his marvelous grasp of volumes in tension and his essentially sculptural genius.

Degas made models in wax throughout most of his life, but only a few people were ever permitted to see them. The bronzes we know were all cast after his death in 1917. Renoir came to sculpture late in life and, as he has told us in a lighthearted way, mainly at the suggestion of his dealer, Vollard. Crippled by arthritis as he was at the end, he had to make use of a young assistant to model the plaster under his constant supervision. But again, like Degas, so great is his grasp of forms in movement and in the round, his impressionist perception of light in relation to volumes is so acute, that the translation of motifs from one medium to the other is apparently achieved with a natural ease and authority (p. 63).

Despiau, for many years a studio assistant to Rodin, is at first glance a dim reflection of his master. But within the narrow limits of his talent he made a sensitive contribution to the portrait. His light-catching, impressionist manipulation of surfaces gives a limited vitality to his pieces, lacking as they do an inner structure that might give them formal strength (p. 65). His father and grandfather were craftsmen in stucco and this tradition must have had something to do with Despiau's decorative emphasis on surface effects at the expense of structure. But in the best of his portrait busts, such as the *Antoinette Schulte* (p. 64), his gift for registering a subtle likeness is clearly evident. He occasionally gives way to a stylized prettiness of treatment, but here his interpretive powers have not been dissipated by any such superficial effort to achieve mere charm.

Rodin's Italian counterpart, Medardo Rosso, has had a pervasive influence in his own country. A revolutionary spirit, a hater of academicians and the tremendous accumulated burden of art history and technical facility which all Italian artists have inherited, Rosso, a true impressionist, selected the subject matter of his sculpture from the world about him. Its topical references, *Sick Man at the Hospital* (p. 66), *Conversation in a Garden* (p. 67), are in direct contrast to the anecdotal or mythological inanities of the official Canova school of marble carvers with whom he found himself in violent opposition. Like all the other sculptors we have noted in the Rodin orbit, he was a modeler rather than a carver. Like Degas, his favourite material was wax, the better probably to reveal the infinite subtleties of light-struck surfaces. Despite his astonishing virtuosity, his weakness seems to be a lack of depth or substance in his forms, the absence of a hard core to sustain the brilliant interplay of light and shade his modeling achieves.

His younger compatriot, Martini, who died as recently as 1947, inherited directly or indirectly much of the furious, unconventional spirit of Rosso. As a teacher in the Venice Academy, and by example, he has had a strong influence on a number of younger Italian sculptors, Marini, Manzù, Fazzini, Viani, to name the most outstanding. His *Shepherd* (p. 68) and *Daedalus and Icarus* (p. 69) are typical examples of his

restless, highly-charged sensibility. His forms are held in a violent, splintery tension which reflects the tragic nature of the artist. He died disillusioned and in extreme poverty, having finally given up sculpture in despair.

Epstein (who seems never to have been a victim of despair), for all his study and absorption of non-Western styles, particularly African Negro and Oceanic, remains chiefly within the Rodin expressionist tradition. Born in Brooklyn, he studied in Paris during the early years of the century when Rodin's fame was at its height and later moved to London, where he has lived ever since. An extreme individualist, a belligerent defender of his own creations which have been attacked again and again by the public and conservative critics, he has produced an amazing body of work. And despite the opposition of official critics he has succeeded in carrying through more major public commissions than most modern sculptors. His figures for the Medical Association Building on the Strand, London, were attacked for their nudity. His London Underground figures, *Night* and *Day*, raised another public outcry, ostensibly because of their violent, expressionistic distortions of the human body. His monument for the tomb of Oscar Wilde, in the Père Lachaise cemetery in Paris, was banned by French officialdom on grounds of obscenity. Epstein has ridden out each of these storms. A man of enormous energy and gusto, the histrionic strength of his monumental conceptions can never be denied. At their worst they are sublimely vulgar failures. But this very vulgarity or earthiness in Epstein's make-up is at the basis of his best sculptural achievements, for example his *Lazarus* (p. 70). Above all he is a great portrait sculptor, probably the greatest of our time. His *Admiral Lord Fisher* (p. 71) is perhaps his best. In it is concentrated all his genius for characterization, together with his magnificent command and orchestration of a dazzlingly complex series of surface planes on the head and on the medal-loaded chest.

THE OBJECT IDEALIZED:
MAILLOL AND RELATED SCULPTORS

Maillol, a painter before turning to sculpture in his forties, said of Michelangelo, "In my young days painters disliked him as a painter and sculptors as a sculptor." Cézanne he considered "the greatest painter of our epoch." Both admissions are a measure of the violence of Maillol's revolt from Rodin the impressionist and eventually Rodin the expressionist. These statements by Maillol were made when he was old, however, and he must have forgotten, or at least he chose to forget, how in his beginnings he derived his figure for the *Blanqui Monument* and the related torso called *Chained Action* (p. 76) from Michelangelo's *Captive* in the Louvre and Rodin's *St. John the Baptist* and *Walking Man*. Even so, the direction of Maillol's revolt from the spiraling formal rhythms and dynamic space conceptions of both these masters is strikingly in evidence. The implied movement of the Blanqui figure is curiously frozen. This is literally action in chains. The thrust and tension of Rodin's angular forms and the flickering play of light over myriad surface planes have been placed in complete

18

reverse. Ovoid rather than angular forms produce a series of closed, static rhythms. The surface of the forms is made smooth to emphasize further the controlled elegiac flow from one form to another. The *Young Cyclist* (p. 75) and the plaster relief *Desire* (p. 78) are further examples of this harmonious arrangement of formal rhythms. Rodin's forms have a volcanic materiality made all the more substantial when they come closest to bursting their corporeal bonds and exploding into surrounding space. Maillol's, by a process of abstraction, become dematerialized, however massive by symbolic implication they are intended to appear. "Form," he said, "pleases me and I create it; but, for me, it is only the means of expressing the idea. It is ideas that I seek. I pursue form in order to attain that which is without form. I try to say what is impalpable, intangible." This idealization of form, variously applied, may be seen, for example, in the lithe sinuosity of his *Ile de France* (p. 79), the ample curves of the *Seated Figure* (p. 82) and the superb, linear sweep of *The River* (p. 80). His overriding idea, I presume, from his lifelong preoccupation with the female nude was the womanness of woman, the earth-mother of the peasant, folk memory. In his *Mediterranean* (pp. 72–74), one of his earliest sculptures but perhaps his most typical, the majesty of Maillol's idea can be appreciated and, at the same time, by comparing this figure with its prototype, Michelangelo's *Night*, one can see how much he has sacrificed of formal and spatial variety and intensity. Perhaps this idealization and therefore abstraction of form in Maillol explains why his sculpture early gained wide popular approval. For one person who looked at his work as sculpture, thousands saw in it a type which inevitably came to be known as the Maillol woman.

Nevertheless, it must be admitted that to the forward-looking generation of sculptors immediately following Rodin, Maillol appeared as a healthy revolutionary come to deliver them from what they considered to be the excessive literary gesturings of the older master. His influence has been felt directly or at a distance by many artists, however much they may differ in personality and in their other sources of stylistic inspiration.

Lehmbruck, probably the greatest sculptor Germany has produced in this century, admired both Maillol and Rodin. His *Standing Woman* of 1910 (p. 83) is still close to the former. Within one year he turned from the poised, compact Mediterranean calm of this figure to the *Kneeling Woman* of 1911 (pp. 84–87). In one short stroke he found the combination of medieval sentiment and elongation of form which were perhaps more in keeping with his Northern temperament but which also may reflect something of his admiration for Rodin's expressionistic formal exaggerations. At any rate, whatever his deviations from the normal proportions of the human figure, he never quite departs in the composition of the whole from the closed, static rhythms of Maillol. Elegance and lyrical tenderness are the qualities that are most appealing in his *Kneeling Woman*. The exquisite relationships of the several parts of the figure, the inevitability of its proportions, are what make this one of the masterpieces of twentieth-century sculpture. His *Standing Youth* (pp. 88, 89) is a monumental companion figure. His best work is one of his last, the *Seated Youth* of 1918 (pp. 90, 91), done a year before his death. The

tender melancholy of the *Kneeling Woman* is here replaced, after the fearful experience of war and defeat, by a deeply tragic emotion. In the noble disposition of masses and contours all suggestion of melodramatic gesture or sentimentality of expression is avoided. The *Seated Youth* is a fitting monument to the dead and is in fact so used today in the artist's native town of Duisburg.

Another German sculptor, Barlach, while he found his chief inspiration in Russian folk-carvings and medieval sculpture, traditions as far removed as possible from the neo-classicism of Maillol, nevertheless may be associated with the latter's generalization of form and, despite some expressionist distortion, the ordering of forms within a relatively static, closed system (pp. 92–93).

So too, Kolbe, Marcks, de Fiori and Blumenthal, however much they may diverge from the Maillol aesthetic, remain within the ideal world of Maillol's vision. Kolbe's principal interest was the figure in arrested movement (p. 94), poised in the act of ascending or descending, or in an adagio dance step. But, as with Maillol's *Chained Action*, the movement is frozen. Unlike Lehmbruck, Kolbe often lacks emotional discretion. His greatest weakness is sentimentality, a sentimentality comparable to that of the Belgian sculptor Minne, who may have influenced him, and in Kolbe's case a weakness which at the end of his career made him peculiarly susceptible to the empty heroics of the Nazi ideal of German youth. By contrast, Marcks retained something of Lehmbruck's sincerity of sentiment (p. 95) and something of Maillol's sense of monumentality. As a consequence, he was considered degenerate by the Nazis.

De Fiori (p. 96) and Blumenthal (p. 97), perhaps the most promising German sculptors of the twenties, were not to the Nazis' taste either. The first emigrated to Brazil in the thirties and died there in 1945. The second died, before realizing his full promise, on the Russian front during the last war. Their highly individual essays in unusual arrangements of formal balance are significant extensions of the Maillol tradition.

Gaston Lachaise came to America from France in 1906, after an exacting training in the École des Beaux-Arts. A master-craftsman, carver, modeler in wood, stone and metal, he worked first as an assistant to two American academic sculptors. By 1912 he struck out on his own and began his first *Standing Woman* (p. 98). His ideal of woman is different from Maillol's, but they are both idealists nevertheless. The amplitude of Lachaise's women, carried to a final point in his later *Standing Woman* (pp. 100, 101) and *Floating Figure* (p. 99), is of a similar order, however different in degree of voluptuousness, to Maillol's peasant woman from Southern France. The marvelous balance of masses (p. 102) and the monumental sensuousness of Lachaise's nudes may owe something to Hindu sculpture and, as we shall see later, his emphasis upon ovoid forms and extreme sensitiveness of finish to Brancusi. Quite apart from influences, he is a great original genius, and one of the greatest to have worked in America.

Another American, who came here from Russia as a child, William Zorach, has been for many years an exponent of direct carving and of the Maillol-derived ideal of

20

the figure. His *Torso* (p. 103), one of his best sculptures, has an impressive massiveness and simplicity of organization.

Finally, the Spaniard, Gonzalez, who died during the last war, produced in hammered sheet iron, a few figures as great as any of this company. Son of a Barcelona metal-worker, and in the old Spanish tradition of wrought-iron craftsmanship, his *La Montserrat* (pp. 104, 105) has affinities with the Belgian Meunier's sculpture of social commentary. As an idealization of peasant nobility and grace, *La Montserrat* is one of the few masterpieces of twentieth-century genre sculpture. However, most of Gonzalez's work took a surrealist, abstract direction as we shall note later.

THE OBJECT PURIFIED: BRANCUSI
AND ORGANIC ABSTRACTION

The attempt to bring order and control out of the explosive expressionism of Rodin took various directions. Maillol's, like Cézanne's, represented a restudy of neo-classic rules of compositional containment, using the study of the actual nude as a revivifying force. Two other approaches are represented by the work of Brancusi and his followers, and by the cubists.

Brancusi's geometrical simplification or abstraction of forms has sometimes been confused with cubism, but essentially the two approaches are entirely different. Brancusi has always stood alone, apart from all movements. He has clearly influenced a number of modern sculptors, but he has never formed a school for reasons that will become clear as we look at the extraordinary individuality of his work. A Rumanian by birth, he went to Paris as a young man, having acquired a thorough academic training in Budapest. He came under Rodin's influence and, as we have already seen, unquestionably absorbed something of that master's poetic firé. But whether through inheritance or geographical conditioning he early turned from the Western, renaissance-derived tradition of Rodin and looked towards Oriental, African and perhaps prehistoric Greek Cycladic sculpture for inspiration. The disgust with Western rationalism and intellectual sophistication which Gauguin's career typifies, and the search for new instinctive sources of artistic energy which his study of folk art in Brittany and the South Sea Islands represents, prepared the way, as is well known, for many artists in the first decade of the twentieth century to seek similar sources of inspiration in non-Western artistic currents. The cubists and many German expressionist painters found in African sculpture an expressive emotional power allied with an astonishing geometrical simplicity of formal organization which were widely recognized as healthy antidotes to what was considered to be the outworn surface virtuosity taught by the academies of art at the turn of the century.

Furthermore, Paris at this time and until the beginning of World War I served as a world focal point for the study and absorption of the thought and art of both Eastern and Western peoples. France's early associations with the Near East through

Napoleon's conquests, her African, Indo-Chinese and South Seas colonies produced a rich flow of ideas and artifacts which her archaeologists and ethnographers eagerly sought to understand and classify. The very rational, encyclopaedic gifts of the French mind and tradition which were applied to this study of diverse cultures outside the main stream of the West produced thus a curious anti-intellectual reaction on many twentieth-century artists, a reaction which has been a predominant characteristic of modern art up to the present.

It is not hard to understand why the ferment of ideas which Paris cultivated so assiduously should have attracted to her students from all over the world; nor why an artist like Brancusi from Rumania, together with many others from every country in Europe, the Balkans and Russia were inevitably drawn to her, and in themselves still further enriched the international cultural brew that reached the boiling-point, and finally boiled over, around 1914.

Brancusi's particular contribution was to fuse, out of his own Rumanian folk tradition, the barbaric intensity of African and prehistoric sculpture with the occult sophistication of that of India and China. Perhaps out of the age-old Russian fusion of Eastern mysticism and Western empiricism this Rumanian artist was given the initial motivation for his art. However that may be, one can appreciate this fusion in such an early piece of sculpture as *The Kiss* (p. 106). Here is revealed that combination of barbaric, elemental emotional power with something of the occult geometrical symbolism Brancusi absorbed from his preoccupation with Tibetan philosophers and theosophical ideas derived from Buddhist and Hindu art and religion. In Buddhist and Yoga symbolism there is a well-known preoccupation with the mysteries of the sex or the life-force. This symbolism sometimes took the form of extremely abstract geometrical configurations. For example, an equilateral triangle when standing on its base represented the male principle and, placed on its apex, the female. Is it too far fetched, given Brancusi's occult interest and the subject of this piece, to see in the triangular confrontation of the two heads and the embracing arms a symbolical suggestion of sexual potency?

Perhaps such wood carvings as the *Prodigal Son* (p. 107) and *Adam and Eve* (p. 114) have more in common with African Negro art, not only in their choice of material, but in their extraordinarily subtle arrangement of forms and planes. More obviously Oriental, on the other hand, is the portrait of *Mlle Pogany* (pp. 108, 109). The spiral turning of the head and the simplifications of planes and the curvilinear emphasis of forms throughout are strongly reminiscent of some Indian Gandharan heads. The spiral as a geometrical figure, according to the philosophy of Yoga, represents the cosmic force known as "the Great Coiled One" and, according to one authority, "has its seat in the human body; for the latter, as the microcosm of the macrocosm, is said to have a series of psychic centers, corresponding to the sphere of the cosmic yantra, arranged one over the other from the base of the spine to the top of the brain."[1] We are surely not reading too much into the coiled tension of this head of Mademoiselle

[1] E. B. Havell. *Indian Sculpture and Painting*. London, John Murray, 1928, p. 59.

22

Pogany when we see in it not only a stylistic but a symbolic reflection of Brancusi's contemplation of Indian sculpture and ideas. The smooth, highly polished surface of the bronze or marble, in both of which materials Brancusi executed this piece, and many of his other works, is also a distinguishing Oriental mark of his sculpture. By this very extreme finish Brancusi appears to be peeling off layer after layer of the material in which he is working to arrive at the point of mystical organic essence which lies hidden in the piece of metal or stone. This search for the essence of life bound up in the material, if carried a hair's breadth beyond a certain point of cutting or polishing, one feels, would result in a totally dead shape. It is the mystical mastery of the artist Brancusi over his materials that seems to tell him when the dividing line between organic life and dead geometry has been reached. In his search, he pushed to the farthest frontier of this life-revealing abstraction of forms in the egg-shaped sculpture called *The New-Born* (p. 112) and in a similar work called *Sculpture for the Blind*. The latter title explains one of the basic appeals of Brancusi's sculpture, that we are asked to perceive and do perceive in visual as well as tactile terms at one and the same time. The dual range of visual and tactile perfection which Brancusi seeks in all his work combined with the mysterious, occult overtones which his forms call up explain the extraordinary fascination of his sculpture to observers of every degree of simplicity and sophistication. And it is to a universal public that Brancusi is consciously appealing. That he has been more than successful his *Bird in Space* (pp. 110, 111) has finally borne witness. When it was first brought to America in the twenties for an exhibition in New York our customs inspectors, lacking either the eye of innocence or the knowledge that should accompany sophistication, refused to accept it as a piece of sculpture at all and claimed that it was dutiable simply as a piece of metal. The case was taken to court, and a discerning judge, supported by many art critics, decided in Brancusi's favor. It is now, of course, the classic symbol of abstract beauty in our time, and its influence has been felt at however banal a level in all kinds of familiar streamlined objects. The oval or the egg-shape which Brancusi has more and more explored in *The New-Born*, the *Bird in Space*, *The Fish* (p. 113) and a limited number of other sculptures (his production has not been enormous) has had a profound influence directly or indirectly on many other twentieth-century sculptors.

Brancusi introduced one more important innovation to twentieth-century sculpture —mechanical movement. Not all of his bases are movable but for some he has constructed turntables which slowly rotate the sculpture before the observers' eyes. In this way he has sought to control and to emphasize the impression of forms moving in space, absorbing and reflecting varying angles and degrees of light on their highly polished surfaces.

Brancusi's search for the image in the material, his purification of form and contour, the better to reveal the spirit, as it were, that lies hidden in the otherwise inanimate substance of stone, wood or metal, has probably been as responsible as any other factor for the revival of interest in direct carving, as against modeling. It is significant, in any case, that many of the modern sculptors who have been most influenced by

him, for example, Modigliani and Moore, made a practice of direct carving in all or most of their work.

Modigliani we have already pointed to as a rare example of the direct carver among painter-sculptors, and he must have been partly influenced in his choice of method by study with Brancusi. His *Head* (p. 115), one of many of a similar kind, reflects also the African Negro source of much of his master's inspiration, and the *Caryatid* (p. 116) may well derive from that other pole of Brancusi's art, the Oriental, particularly the voluptuous female figures of Hindu sculpture.

Matisse's remarkable *Back, III* (p. 117), in the abstract reduction of the planes of the figure, cleft by the great accent of the plait of hair, presents a formal simplification comparable to Brancusi's organic abstraction. The first two *Backs*, done ten or twenty years before the third, are still in the Rodinesque tradition of his *Reclining Nude, I* and the *Slave*.

Lachaise in his *Acrobat* and *Torso* (pp. 118, 119) also turned at the end of his life to a Brancusi-like abstraction of form, by contrast with his standing and floating women we have already noted. Had he lived this might well have been the new direction his sculpture would have taken. Another American sculptor, John Flannagan, in his best work achieved a simplified union of material and image (pp. 120, 121) that bear a relation to Brancusi's principles.

The two sculptors, however, who next to Brancusi have contributed most to the development of organic abstract sculpture are Jean Arp and Henry Moore. While Arp was one of the founders of the dada movement and was closely associated with the surrealists, and Moore likewise was influenced early in his career by similar tendencies, both have their formal origins in Brancusi. For over thirty years Arp has polished and refined his irregular or ovoid shapes, first in jig-sawed relief constructions (p. 122) and later in the round (p. 123). Like Brancusi he has held his forms to an elemental simplicity which in precision of finish and severity of contour are the least fantastic of all surrealist sculpture. As with the forms of Brancusi's *Bird in Space* or *The New-Born* they present a spiritualized essence; they have a life of their own related to natural forms but, except in their organic structure, not imitative of them.

Moore has been influenced by Arp as well as by Brancusi as his *Two Forms* (p. 125) and *Square Form* (p. 124) clearly show. Like Brancusi and Picasso, whose organic abstract painting of the late twenties influenced him also, Moore has a capacious appetite for the art of many periods and places. He has studied such divergent sources as renaissance, medieval, Sumerian, African Negro and pre-Columbian art. Although much of his work in the thirties was extremely abstract (the strung wire and lead construction, *The Bride* (p. 129) is a still later example), in his major sculpture he has concentrated to a much greater extent than Arp or Brancusi, on the elementary forms and rhythms of the human body. While he was never strictly speaking a surrealist, he has in common with many contemporary artists derived much from the surrealists' investigations of the world of the unconscious. As the renaissance artist helped medical men to develop a scientific knowledge of anatomy, so Moore

24

by emphasizing certain features of the body and exaggerating or contracting others suggests a sort of foetal connection with other phenomena in nature which the biological and psychological sciences of our day are exploring. Until recently Moore carved directly in wood and stone and, a great respecter of his materials, created images related to trees and stones themselves. Some contemporary sculptors have exploited the accidental shapes of field stone and tree trunks, assisting the stone or wood, as it were, to better represent the form it is striving towards. Flannagan often worked in this way. Moore, on the contrary, establishes his own synthesis of body-stone and stone-body by creative means, as independent as possible of the accidents of nature. His reclining figures (pp. 126–128) have often a strangely ominous air, creatures of a tragic world, a world from which much of human life has vanished or has reverted to a silent partner-ship with some prehistoric landscape. Never chaotic in themselves, these figures are in a sense an anarchic answer or reaction to war-induced chaos. They are spiritual expressions, less optimistic than Brancusi's, in the truly religious meaning of the word.

THE OBJECT DISSECTED: THE CUBISTS AND FUTURISTS

The third and most influential reaction to Rodin, following Maillol's neo-classicism and what might be called Brancusi's occult abstractionism, was cubism and its dynamic relative, futurism. Now while cubism and futurism were in their origins and in most of their production almost wholly painting movements, the few cubist and futurist sculptors who were either, like Picasso and Boccioni, painters first, or who, like Archipenko, Lipchitz and Laurens, followed closely every move of the painters, exerted an influence out of all proportion to their numbers. Of the whole small company Boccioni and the cubist-futurist Duchamp-Villon produced the fewest but perhaps the most memorable sculptures.

Picasso's *Head of a Woman* (p. 130), done about 1909, is one of the first examples of cubist sculpture. The complex geometrical faceting of the surface should be com-pared with the myriad small and large light-catching protuberances on the surface of Rodin's bronzes. The latter, together with the internal movement of the forms themselves, are marks of the emotional intensity which the cubists forsook in order to leave themselves free, following Cézanne, to examine dispassionately the formal structure of things in relation both to time and space. This, like the semi-scientific light investigations of the impressionists, was also a semi-scientific approach to art which was undoubtedly the artist's conscious or unconscious reaction to the increasing emphasis being placed throughout the Western world on scientific or technological discoveries. Sated, bored and frightened as many of us are today by a scientific revolution that is almost, if not quite, out of control, it is perhaps difficult for us to appreciate the buoyant spirit of discovery which must have marked the first decade of this century when the space-bridging and time-contracting airplane, automobile and wireless telegraph burst upon the world. The excitement may have been short-lived, rudely shattered as it was by the first major convulsion of the scientific revolution,

the 1914–18 war. But between 1908 and 1914, in a short six years, the cubist revolution in seeing took place, a revolution comparable to the discovery of perspective in the renaissance. Cubism was in fact a new multi-focus perspective for the examination or analysis simultaneously of different views of an object or figure either at rest, as with the cubists, or in motion, as with the futurists. It is not too much to say that the new time-space continuum which your cubist-futurist painter sought to rationalize in paint has proved to be the greatest energizing force in modern art, whether in painting, sculpture or architecture. It is also very probable, however, that just as we are suffering socially and politically from the appalling dislocations produced by the scientific revolution, we are suffering in a similar fashion from the violent reappraisal of nature and reality which cubism, futurism and their subsequent developments have administered to twentieth-century art.

Picasso's *Head* represents a very early, tentative stage of cubist analysis. There is no attempt here to show various views of the head at once—rather it is a severe geometrical breakdown or faceting of important planes, an experimental, formal dissection of the head's structure. Out of this kind of study, more in painting than in sculpture, Picasso, Braque and their followers carried the process of dissection to its multi-viewed conclusion. Matisse in his *Jeannette*, *V* (pp. 132–133) completed a series of studies related to the cubist analysis, starting with a Rodinesque portrait and ending with this magnificent, curvilinear projection of the principal masses of the head. Where Picasso's diamond cutting treatment of the surface explored the inner recesses of form, with the unemotional precision of a surgeon, Matisse, recalling again the expressionist Rodin, bifurcates and exaggerates certain features of the head, and by this means increases the sculptural effect of weight and density to a monumental degree.

Picasso quickly carried the cubist analysis to an extreme point of geometrical analysis in such a wood construction as the *Mandolin* of 1914 (p. 144), a three-dimensional development of his collages. Following closely this stage of cubist painting and particularly the work of Picasso, Braque and Gris, the two chief sculptors of the cubist movement, Lipchitz and Laurens, carried the cubist syntax to a conclusion, at least as far as they were concerned, in the next fifteen years. Of the two, Lipchitz, a friend of Juan Gris, is the more austere and architectural. The contrapuntal integration of the masses in the *Man with a Guitar* (p. 139) and the *Song of the Vowels* (p. 142) is at the apex of cubist achievement in the complete realization of volumes in space. The *Song of the Vowels* marks a turning point in Lipchitz's career when he begins to forsake the strict analytical approach of the cubist for an expressionist direction, which, as we shall see in his latest work, has more in common with the Rodin tradition than that of his old friend Gris. Laurens, in *Le Grand Poseur* and the *Head* (pp. 143, 145), and Braque in his rare sculpture of 1920 (p. 146), are less puritanical than Lipchitz. In both there is a sensuous, even picturesque treatment of the figure, or the head, in Laurens' wood construction, that tends towards the decorative. Braque particularly, in his fusion of the front and rear silhouettes of the body, comes close to reducing his sculpture to a relief rather than a volume seen in the round.

In point of time the Russian sculptor Archipenko must always be given credit for a cubist analysis of the subtle oppositions of concave and convex forms in describing the nude, for example, the *Woman Combing Her Hair* (p. 138). As early as 1912 he had evolved this particular style in an effort to give a dynamic impression of a figure in movement, an objective which the futurists in Italy had already claimed the previous year, although they sought to arrive at it by somewhat different means. In Archipenko's case it is sad to think that the genuine originality of his discovery very soon found a debased application in his own sculpture and in that of his banal, "modernistic" followers. Zadkine (p. 147), however technically brilliant he may be, is perhaps the best example, aside from Archipenko himself, of the merely decorative level to which this brand of cubism became reduced.

The discipline which analytical cubism demanded was sufficiently severe to prevent for some time any decline into mere decoration. And even when a somewhat decorative stage was reached in so-called synthetic cubism there was less temptation to resort to sentimental, pretty effects. The highly emotional, even melodramatic manifestos of the Italian futurists, on the contrary, displayed a dangerous lack of cubist control. It is perhaps fortunate for the history of futurist sculpture that it was relatively short-lived since its principal exponent, Boccioni in Italy, and the futurist influenced Duchamp-Villon in France, both died young, the first at the beginning of World War I and the other at the end. Whatever their futures might have been, and despite the weaknesses of futurism as a movement, it is not too much to say that Boccioni and Duchamp-Villon produced more important sculpture, as sculpture—and apart from theoretical investigations—than any of the cubists. Boccioni's *Development of a Bottle in Space* (p. 136) and his *Unique Forms of Continuity in Space* (pp. 134, 135) are, in fact, two of the great masterpieces of twentieth-century sculpture. The first is a demonstration of his dynamic, swirling treatment of an otherwise static form to suggest the fusion or interpenetration of mass and space. The *Unique Forms of Continuity in Space* is an extraordinary tour de force of the imagination. We are all now familiar with shapes of moving objects under stress as revealed by the stroboscopic camera, and certainly the futurists were familiar with early and more primitive forms of speed photography. But without literally copying such photographic phenomena, Boccioni has given us a monumental and supremely beautiful realization of a striding figure with the lines and planes of forceful movement imaginatively determined. In such a demonstration we have in a flash the wonderful fusion of the scientific and artistic imaginations typified at its highest point in Boccioni's fellow-countryman and progenitor, Leonardo da Vinci. And like Leonardo, Boccioni anticipated many future developments in twentieth-century art. His futurist sculpture manifesto of 1912 foretells many of the spatial innovations of the Russian constructivists, as well as mobile sculpture and the use of unconventional materials like glass, cardboard, leather and cloth.

The Italian futurist worship of motion, symbolized by the machine, finds a more lucid answer than at least any of the painters were able to produce, in

Duchamp-Villon's *Horse* (p. 137). The original idea (p. 136) included a rider, but in the final work he is removed in order to emphasize the fusion of a mechanical with an animal image. The marvelously interrelated formal convolutions, the coiled tension of this horse-cum-machine is another monument to a marriage of the scientific and artistic imaginations.

THE OBJECT CONSTRUCTED ON GEOMETRIC PRINCIPLES

The futurists' glorification of technology was first echoed in Russia during and immediately after the first World War by so-called constructivist sculptors like Tatlin, Rodchenko, Gabo and Pevsner. Later, constructivist ideas spread throughout Europe. Optimistic acceptance of scientific and technological progress marks all the early constructivist experiments. Inspired by the promise of the social revolution in Russia, by a somewhat sentimental socialism as with the Bauhaus's Moholy-Nagy and his students, by the more prosaic orderliness of the Stijl group in Holland or by the somewhat Romantic outlook of England's Ben Nicholson, Barbara Hepworth and other members of Unit One in the thirties, the end-result, with local variations, is much the same. By the avoidance of all reference to living forms, by an absolute dependence upon an abstract geometrical manipulation of spatial rhythms, by excluding any explicit expression of his personal emotions, the constructivist considered that the universal appeal of his work to all classes of mankind would be insured. It is a noble platonic aim, but so far this ideal objective has not been completely realized.

Constructivism and parallel movements in painting such as suprematism and de Stijl are the extreme abstract off-shoots of cubism. Their concern is not with living or organic phenomena but with space—space elevated to a mathematical or mystical element dominating all other instruments of sensation. Gabo and Pevsner did not reach this rarefied position all at once. Both in their early years made constructions along cubist lines, such as Pevsner's *Torso* (p. 148). However, by the use of translucent celluloid (opaque though it may have grown with the passing of time) the intention of the sculptor to enclose space by the most immaterial appearing substance possible, in short, to sculpt with space as the medium, is obvious. Tatlin and Rodchenko by a comparable use of wooden or metal strips captured space within a fine linear web. Pevsner in his *Abstraction* (p. 149) and *Construction* (p. 150), Gabo in his *Column* (p. 151), *Spiral Theme* (p. 153) and *Construction in Space* (p. 152) shows the advancing stages of constructivist manipulation of space. Pevsner for many years now has worked in sheet metal, a material that provides strong linear definition to his compositions. Gabo, by contrast, prefers translucent materials like glass or plastic combined at times with a harp-like gut stringing. What he gains thereby in lightness and airiness he loses, alas, in permanence and stability.

That space is the primary consideration of the contructivist, even when he uses a solid rather than a translucent or linear means of definition, is demonstrated by Vantongerloo's Stijl *Space Sculpture* (p. 154). Here the architectural composition in

28

nickel-silver is of such an abstract geometrical description, the space in and around it becomes, as the sculptor intends, the truly positive element. And similarly, in Ben Nicholson's *Relief* (p. 155) the composition is one of line rather than mass with the wood serving only as a framework or foundation. The delicacy and precision workmanship of contructions by Gabo, Pevsner, and Nicholson undoubtedly provide a good deal of their fascination as objects, comparable to the appeal of a fine machine or mathematical model.

THE OBJECT AND THE SUBCONSCIOUS: THE SURREALISTS

Is it because sculpture and painting, as surrealism served to emphasize, are inextricably linked with our subconscious as well as our conscious reactions to the phenomena of life and nature, that the pure beauty of geometrical constructions tends to appear denatured and impoverished by comparison with an art that refers directly to the organic world? If this is true, it may help to explain why, in sculpture at least, the human figure or related organic forms, apart from the constructivists' denial of them, have continued to exert something of that magic, totemic power that all sculpture from its prehistoric beginnings has possessed.

As a reaction to what they felt was the sterile intellectualism of abstract art, the surrealists revolted from conscious analysis of the world about them. Feeling that reason had dried up the sources of artistic inspiration, the surrealists anarchistically rejected matter-of-fact reality in favor of an imagery dredged up from the subconscious world of dreams, or from fantastic literary sources, or a combination of the two.

Picasso in the late twenties and early thirties made his own extraordinary contribution to surrealism—a movement which touched almost all artists of the period, whether they admitted official participation or no. His strangely elongated *Figure* (p. 156), a number of over life-sized busts of women (p. 157), curiously recalling Matisse's much earlier head, *Jeannette, V* (pp. 132, 133), and a number of fantastic metal constructions (p. 163) will serve to exemplify the range of his surrealist experiments in sculpture. It is perhaps significant that for many years following the first period of cubism before World War I Picasso had abandoned sculpture, and that, under the stimulus of surrealism, he returned to it again. His many paintings of this period, particularly the so-called "bone" pictures, drawings for sculpture and a series of etchings known as *The Sculptor's Studio*, all testify to Picasso's reawakened interest in modeling.

Lipchitz at the end of the twenties may also have been partially influenced by surrealist fantasy when he developed his so-called transparent sculpture, wire-like, although actually cast, constructions such as the *Pegasus* (p. 162).

Picasso's fantasies in wire and sheet metal may have influenced his friend and fellow-countryman, Gonzalez, to turn to surrealist constructions such as his *Angel* (p. 164), *Maternity* (p. 165), *Head* (p. 166), and the *Woman Combing Her Hair* (p. 167).

29

(Concurrently, however, he continued to work in a comparatively realistic style, exemplified by *La Montserrat* (p. 104.)) But since Gonzalez, the practiced metal-worker, is known to have instructed Picasso in some of the techniques of his craft perhaps the exchange was equal. In fact, it is very possible that Gonzalez not only through his own work but also through Picasso's constructions has been largely instrumental in popularizing the use of wrought metals by many of the younger sculptors of today, both here and abroad. Aside from his technical influence, his amazingly sensitive figures (they are never pure abstractions) are among the most original contributions to twentieth-century sculpture. An extremely reserved and shy man, he kept himself and his work practically hidden from public view until his death in 1942. While the Museum of Modern Art, in 1936, was the first museum in America and probably the first in the world to acquire one of his sculptures, most of his production is still unsold in his old Paris studio. Although he has been long known to a few, it is only recently that his full importance has been realized, and time will undoubtedly increase the recognition that is his due.

The sharp, poetic intensity of his imagery marks every piece he made, from the smallest silver construction, a few inches high, to wrought-iron figures of over six feet. His delicate command of intricate interrelations between mass and space is unfailing. That this balance of forces was at the centre of his interest he tells us himself in an extract from some of his unpublished notes:

"The age of iron began many centuries ago by producing very beautiful objects, unfortunately for a large part, arms. Today, it provides as well, bridges and railroads. It is time this metal ceased to be a murderer and the simple instrument of a super-mechanical science. Today the door is wide open for this material to be, at last, forged and hammered by the peaceful hands of an artist.

"Only a cathedral spire can show us a point in the sky where our soul is suspended!

"In the disquietude of the night the stars seem to show to us points of hope in the sky; this immobile spire also indicates to us an endless number of them. It is these points in the infinite which are precursors of the new art: '*To draw in space.*'

"The important problem to solve here is not only to wish to make a work which is harmonious and perfectly balanced—No! But to get this result by the marriage of *material* and *space*. By the union of real forms with imaginary forms, obtained and suggested by established points, or by perforation—and, according to the natural law of love, to mingle them and make them inseparable, one from another, as are the body and the spirit."[1]

The purity of Gonzalez's spirit is not a common characteristic of the surrealists, which is another way of saying that Gonzalez, like all great artists, is beyond classification. A sculptor who is perhaps the best exponent of the movement as such is the Swiss Giacometti. During most of his career he has drawn upon that mysterious domain of the subconscious for much of the trance-like quality of his work. Like Gonzalez his main preoccupation has been with the figure in space, but in a space

[1] Quoted in a letter by his daughter, Mme R. Gonzalez-Hartung, to the author.

30

that is far removed from any normal concept we may have of it. The ghost-like *Head* (p. 158), the nightmarish *Slaughtered Woman* (p. 159), the fantastic *Palace at 4 A.M.* (p. 160), the disquieting *Hands Holding the Void* (p. 161) give a sufficiently diverse record of the fertile depths of the subconscious imagination—the strange new world the surrealists have explored. The most remarkable feature of this world, and the most disturbing, at least as seen by Giacometti, is the pulsating quality of the mass and space relationships, their instability in short. The objects in this world seem not to displace space but to be sucked into it. Space, like water on a stone, seems slowly to be eating the substance of things away. This unending struggle between the object and its ambience Giacometti has observed with an increasing obsession as we shall see later in his most recent work.

Obsessed in a different way by the mysterious relationships of objects and space, Alexander Calder has maintained a childlike combination of innocence and cunning in all his play with wire and sheet metal. His mobiles and stabiles owe something in origin to the space experiments of the constructivists and the crazy machines of the dadaists. His *Steel Fish* (p. 168), his *Whale* (p. 169), the *Thirteen Spines* (p. 170), and the *Lobster Trap and Fish Tail* (p. 171), by their titles alone, but above all in themselves, display a humor and a vitality that must be an inheritance from his ingenious, mechanically inventive Yankee forefathers. The strain of eerie fantasy that is in so many of his constructions, particularly the mobiles, points up by mocking analogies the dull, lifeless quality of our much worshiped machines. The organic origin of practically all his shapes is a constant reminder that man cannot live by science alone, perhaps the most valuable lesson the surrealists attempted to teach before the unimagined horrors of World War II made surrealist fantasy seem like the play-acting of children.

THE LAST DECADE: OLD AND NEW TENDENCIES

World War II and its aftermath of destruction and disillusionment has so dislocated all values, including artistic ones, it is difficult to present any clear impression of what has happened to sculpture in the past ten years. One can point to the continuing influence of Rodin, Maillol and Brancusi, to additional converts to constructivism and surrealism and to a sort of amalgam of the latter two movements to produce what has been called, vaguely, abstract expressionism. The only older movement which finds little or no echo today is cubism. All of which is to say that the complex development of twentieth-century sculpture has now reached an extremely heterogeneous phase. Its very diversity, however, implies an extraordinary vitality, and in America and England, at least, great promise for the future.

Picasso in his *Shepherd Holding a Lamb* (pp. 172–174) and in his *Goat, Skull and Owl* (pp. 175–177) appears to have made a partial return to his Rodin origins. His revival of expressionist modeling is perhaps the most striking reversal he has made in a long mercurial life. To be sure there is a residue of surrealist hypnosis in the

hieratic *Shepherd Holding a Lamb*, which otherwise looks back to Babylonian or Etruscan prototypes. And in the use of corrugated cardboard to model the wings of the owl (the impression alone is left in the bronze, of course) and of *objets trouvés* to construct the *Goat* he recalls similar cubist and surrealist practices. But above all, one feels, he has returned to exuberant modeling of surfaces to achieve an impressionistic drama of light reflections. And by the relative realism of his treatment of man and animals the backward looking nature of his recent sculpture is made all the more emphatic.

Is this return to a form of realism, which has more in common with his pre-cubist sculpture and painting than with anything since, a nostalgic, romantic answer to advancing years? Or is it a reaction to political movements, engendered by the Spanish and World Wars? Some of his paintings done during the war and since have shown a comparable shift towards a more realistic style, but not to quite the same extent as his sculpture. Whatever the explanation for this change, given Picasso's tremendous influence, it may have a marked effect on younger sculptors still unknown.

Lipchitz, after carrying his cubist investigations to an almost completely abstract point in his so-called "transparencies," returned in the early thirties to what he has called "the great stream," typified in his mind by Rodin. Significantly this change was accompanied by a return to modeling in plaster or clay in place of direct carving in stone. Probably under the pressure of world events, the increasing cruelty and oppressive racial program of the Nazis, the threat of war, he came out of the cubist laboratory, as it were, and expressed his horror and anguish in a passionate, non-abstract representation of human and animal forms. He chose and continues to choose for his subject matter mythological themes such as *Europa and the Bull, Prometheus Strangling the Bull*, or, simply and grandly, the age-old motif of the *Mother and Child* (p. 178), in the latter instance inspired by a legless woman he saw singing in the street. His *Prayer* (p. 180) and *Sacrifice* (p. 181) are still later symbolic expressions, directly induced by the recent war. In this later phase of his work, all his profound cubist researches into form and space are merged with a devoted extension of Rodin's principle of studied exaggeration of masses, to produce works of great monumental and emotional power. Lipchitz came to this country as a refugee in 1941. He is one of the few great artists who came here during the war who has succeeded in adjusting himself at an advanced stage of his career, and whose art has grown and developed despite, and perhaps because of, its having been transplanted from Paris to New York.

Lipchitz's fellow cubist, Laurens, has also departed from the analytical experiments of his youth in favor of a more naturalistic, if still highly stylized treatment of the human figure. His *Mermaid* (p. 182) and *Luna* (p. 183), the one in bronze and the other in marble, are typical of his post-cubist work. Retaining, unlike Lipchitz, an equal attachment to direct stone carving and modeling in plaster, Laurens's later sculpture continues to have that quality of dispassionate, reticent elegance that distinguished his cubist carvings and constructions. His particular exaggerations of form are there,

one feels, not to express any obvious violence of emotion, but because the studied rhythm of the composition demands them. He, too, is in the great stream of Rodin, undoubtedly, but the latter's explosive fire has been refined for his purposes to a clear, sharp flame.

Continuing with the older giants: Maillol died in 1944. His *River* (p. 80), which we have already mentioned, is among the last pieces on which he worked. In his long and active life as a sculptor he produced few, if any, modifications of his original neo-classic thesis as stated in his *Mediterranean*. His influence on younger sculptors has seriously waned, unless one admits the dubious absorption of his ideas by academic or near-academic followers. In America, Maldarelli (p. 190) and de Creeft (p. 191) are among the few sculptors who still retain something of the master's original freshness of imagination and feeling. Jean Arp's surrealist extension of Brancusi's organic abstract forms continues to exert a strong influence on some younger sculptors, but his present work shows no radical deviation from the direction he established in the twenties and thirties (p. 196). The constructivists, Pevsner and Gabo, also maintain a steady, unchanging course in their elaboration of linear definitions of space (pp. 202, 203). Alexander Calder's stream of fantasy shows no signs of drying up. The only additions he has made to his family of constructions are the relatively minor and still tentative incorporation of sound effects in his so-called gongs—the addition of a metal cymbal and clapper to his otherwise traditional hanging mobiles (p. 214); and the still further amplification of his cantilever mobiles by the use of cage-like supports (p. 215). If anything, his humor has become more playful and light-hearted and expresses itself in increasingly lighter and more lyrical shapes.

Giacometti and Moore have in the past ten years shown a more radical development of their individual styles. Giacometti has now concentrated almost wholly on the human figure in space, and as time has gone on the organic struggle which he originally posed between man and space has driven him to an extraordinary resolution of the problem. His figures have been dehydrated, as it were, to a point of extreme thinness and elongation in order to exact the maximum victory of limited matter over unlimited space. In a sense this is a surrealist's complex, organic answer to the constructivist's airy geometry. More than that, these astonishing figures of Giacometti, the *Man Pointing* (p. 210), the *City Square* (p. 211) and the *Chariot* (p. 212), have a symbolic significance which the pure geometry of the constructivists can never call upon. Giacometti's space-devouring, ghostly figures, moving as in a dream from nowhere to nowhere, imply the overwhelming loneliness of modern man in a space that has overnight taken on a fearful atomic dimension.

Moore, perhaps the greatest eclectic among modern sculptors, has extended the range of his imagery enormously during and since the war. From a Brancusi-like preoccupation with direct stone-carving and his refined search for the form hidden in the material, he has expanded his vision, probably under the stimulus of his war-time observation of figures in bomb shelters and miners in pits, to a more dynamic, less foetal account of the human body. From the metaphorical, stone-body, body-stone

C

33

implications of his earlier reclining nudes, from their prophesy of an age when man would become one with the rocks about him, he has turned, like Lipchitz, to themes of life and generation. Indicative of this new direction are his *Madonna and Child*, commissioned in 1943 for the church of St. Matthew in Northampton, England, or the many studies he has made of the family motif which have found their final statement in the large bronze *Family Group* (p. 194). His martian-like *Double Standing Figure* (p. 195) may appear at first sight as a reversal of this more humanitarian tendency, but further study will reveal a quality of fantasy, even humor, in their plated shoulders and insect bodies that is totally absent from his reclining figures of the thirties. Many of these later works of Moore are cast in bronze and thus represent an important departure from his earlier adherence to direct carving in stone or wood. The baroque flowering of Moore's imagination has driven him, as it has driven Lipchitz, to the fluent potentials of modeling to express the greater richness and complexity of his formal concepts.

The important younger sculptors (young in reputation, not necessarily in years) who have come up during and since the last war may be divided broadly into three groups. Those who are following the organic abstract tradition of Brancusi, Arp and Moore; those who are continuing the constructivist tradition; and, the most avant-garde of all, the so-called abstract expressionists who perhaps owe more to the meta-phorical, symbolic and technical example of surrealists like Giacometti and Gonzalez than to any other one source.

Outside these groups lie three of the leading Italian sculptors, Marini, Manzù and Fazzini. All three look back to the renaissance-derived expressionist tradition which Rodin, Rosso and Martini had established in their several ways. Fazzini is the most archaistic of the three (p. 184). All are modelers by preference, and each displays a technical virtuosity which would have dismayed their futurist compatriot Boccioni, who detested mere virtuosity for its own sake. Of the three, Marini, despite his archaizing tendencies, is perhaps the strongest and most original talent. He has concentrated on a relatively limited number of motifs, the horse and rider, the female nude and portrait heads. The latter, for example his *Stravinsky* (p. 186), are among the most powerful characterizations of their kind, in a century which, with the exception of Rodin and Epstein, has produced little of importance in this genre. His *Quadriga* (p. 184) is a brilliant exercise in the ancient Roman relief tradition. His *Dancer* (p. 185) and *Horse* (p. 187) are more personal expressions of his masterful command of forms and their rhythmic interplay. The *Horse*, his most recent work, by the architectural severity of its composition may well indicate a new and more austere development in his career, in an attempt to escape from the somewhat sentimental and literary implications of his earlier equestrian figures. The screaming head may uncomfortably remind one of Picasso's horse in *Guernica*. In all other respects, this is a noble and original treatment of an ancient sculptural theme.

Manzù's best work to date has been a striking series of low reliefs depicting incidents from the Passion. Many of the incidents contain topical references to the contemporary

34

Italian scene, for example, the *Cardinal and Deposition* (p. 189). Another shows a brutal, debauched German officer at the Crucifixion. Manzù's portraits, for example, the *Portrait of a Lady* (p. 188), have a romantic, impressionistic appeal which reminds one of Rosso, in a more realistic vein.

These three Italians, to repeat, revert to a pre-cubist phase of sculpture. Returning to the post-cubist groups of younger sculptors, the organic abstract tradition of Brancusi, Arp and Moore is represented in England by Barbara Hepworth, who is a younger contemporary of Moore, but who is only now beginning to be better known outside England. Her *Cosden Head* of 1949 (p. 197), although less abstract than her early work, is still closer to Moore's forms of the early thirties than to any other sculpture today. Another young Englishman, Bernard Meadows, was for many years an assistant in Moore's studio and is today his closest follower, as his *Standing Figure* (p. 197) clearly shows. Two Germans, Karl Hartung and Bernard Heiliger, while neither of them are particularly young in years, have become known outside of Germany since the war and after the removal of the interdiction the Nazis had imposed on all art that did not conform to the vulgar realism that was the party line. Each in his individual way is following an organic abstract direction, applied particularly to the human figure. Hartung, the older of the two, is the more mature in his absorption of Brancusi's and Arp's forms and in his adaptation of them to his own needs, in, for example, his *Figure* (p. 201). Heiliger for some time came under the spell of Moore, but in his *Seraph* (p. 199) he appears to be struggling towards a more individual statement. Viani in Italy is the only younger Italian of note who has had the courage to turn from the renaissance-bound tradition of his own country in favor of the formal purity of Arp. His *Torso* (p. 198) is extremely sensitive in its subtle modulations of form. Unfortunately, for reasons of health and economy he has not been able to execute as many of his ideas in marble as he would wish and has had to be content to work in plaster, hoping some day to translate his models into stone. In America Isamu Noguchi, son of a Japanese poet, is the chief representative of organic abstraction. Brancusi, his spiritual master, derived many of his abstract ideas from Oriental sculpture. Noguchi acquired his directly from study in the Orient. The pictographic symbolism of his *Cronos* (p. 200) is of a power and authoritativeness unattainable perhaps by any artist of purely Western blood.

The organic abstract tradition, which this first group of younger sculptors is following, is chiefly preoccupied with the solidity of volumes and, even when these are perforated, the perforations are used to emphasize still further the substantial nature of the remaining mass. Space in this conception of form is in a sense a negative factor, or rather it only takes on reality, is created in fact, by the presence of form. The constructivist and surrealist traditions, on the other hand, have emphasized the positiveness of space and in their most advanced manifestations have reduced the substantial or formal aspects of their creations to a minimum and have in effect drawn in space rather than modeled or carved in materials.

In the somewhat earlier stages of constructivism the Swiss Max Bill, who was

associated with the Bauhaus in Germany, constructs many pieces in sheet metal and concrete (p. 204). Uhlmann in Germany uses sheet metal also (p. 208), as does de Rivera in America (p. 205). A still younger generation of constructivists, however, have turned to wire; for example, the Americans Lippold and Lassaw, or in the case of the English sculptor, Robert Adams, to finely joined strips of wood (p. 209). Lippold's *Variation No. 7: Full Moon* (p. 206), his masterpiece, is a lyrical, astronomical, linear music that makes earlier abstractions by Gabo and Pevsner almost weighty by comparison. Space has been captured here in a gossamer net. If Lippold's is an almost rococo resolution of the constructivist's music of the spheres, Lassaw's *Monoceros* (p. 207) is its baroque counterpart. Like a fugue it rises architecturally, cube on cube, to a splendid resolution.

Even so, however refined and graceful these younger constructivists are, some of us miss a quality of passion, a lack of human involvement that seems to express a strange aloofness in the face of the political and emotional turmoil of today. Perhaps they might say in defense that detachment is the only antidote to chaos.

The abstract expressionists have taken no such journey to felicity. By sometimes obscure and often violent imagery they have attempted in visual metaphor and symbol to prod the observer out of any complacent world of escape. There is considerable diversity among the exponents of this group, some of whom are English, most of whom are American. Reg Butler and Eduardo Paolozzi are both British born, the latter of an Italian father. Butler's insect-like human figures (p. 213), blood relations to Giacometti's creatures of the void, though closer to Gonzalez's delicate evocations, are the most technically expert wrought-iron drawings being made today. If they have a weakness it perhaps lies in an overly facile line that verges on the decorative. Paolozzi, an artist who has learned from Picasso's *Guernica* drawings and the drawings of Paul Klee, who has looked long at strange plants, fish and flying things, out of this wealth of observation has evolved a highly original series of images. Outstanding is his *Cage* (p. 217) which has been said to call to mind a flight of birds. However that may be, as a construction it has, like Klee's art, an organic logic of its own which, like nature, is its own reason for being. More deeply indebted to Giacometti than to any other master, another Englishman, William Turnbull, is experimenting with cacti or thorn-like forms in space (p. 218). Lynn Chadwick, England's best-known mobilist, on the other hand, has sat at the feet of Alexander Calder. That he is able to make a contribution of his own in a field that Calder has almost monopolized for himself, his ingenious and beautifully balanced *Fisheater* (p. 216) is sufficient evidence.

It is, however, in America that the most vital wing of this new sculpture has sprung up. No other single country since the war has produced such a large crop of fresh and internationally significant talent. David Smith before the war announced himself as one of the most promising avant-garde sculptors in this country. He has since fulfilled that promise, and with an energy and imaginative grasp of his material, wrought iron and cut steel, he has produced a body of sculpture that is of great importance. Using the surrealist method of metaphor he has drawn in metal a richer and more varied set of images than any other sculptor of his generation. He is by no

36

means always successful in his valiant struggle with his material, but when he is, the result, as in the *Banquet* (p. 219), is a triumphant justification of all his labor. Silhouetted against the sky, as they should be seen, these hieroglyphs in space have a clarity and finality that only a powerful imagination can achieve. In some of his other conceptions, such as his *Hudson River Landscape* or *Australia*, the breadth and originality of his space-commanding vision are undeniable. He is an admirer of Gonzalez, and in his youth he must have been inspired by the constructions of that master metal craftsman as well as by those of Picasso. Mary Callery also absorbed something from Picasso and perhaps more from Léger. But eventually she has arrived at her highly individual attenuated figures (p. 220), balancing and weaving their own particular patterns in space. David Hare, perhaps our purest surrealist sculptor, has brazed and welded wire and sheet metal into some of the most intricate constructions produced by any of this group. He is sometimes a victim of his own amazing industry, but at his best, in, for example, his *Figure with Bird* (p. 221), the genuine totemic magic he is striving for is completely realized. Theodore Roszak, another worker in brazed metal, has said of his sculpture: "The forms that I find necessary to assert are meant to be blunt reminders of primordial strife and struggle, reminiscent of those brute forces that not only produced life, but in turn threaten to destroy it." His *Spectre of Kitty Hawk* (p. 222), with its jagged clawing of space—a fearful commentary upon the power of the Wright brothers' invention—is perhaps the finest example of his dynamic genius. Finally with Herbert Ferber and Seymour Lipton we conclude this summary account of a selection of the best of our younger Americans. Lipton's *Cerberus* (p. 224) with its anguished, fractured, spiked forms impales the eye with murderous force. Herbert Ferber's "*. . . and the bush was not consumed*" (p. 223), a commissioned sculpture for a synagogue in Millburn, New Jersey, is one of the most successful applications of the abstract expressionists' manipulation of space for the presentation of a specific religious symbol.

It is remarkable that all these younger Americans, and most of their British brethren, are working directly in wrought metals. The very intractibility of their materials, although most of them would deny the importance of materials as such, is almost a symbol of the toughness and vitality of their outlook. Their new imagery combined with their mastery of unconventional techniques are inspiring evidence that still another sector of the limitless frontier of sculpture is being explored right in our time.

SCULPTORS ON SCULPTURE

AUGUSTE RODIN

I have invented nothing; I only rediscover, and it seems to be new because the aim and the methods of my art have in a general way been lost sight of. People mistake for innovation what is only a return to the laws of the great statuary of antiquity. It is true that I like certain symbols. I look at things from a symbolical viewpoint, but it is Nature that gives me all that. I do not imitate the Greeks, but I try to put myself in the state of mind of the men who have left us the statues of antiquity. The schools copy their works, but what is of importance is to rediscover their methods.

First I made close studies after nature, like *The Bronze Age*. Later I understood that art required more breadth—exaggeration, in fact, and my aim was then, after the *Burghers of Calais*, to find ways of exaggerating logically—that is to say, by reasonable amplification of the modeling. That, also, consists in the constant reduction of the face to a geometrical figure, and the resolve to sacrifice every part of the face to the synthesis of its aspect. Look what they did in Gothic times. Take the Cathedral of Chartres as an example: one of its towers is massive and without ornamentation, having been neglected in order that the exquisite delicacy of the other could be better seen. In sculpture the projection of the sheaths of muscles must be accentuated, the shortenings heightened, the holes made deeper. Sculpture is the art of the hole and the lump, not the straightness of smooth faces without modeling. The ignorant say: "That is not finished," but there is no notion more false than this of finish, unless it be that of "elegance." People would kill art with these two ideas. It is by work carried to its extremity not in the sense of finish or the copying of details, but in the justness of the successive planes, that one obtains solidity and life. The public, which has been perverted by academical prejudices, confounds art with neatness or spruceness. Molding from nature is copying of the most exact kind, and yet it has neither movement nor eloquence. Art steps in to exaggerate certain planes and give fineness to others. In sculpture everything depends on the way modeling is carried out, and the active line of the plane found, the hollows and projections rendered, and their connections. That is how one obtains fine lights and beautiful shadows that are not opaque. All this is a matter personal to the tact and temperament of each sculptor, and that is why it is not a transmissible method or studio recipe, but a just law. I see it in Michelangelo and in the ancients.

see bibl. 105, p. 14

38

ARTURO MARTINI

The fundamental element of the individuality of a work of art—is rhythm. It does not come from the subject itself, rather the artist draws it from his own depths, imposing on the vision drawn from reality his own proper composite wave-lengths, his own lyric scansion.

Punctuation, spatial time which creates the stages of a work of art. It appears in every creation—musical, pictorial or poetic.

In sculpture, however, the rhythm is imposed by the subject where it existed before the creation.

It is not given to violate a human or animal body beyond the limits of dignity and verisimilitude; on the other hand if the sculptor were able to dispose the limbs of a tree according to the proper rhythm, he would do no apparent violence to the laws governing nature.

Where are the rhythmical and lyric possibilities if, having done one eye, one must inexorably produce the other, one ear, the other ear, one arm and one leg, the other arm and the other leg, and all in a monochrome, set in a strange element.

The contrast of forms and diverse values resolutely assists, in the other arts, in the rhythmical construction of the work.

Sculpture is burdened with the yoke of the human or animal figure; and the servitude and the methods it uses are testified to by the works of all ages.

The unique resource of the antique sculptors was drapery, beneath which they concealed and sometimes changed the articulation of the human body.

The fusion of diverse figures (human and animal) has remained always an illusion because the rhythm does not cease to be oppressed by the figurative element.

see bibl. 87, pp. 14-15

ARISTIDE MAILLOL

One must synthesize. In youth we do so naturally, like the Negro sculptors who have reduced twenty forms to one. . . . We live in an epoch in which a great many things need to be synthesized. I should make better Egyptian sculpture than modern, and better gods than men.

The particular does not interest me; what matters to me is the general idea. In Michelangelo, so far removed from the art of Egypt, what fascinates you is the concept of power, the whole, the great point of view to which he committed himself. The *Slaves*, the *Tombs*, are sculpture made to be seen from one side only. For me, sculpture is the block; my figure, *France*, has more than twenty sides. I made her grow; she did not offer more than four. I had to keep working on her. Sculpture, for me, must have at least four sides.

Nature is deceptive. If I looked at her less, I would produce not the real, but the true. Art is complex, I said to Rodin, who smiled because he felt that I was struggling with nature. I was trying to simplify, whereas he noted all the profiles, all the details;

it was a matter of conscience. In his figure, *Enthusiasm*, the smallest reliefs are noted with an unheard of scrupulousness.

When I made my first statuette in wood, I took a tree trunk and shaped it, trying to reproduce my general feeling about the grace of a woman. I have lost sight of that statuette. Thirty years later, looking at a photograph of it, I took it for Chinese sculpture. It seemed to me to have come out of another epoch. I had no other thought than to carve a beautiful form from the wood. That gave me the key to what the ancients did. . . .

. . . I did not arrive at this idea of synthesis by a process of reasoning but through the study of nature, from which I have drawn directly and according to my feeling.

see bibl. 80, pp. 31, 32

WILHELM LEHMBRUCK

All art is measure. Measure set against measure, that is all. Measure, or in figures proportion, determines the impression, determines the effect, determines the expression of the body, determines the line, the silhouette—everything. Therefore a good sculpture must be treated like a good composition, like a building, where measure is weighed against measure, and so it is impossible to negate detail, for detail is the small measure for the whole. Like the painter who divides the flat surface the sculptor also sees the volume of his statue as a flat surface and divides it.

see bibl. 74, p. 76

CONSTANTIN BRANCUSI

Direct carving is the true path to sculpture, but also the most dangerous for those who do not know how to walk. And in the end, direct carving or indirect, it really doesn't matter. It is the thing made which counts!

Finish is a necessity for the relatively positive forms of certain materials. It is not obligatory, it is even useless for those who cut carcasses (*font le bifteck*).

Simplicity is not an end in art, but one reaches simplicity in spite of oneself by approaching the real meaning of things.

see bibl. 49, p. 235

JEAN ARP

In art too man loves a void. It is impossible for him to comprehend as art anything other than a landscape prepared with vinegar and oil or a lady's shanks cast in marble or bronze. Every living transformation of art is as objectionable to him as the eternal transformation of life. Straight lines and pure colors particularly excite his fury. Man does not want to look at the origin of things. The purity of the world emphasizes too much his own degeneration. That is why man clings like a drowning creature to each graceful garland and out of sheer cowardice becomes a specialist in stocks and bonds. . . . Art is a fruit growing out of man like the fruit out of a plant like the child out of the mother. While the fruit of the plant grows independent forms and never resembles a

balloon or a president in a cutaway suit the artistic fruit of man shows for the most part a ridiculous resemblance to the appearance of other things. Reason tells man to stand above nature and to be the measure of all things. Thus man thinks he is able to live and to create against the laws of nature and he creates abortions. Through reason man became a tragic and ugly figure. I dare say he would create even his children in the form of vases with umbilical cords if he could do so. Reason has cut man off from nature.

see bibl. 41, p. 222

HENRY MOORE

. . . All good art has contained both abstract and surrealist elements, just as it has contained both classical and romantic elements—order and surprise, intellect and imagination, conscious and unconscious. Both sides of the artist's personality must play their part. And I think the first inception of a painting or a sculpture may begin from either end. As far as my own experience is concerned, I sometimes begin a drawing with no preconceived problem to solve, with only the desire to use pencil on paper, and make lines, tones and shapes with no conscious aim; but as my mind takes in what is so produced a point arrives where some idea becomes conscious and crystallizes, and then a control and ordering begins to take place.

Or sometimes I start with a set subject; or to solve, in a block of stone of known dimensions, a sculptural problem I've given myself, and then consciously attempt to build an ordered relationship of forms, which shall express my idea. But if the work is to be more than just a sculptural exercise, unexplainable jumps in the process of thought occur; and the imagination plays its part.

It might seem from what I have said of shape and form that I regard them as ends in themselves. Far from it. I am very much aware that associational, psychological factors play a large part in sculpture. The meaning and significance of form itself probably depends on the countless associations of man's history. For example, rounded forms convey an idea of fruitfulness, maturity, probably because the earth, woman's breasts, and most fruit are rounded, and these shapes are important because they have this background in our habits of perception. I think the humanist organic element will always be for me of fundamental importance in sculpture, giving sculpture its vitality. Each particular carving I make takes on in my mind a human, or occasionally animal, character and personality, and this personality controls its design and formal qualities, and makes me satisfied or dissatisfied with the work as it develops.

see bibl. 90

UMBERTO BOCCIONI

. . . When we speak of movement it is not cinematographic preoccupation which guides us, nor vain competition with the snapshot, nor the puerile curiosity of watching and tracing the trajectory of an object moving from point A to point B. We wish, on the contrary, to get nearer to *pure sensation*, to create form in our plastic intuition, to

create the apparition in its total duration, to live the object in its manifestation. Thus not only to give an object with the integrity which is drawn from *superior analysis*, like Picasso, but to give the simultaneous form that issues from the drama of the object in its environment. It is in this way that we came to the destruction of the object and of similar representation.

The action that the object manifests in its environment represents its motion. We believe firmly that only through its motion does the object determine its drama and indicate the proportions for its creation. Therefore it is completely wrong to speak of little fragmentary accidents as the things we wish to pin down. What truly makes a noxious falsehood of old painting is the separation between the study of matter and the study of energy—the study of quantity or knowledge (which I have called centripetal construction) and the study of quality or appearance, the relation of the object to its environment, which is centrifugal construction. . . .

. . . Today one cannot study a cadaver to create a living man in art—as one cannot study a still automobile to render it in motion. Man, like the automobile, must be studied through his vital laws, through his dynamism which is the *simultaneous action* of his absolute and relative motion.[1]

We wish to model the atmosphere, draw the forces in objects, their reciprocal influences, the unique form of continuity in space. . . .

. . . We can affirm and create plastically the vibrations, the emanations, the density, the motions, the invisible aura of the object and its action, the analogous synthesis which lives on the borderline between the real object and its plastic ideal, all that sums up the life of the object. . . .[2]

. . . Sculpture should therefore make objects live, rendering tangible, systematic and plastic their prolongation in space, for no one can doubt any longer that one object ends where another begins and that there is nothing which surrounds our bodies— bottle, automobile, house, tree, street—that doesn't cut and bisect them with an arabasque of curves and lines.[3]

[1] *see bibl. 46, pp. 174–177*
[2] *see bibl. 46, p. 325*
[3] *see bibl. 46, p. 396*

JACQUES LIPCHITZ

With artists it is not merely a question of genius or of talent and it is something much more than science: there is an accumulation of actual experience. Each artist falls heir to all that the ages before him have worked out. Each time an artist widens the frontiers of expression he contributes to this heritage. The liberty in representation, for example, which the cubists brought to art was a contribution. But without Impressionism's destruction of conventional forms, arrived at through their analysis of light-effects, the cubists could never have found their way to the liberties they won.

42

The great revolution in art in recent times was that of the Impressionists. And one of the great geniuses of Impressionism was Rodin. Perhaps Cézanne was a greater intellect but Rodin's artistic gifts were superior. Rodin was the supreme master of light composition in sculpture.

It was cubism's reaction which broke the Impressionist line for our period. The younger generation will probably soon pick it up. Yet much as I admire the Impressionists, and Rodin, I always say, "I am a cubist, I am always a cubist."

. . . Cubism, however, was not a school, an aesthetic, or merely a discipline—it was a new view of the universe. Cubism sought a new way to represent nature, a manner adequate to the age. Cubism was essentially a search for a new syntax. Once this was arrived at there was no reason for not employing it in the expression of a full message. This is what I feel I have done and what I am still trying to do. This is why I say I am still a cubist, but expressing myself freely with all the means at my disposal from the cubist point of view, not merely limiting myself to cubism's syntax.

see bibl. 76, pp. 84, 88

HENRI LAURENS

Essentially sculpture means taking possession of a space, the construction of an object by means of hollows and volumes, fullnesses and voids; their alternations, their contrasts, their constant and reciprocal tension, and in final form, their equilibrium.

The relative success of the work and the happy solution of its particular problem correspond to the intensity of this composition of forms. It should be static despite its movement when space radiates and forms about it. I have done polychrome sculpture; I wanted to do away with variations of light and, by means of color, to fix once and for all the relationship of the components, so that a red volume remains red regardless of the light. For me, polychrome is the interior light of the sculpture.

Sculpture has its place in the moments through which it participates in the life of man. It is the natural ally of architecture and has always been during the great epochs. A Roman Christ or an Angkor dancer had a normal purpose. This usage of sculpture should be reconciled with the principle which I consider essential: the total occupation of space in three dimensions, with all the faces of the sculpture having an equal and self-same importance, and perhaps a new assimilation of architecture.

This will be the task of the young sculptors. We others who derive from the cubist period are entirely devoted to inquiries, to experiments, to their slow development, and we cannot spend time on their applications. The time was not yet ripe for us, and architects wanted only to obtain perfect severity—their revenge on the excesses of nineteenth-century style. They were not disposed to any discreditable collaboration. But I think that in the future, because of the work accomplished by their elders, sculptors and architects will discover the conditions for a new alliance.

see bibl. 73

NAUM GABO AND ANTOINE PEVSNER

We call ourselves "constructivists" because our pictures are not painted and our sculptures are not modeled, but on the contrary constructed in space and with the aid of space. Our school could more clearly be designated by the term "constructive realism." The guiding principle of this school is the search for a synthesis of the plastic arts (painting, sculpture, architecture) in the sense that its adepts try to combine the forms of the different plastic arts in one form, a single construction in space and time.

The fundamental principles of "constructive realism" published in 1920 by Gabo and myself in the *Realist Manifesto* have not changed. They may be formulated in the four following points.

1. Space and time are the two essential elements of real life. To correspond with real life, art must then be founded on these two elements.

2. Volume is not the only spatial element.

3. Static rhythms alone are not capable of giving the expression of real time. On the contrary, kinetic and dynamic elements are of a nature to give this expression.

4. Art must cease being representational in order to become creative.

The volume of mass and the volume of space are not, sculpturally, the same thing. More important for us as constructivists, they are two different materials. Mass and space are two concrete and measurable things. We consider and use space as a new and absolutely sculptural element, a material substance which really enters into construction.

Consequently, space becomes one of the fundamental attributes of sculpture. For us, it ceases to be an abstraction, in order to take its place as a malleable material and incorporate itself with the sculptural elements of our construction.

Mass volume remains one of the attributes of sculpture in so far as the theme demands an expression of solidity. By the treatment and enclosure (*recouvrement*) of the mass, and also by the methodical arrangement of the spatial forms of which our construction is composed, we enrich our works of art both by the contrast of these materials and by their own quality of expression. Thus this constructive art embraces and contains in itself all the forms ideally possible and is applicable also to an infinity of forms hidden in nature.

To palliate that poverty of sculpture which results from the exclusive use of mass volumes, we execute our constructions also in transparent materials in such a way that air which circulates becomes an integral part of the work. Sculpture of mass is dependent on lighting, while our constructions carry shadows and light within themselves. Moreover, variations of color can be increased to infinity by the use of materials of different tones. But it is by no means for aesthetic ends that we use recently discovered materials. They only serve as means for realizing our spiritual compositions. Constructivism is exclusively the result of reason, strict logic. It springs at once from science, from art and the condition of the life of man. And, being pure art, it permits every delicacy of execution.

see bibl. 61, p. 63

ALBERTO GIACOMETTI

It was not anymore the exterior of beings that interested me but what I felt affected my life. During all the previous years (the period of the Academy) there had been a disagreeable contrast for me between life and work, one prevented the other; I found no solution. The fact of wanting to copy a body at a fixed hour and a body, by the way, to which I was indifferent, seemed to me an activity that was false at its base, stupid, and which made me waste many hours of my life.

It was not important anymore to make a figure exteriorly life-like, but to live and to realize what moved me within, or what I desired. But all this changed, contradicted itself, and continued by contrast. A need also to find a solution between things that were full a nd calm, and clear and violent. Which led during those years (1932–34 approximately) to objects moving in opposite directions, a kind of landscape-head, lying down, a woman strangled, her jugular vein cut, construction of a palace with a bird skeleton and a dorsal spine in a cage, and a woman at the other end. A layout for a large garden sculpture (I wanted that one could walk, sit and lean, on the sculpture). A table for a hall, and very abstract objects brought me by contrariwise to figures and skull-heads.

I saw afresh the bodies that attracted me in life and the abstract forms which I felt were true in sculpture. But I wanted the one without losing the other (very briefly put).

I worked with the model all day from 1935 to 1940.

Nothing turned out as I had imagined. A head (I quickly left aside figures, it was too much) became for me a completely unknown object, one with no dimensions. Twice a year I began two heads, always the same without ever ending, I put my studies aside. (I still have the casts.)

Finally, in trying to accomplish a little, I began to work from memory. This mainly to know how much I retained of all this work. During all these years I drew and painted a little, most of the time from nature.

But wanting to create from memory what I had seen, to my terror the sculptures became smaller and smaller, they only had a likeness when very small, yet their dimensions revolted me, and tirelessly I began again and again, to end, several months later, at the same point.

A large figure seemed to me untrue and a small one intolerable, and then often they became so very small that with one touch from my knife they disappeared into dust. But head and figures only seemed to be true when only small.

All this changed a little in 1945 through drawing.

This led me to want to make larger figures, then to my surprise, they achieved a resemblance only when long and slender.

And it is almost there where I am today, no, where I still was yesterday and I realize this instant that if I can draw easily all sculpture I could only with difficulty draw those I made during these last years; perhaps if I could draw them it would not be necessary to make them, but I am not sure about all this.

see bibl. 63, pp. 42, 44

45

RICHARD LIPPOLD

... Once the fear of dealing with delicate tensions has been overcome, one is free again for all the elements of life to function, and a new adjustment to the immediate environment is established.

We can hope—even prove—that our wisdom is stronger than our weapons. This construction [*Variation No. 7: Full Moon*, p. 206] is such proof. The firmer the tensions within it are established, the more placid is the effect. Patience and love are the elements which gave it life, and patience and love must be used in all dealings with it, its hanging and its seeing. Fortunately, patience and love are both marvelous feelings, so there is little difficulty in calling upon them to help you.

... Once installed, nothing can disturb it except the most delicate of matter; dust, a piece of paper, an enthusiastic finger. Again we must remember that a slip of paper in the wrong place—someone's desk or a portfolio—can now destroy mankind. It is not the main tensions we must fear, it is the little delicate relationships which we must control.

see bibl. 78, pp. 22, 50

THEODORE J. ROSZAK

The work that I am now doing constitutes an almost complete reversal of ideas and feelings, from my former work [constructivist sculpture done before 1945]. Instead of looking at densely populated man-made cities, it now begins by contemplating the clearing. Instead of sharp and confident edges, its lines and shapes are now gnarled and knotted, even hesitant. Instead of serving up slick chromium, its surfaces are scorched and coarsely pitted. The only reminder, of my earlier experiences, that I have retained is the overruling structure and concept of Space. . . . No longer buoyant, but unobtrusively concealed, where I now think it properly belongs. . . .

... The forms that I find necessary to assert, are meant to be blunt reminders of primordial strife and struggle, reminiscent of those brute forces that not only produced life, but in turn threatened to destroy it. I feel that, if necessary, one must be ready to summon one's total being with an all-consuming rage against those forces that are blind to the primacy of life-giving values. . . . Perhaps, by this sheer dedication, one may yet merge force with grace.

It is altogether possible that society may be on the threshold of a great transformation—and while its external circumstances may remain relatively unchanged, I believe, we will witness vast shifts in emotional and moral outlook. It is not without possibility, too, that the next most important phase of our century, will see the entrance of the Baroque symbol.

The rhythm between the discipline of the classic and the emotional stirring of the

Baroque may well establish a new synthesis toward the completeness of man and his hopes for the fullness of life.

Sculpture and architecture have always symbolized unified institutions and a unified man. Painting with its subtle mutations of change and broad versatility flourishes best within an atmosphere of suspension and discord. This explains in part why painting is still the dominant voice in these times. But, I believe we are faced with the prospect of an impending cycle of social change that is already indicated by the growing presence of a new architecture and sculpture.

see bibl. 4

opposite: AUGUSTE RODIN: *The Gate of Hell*. 1880–1917. Bronze, 20′ 10″ × 13′ 1½″ × 33½″. Musée Rodin, Paris

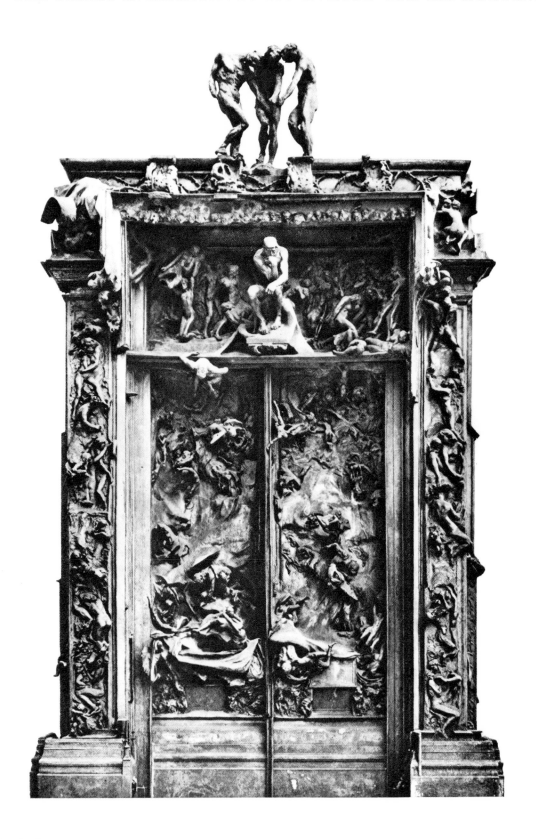

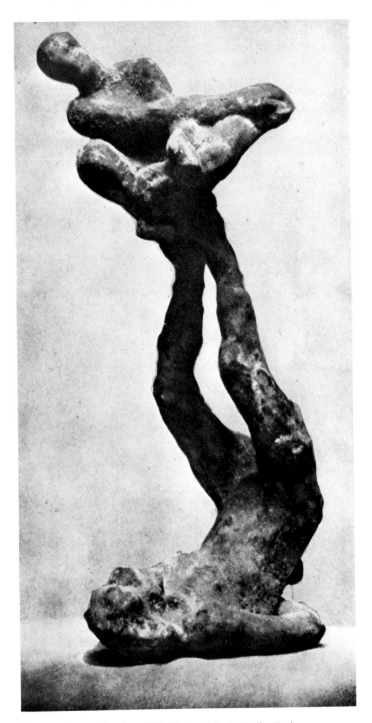

AUGUSTE RODIN: *Jugglers*. 1909. Plaster. Musée Rodin, Paris

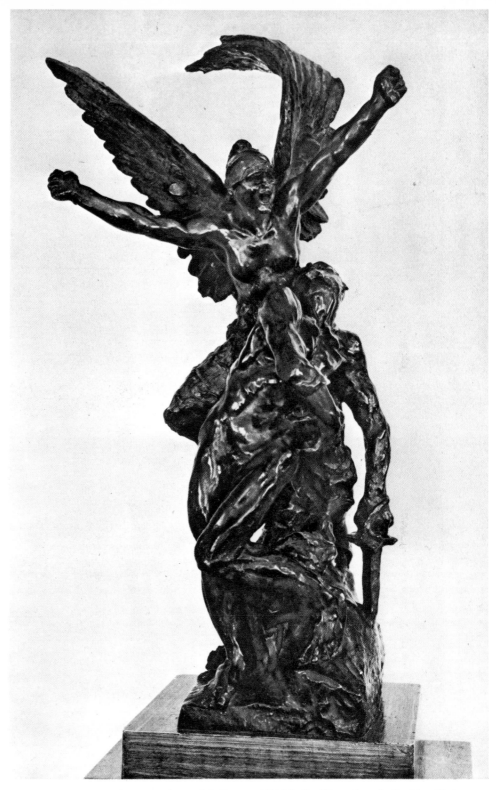

AUGUSTE RODIN: *Study for The Defense.* 1878. Bronze, 45″ high. Paul Rosenberg & Co., New York

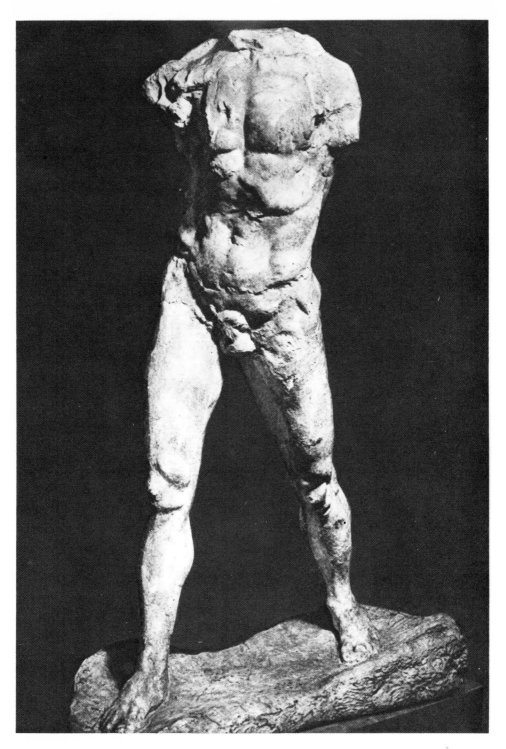

AUGUSTE RODIN: *Walking Man*. 1877. Plaster, 7′ 4⅝″ high. Musée Rodin, Paris

52

AUGUSTE RODIN: *St. John the Baptist Preaching*. 1878–80. Bronze, 6′ 8½″ high. The City Art Museum of St. Louis, Mo.

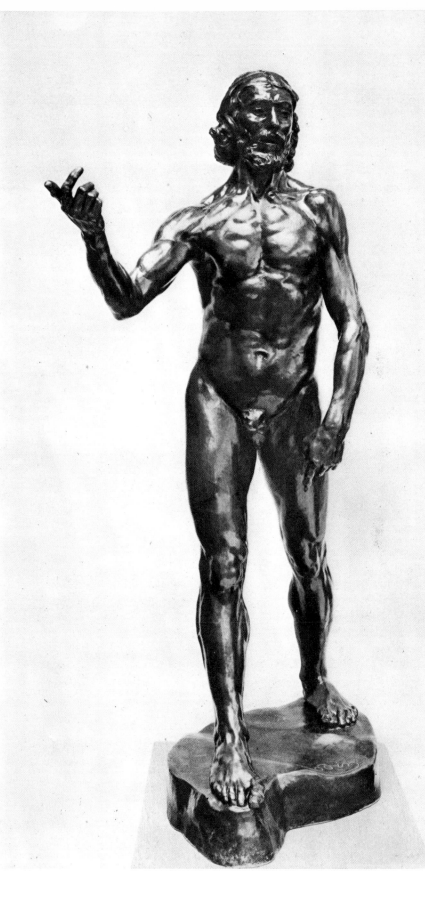

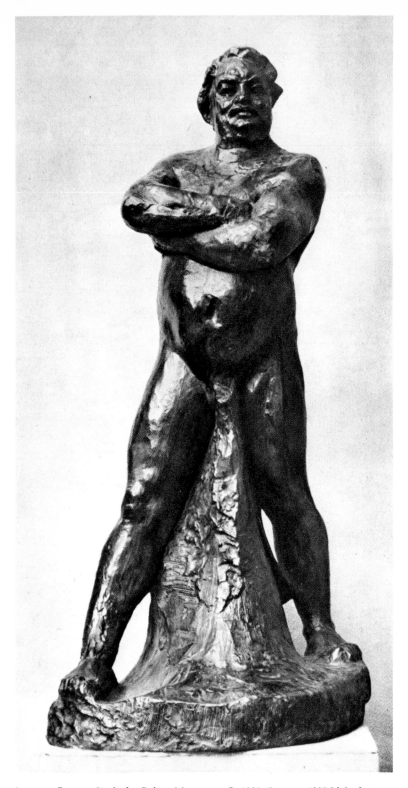

AUGUSTE RODIN: *Study for Balzac Monument.* C. 1893. Bronze, 49½″ high. Jacques Seligmann & Co., New York

54

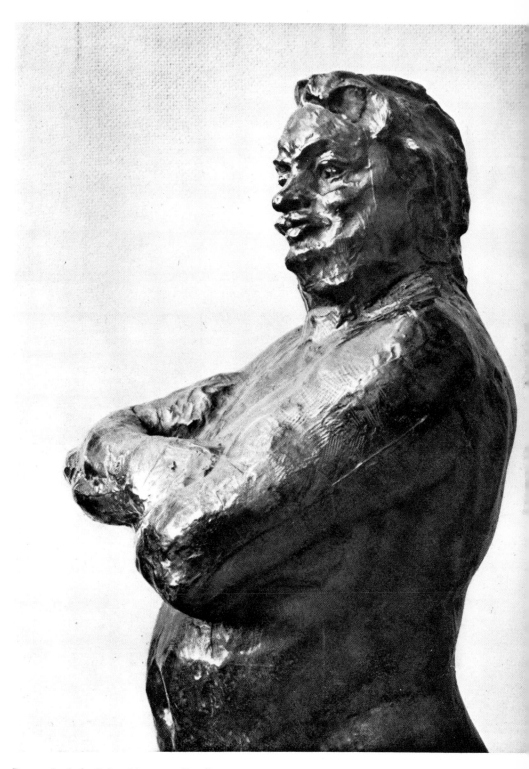

RODIN: *Study for Balzac Monument.* Detail

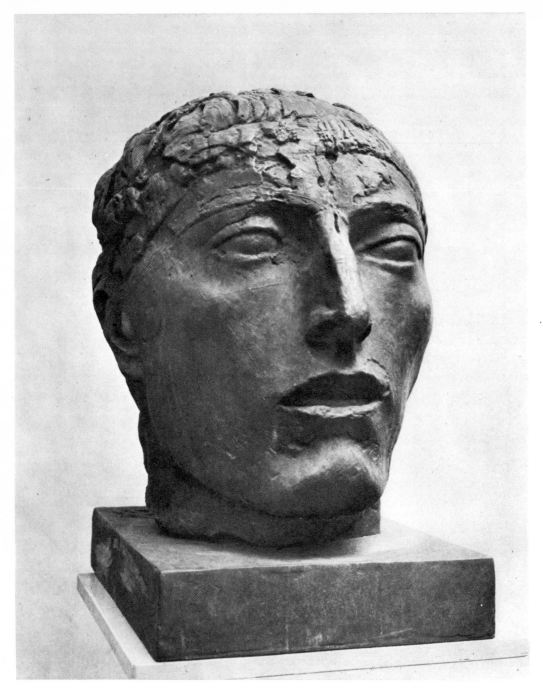

ANTOINE BOURDELLE: *Head of a Man.* 1910? Bronze, over life-size. Collection Wright Ludington, Santa Barbara, Calif.

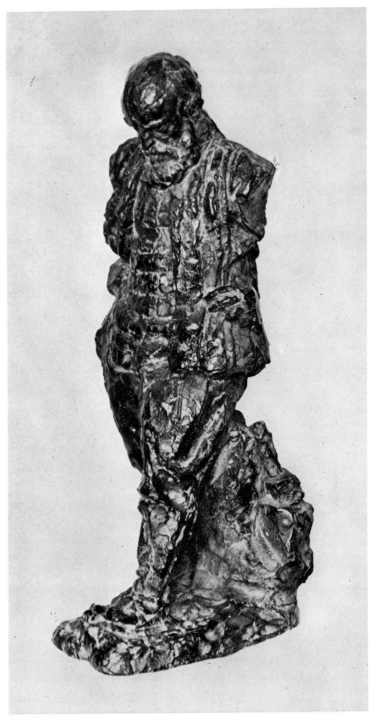

ANTOINE BOURDELLE: *Self Portrait*. C. 1920 (plaster); cast in bronze post-humously, 22¾″ high. Collection Mr. and Mrs. Richard S. Davis, Wayzata, Minn.

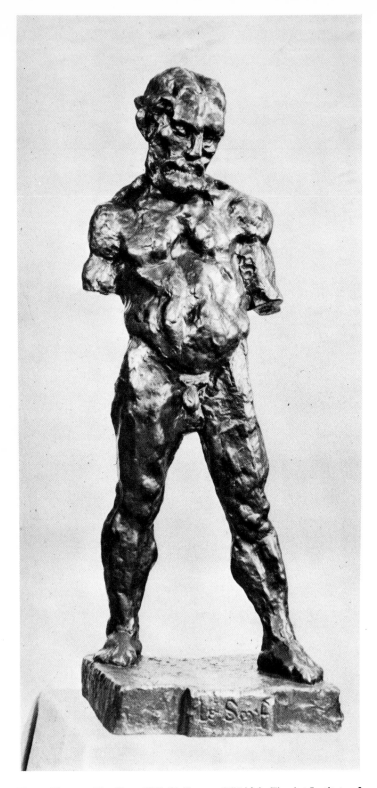

HENRI MATISSE: *The Slave*. 1900–03. Bronze, 36¼" high. The Art Institute of
Chicago, Edward E. Ayer Collection

58

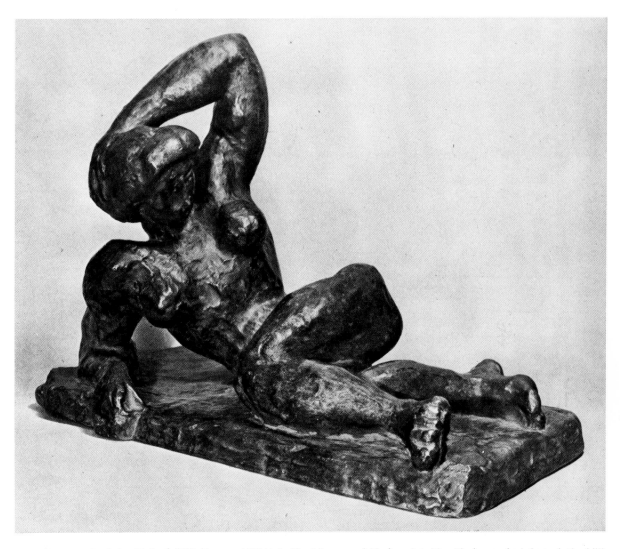

HENRI MATISSE: *Reclining Nude, I.* 1907. Bronze, 13½″ high. The Museum of Modern Art, New York, acquired through the Lillie P. Bliss Bequest

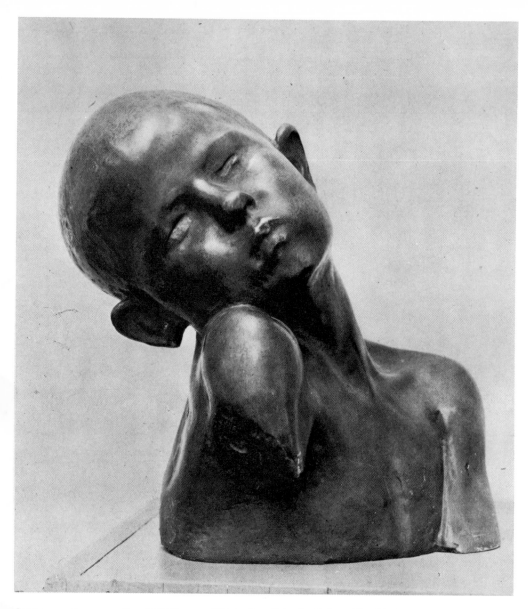

CONSTANTIN BRANCUSI: *Boy*. 1907. Bronze, 8″ high. Curt Valentin Gallery, New York

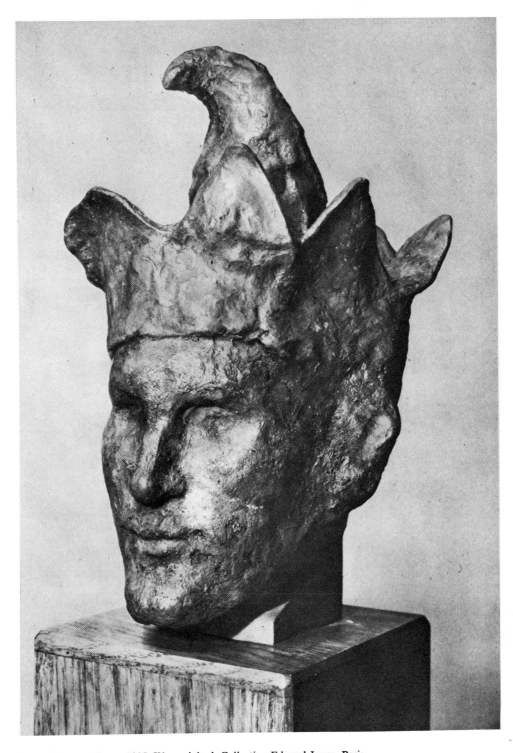

PABLO PICASSO: *Jester*. 1905. Wax original. Collection Edward Jonas, Paris

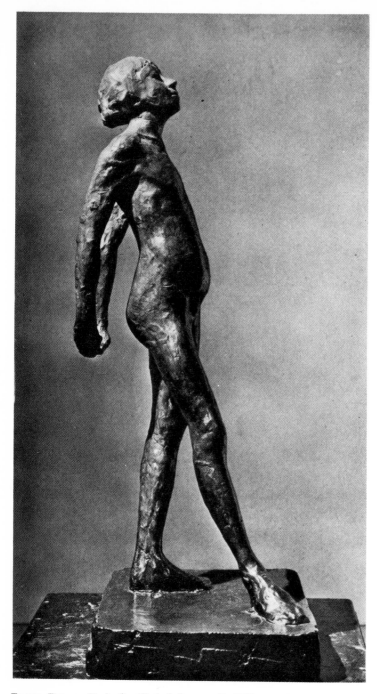

EDGAR DEGAS: *Study for Clothed Dancer*. C. 1872; cast in bronze post-humously c. 1919–21, 28¾" high. Albright Art Gallery, Buffalo, N.Y.

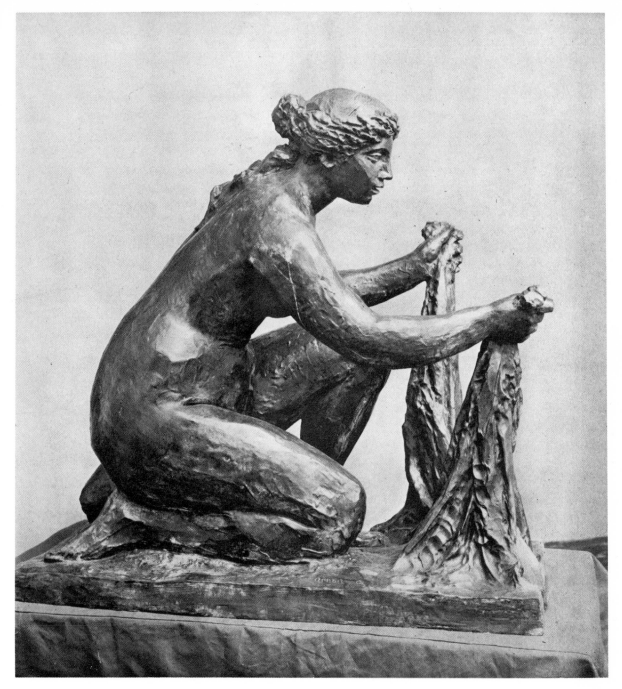

AUGUSTE RENOIR: *Washerwoman.* 1917. Bronze, 48″ high. Curt Valentin Gallery, New York

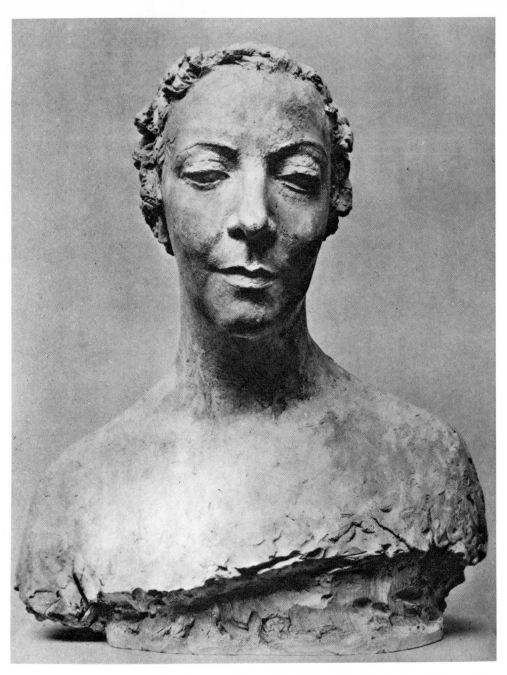

CHARLES DESPIAU: *Antoinette Schulte*. 1934. Original plaster, 21½″ high. Albright Art Gallery, Buffalo, N.Y.

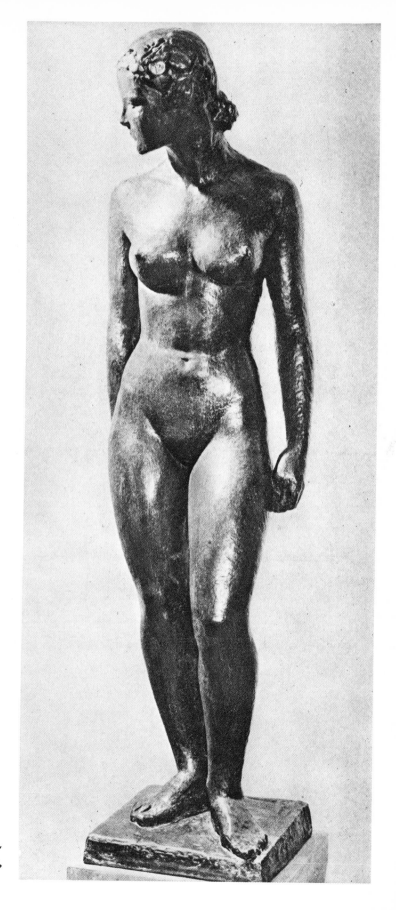

CHARLES DESPIAU: *Assia*. 1938. Bronze, 6' ¾"
high. The Museum of Modern Art, New York,
gift of Mrs. Simon Guggenheim

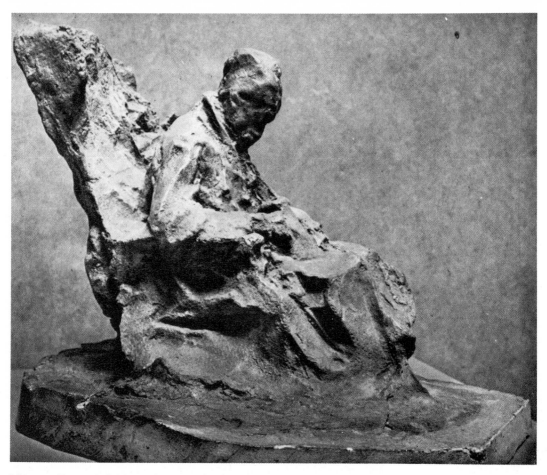

MEDARDO ROSSO: *Sick Man at the Hospital*. 1889. Plaster. Museo di Barzio, Italy

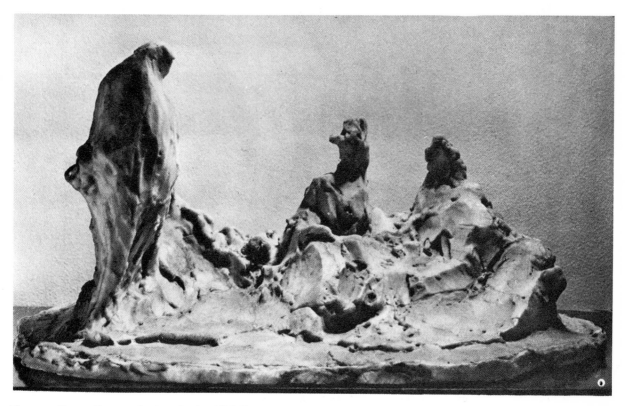

MEDARDO ROSSO: *Conversation in a Garden.* 1893. Wax. Museo di Barzio, Italy

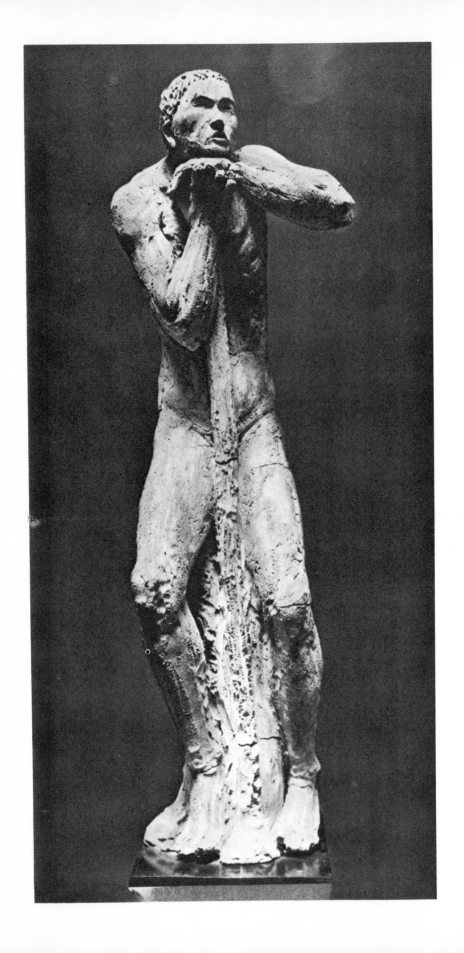

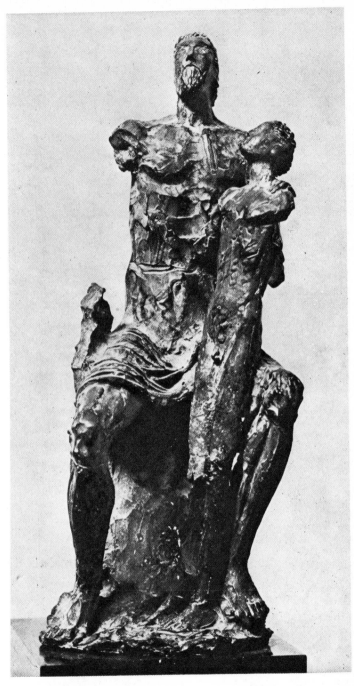

ARTURO MARTINI: *Daedalus and Icarus*. 1934–35. Bronze, 24″ high. The Museum of Modern Art, New York

ARTURO MARTINI: *The Shepherd*. 1930. Terra cotta, over life-size. Galleria Nazionale d'Arte Moderna, Rome

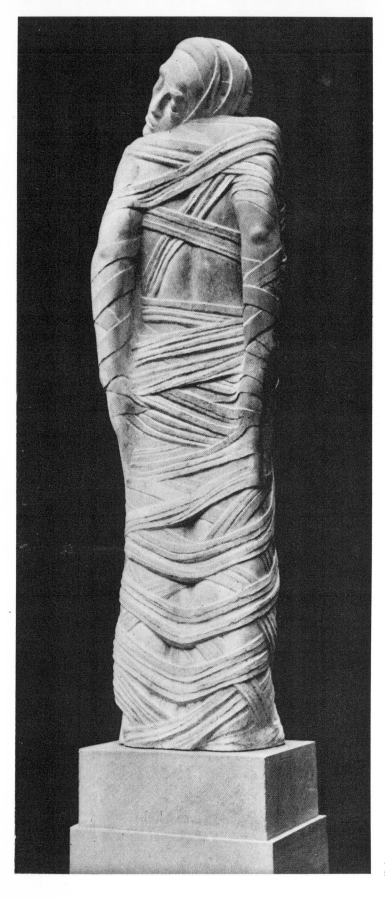

JACOB EPSTEIN: *Lazarus*. 1949. Hoptonwood stone, 7′ 7″ high. New College, Oxford, England

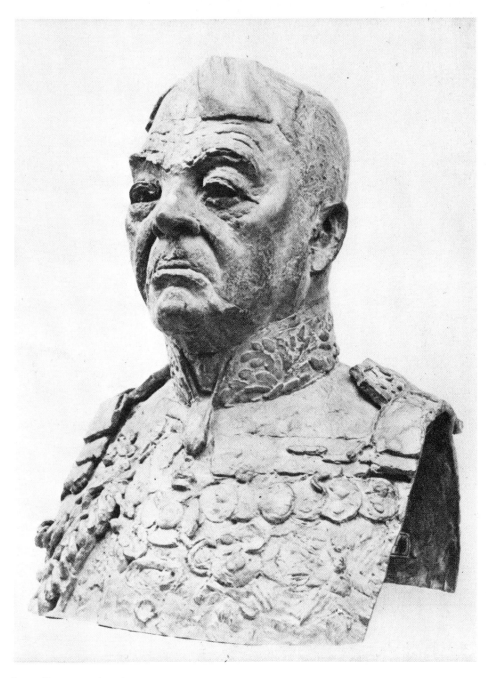

JACOB EPSTEIN: *Admiral Lord Fisher*. 1915. Bronze, life-size. Imperial War Museum, London

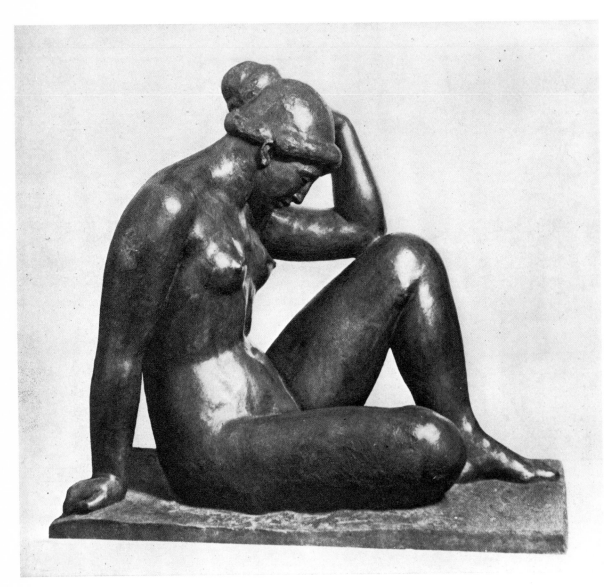

ARISTIDE MAILLOL: *Mediterranean*. C. 1901. Bronze, 41″ high. Collection Stephen C. Clark, New York

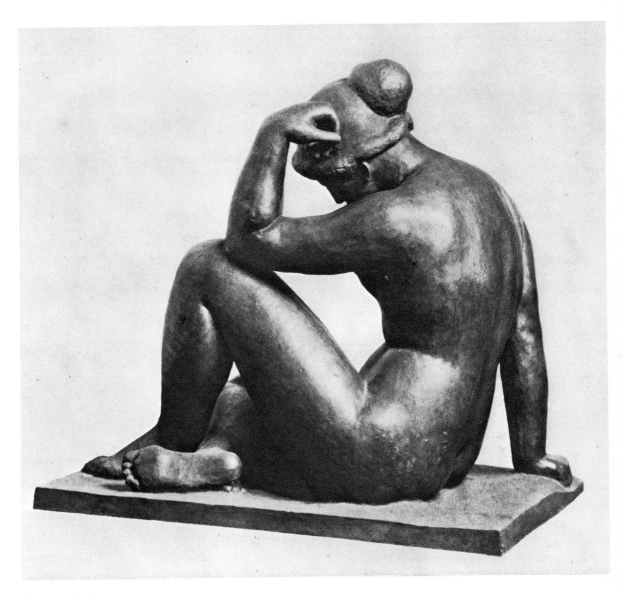

MAILLOL: *Mediterranean*

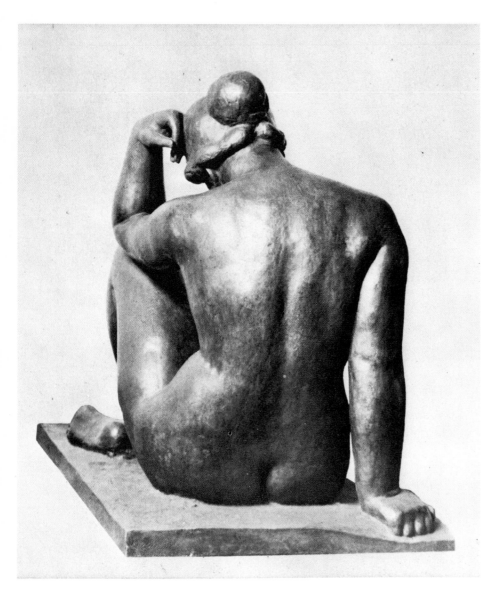

MAILLOL: *Mediterranean.* Rear view

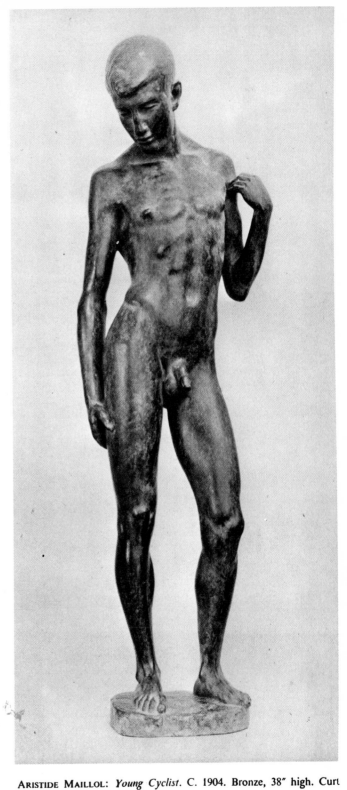

ARISTIDE MAILLOL: *Young Cyclist*. C. 1904. Bronze, 38″ high. Curt Valentin Gallery, New York

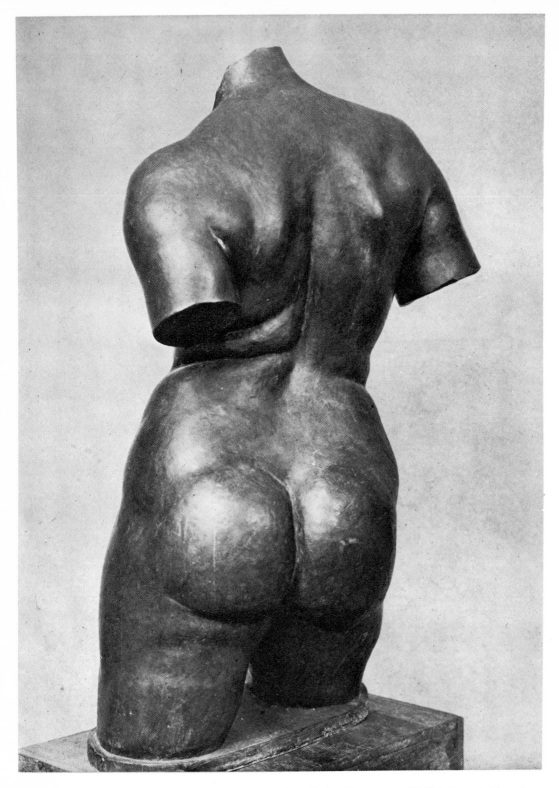

ARISTIDE MAILLOL: *Chained Action* (torso, monument to Blanqui). C. 1906. Bronze, 47″ high. Extended loan from the Metropolitan Museum of Art, New York, to the Museum of Modern Art, New York

76

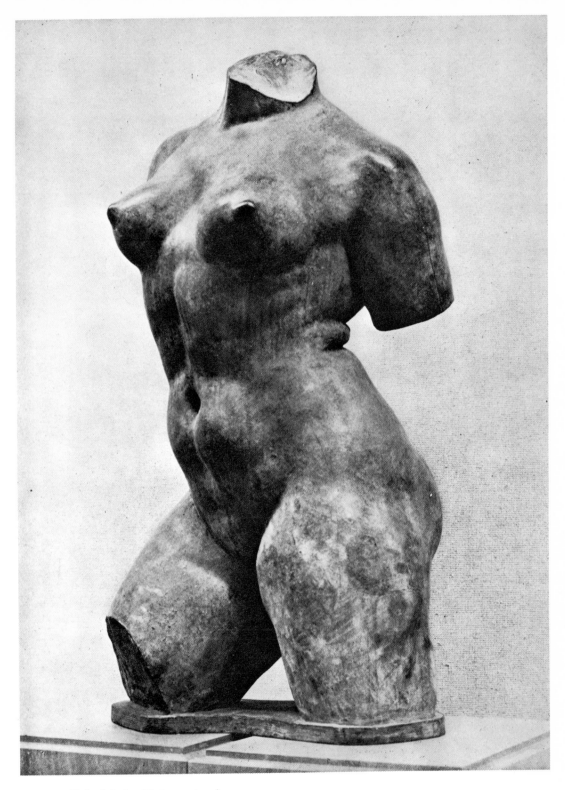

MAILLOL: *Chained Action*. Three-quarter view

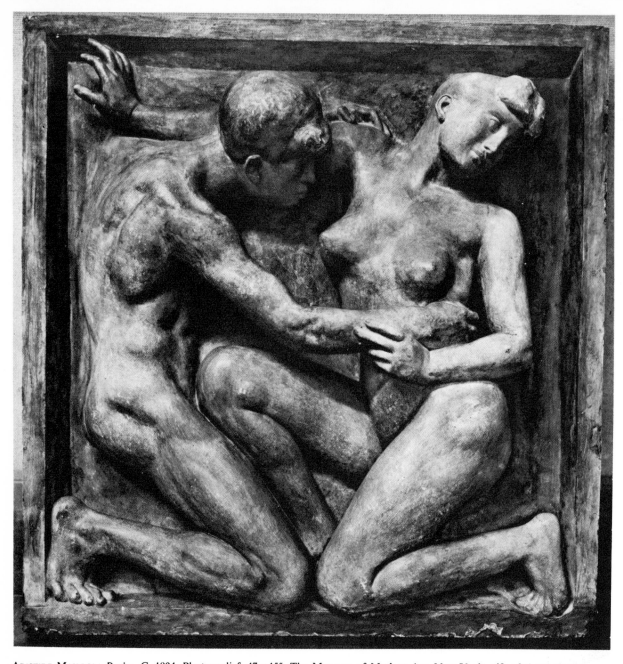

ARISTIDE MAILLOL: *Desire*. C. 1904. Plaster relief, 47×45″. The Museum of Modern Art, New York, gift of the sculptor

78

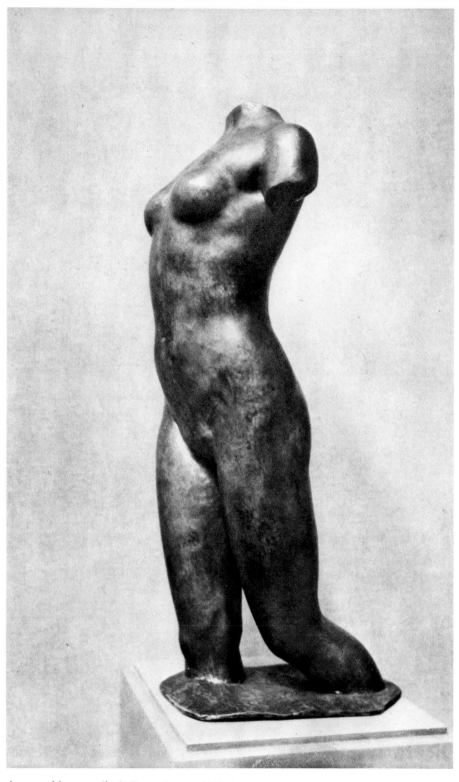

ARISTIDE MAILLOL: *Ile de France* (torso). 1910. Bronze, 43″ high. The Museum of Modern Art, New York, gift of A. Conger Goodyear

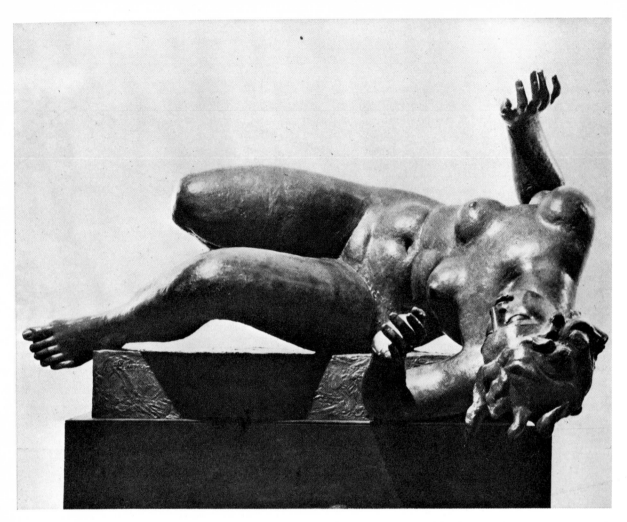

ARISTIDE MAILLOL: *The River*. C. 1939–43. Lead, 7′ 6″ long, 53¾″ high. The Museum of Modern Art, New York, Mrs. Simon Guggenheim Fund

MAILLOL: *The River*. Detail

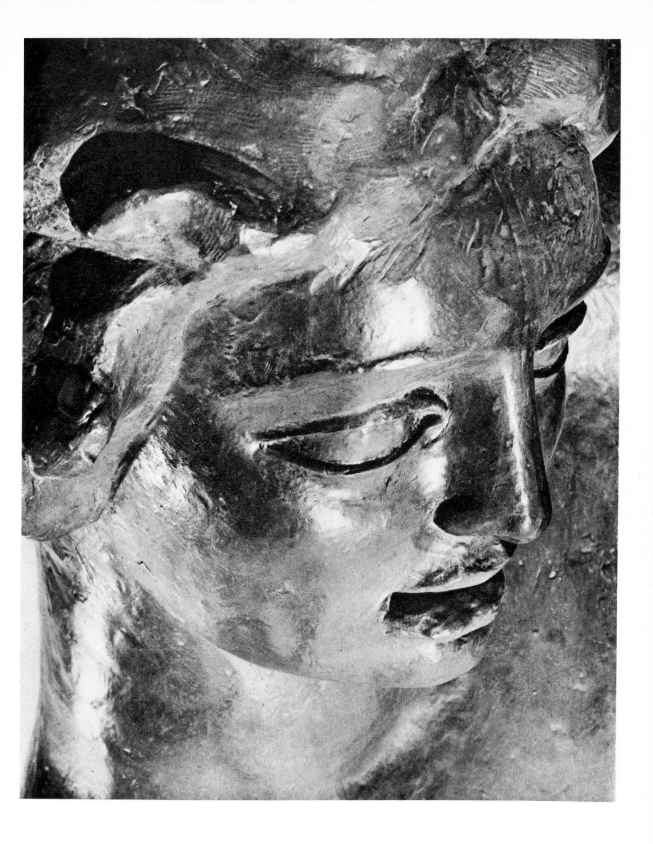

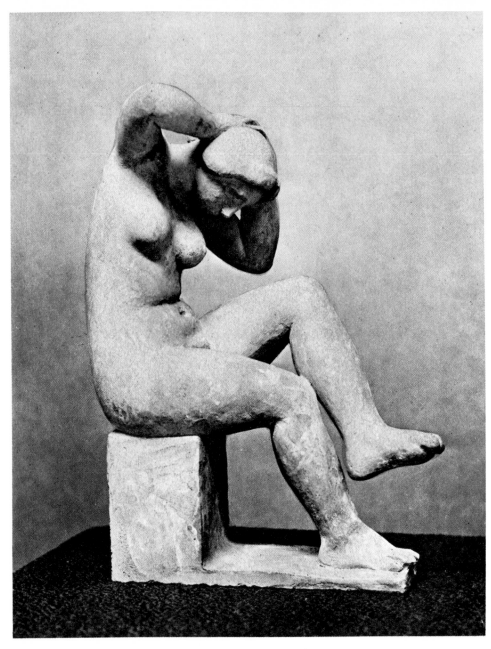

ARISTIDE MAILLOL: *Seated Figure*. C. 1930. Terra cotta, 9″ high. The Museum of Modern Art, New York, gift of Saidie A. May

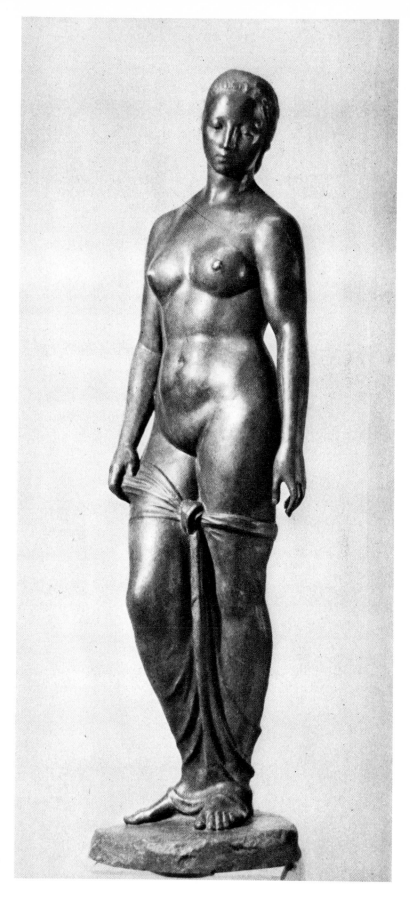

WILHELM LEHMBRUCK: *Standing Woman.*
1910. Bronze, 6′ 4″ high. The Museum of
Modern Art, New York

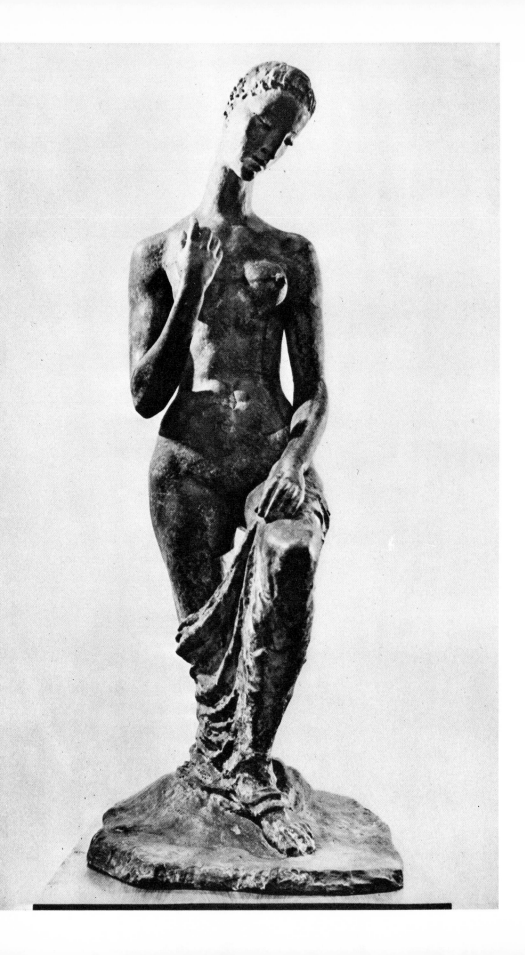

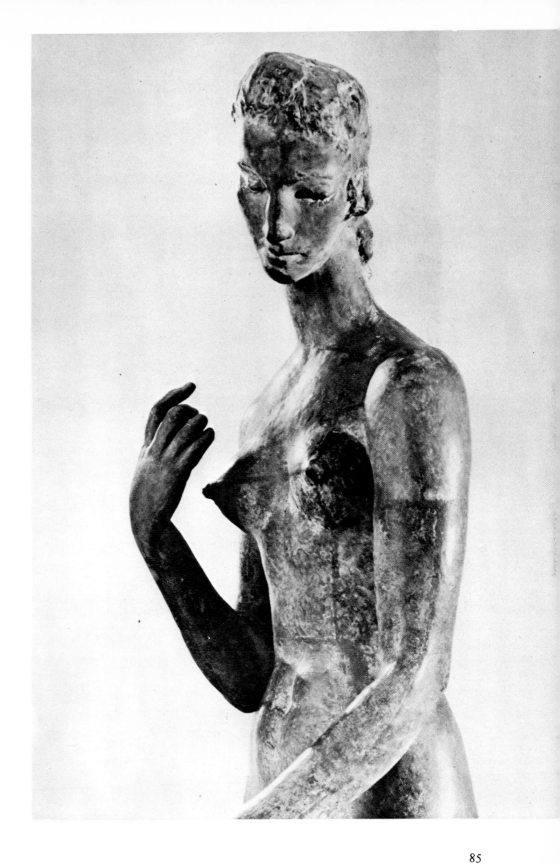

WILHELM LEHMBRUCK: *Kneeling Woman*. 1911. Cast stone, 69½" high. The Museum of Modern Art, New York, gift of Mrs. John D. Rockefeller, Jr.

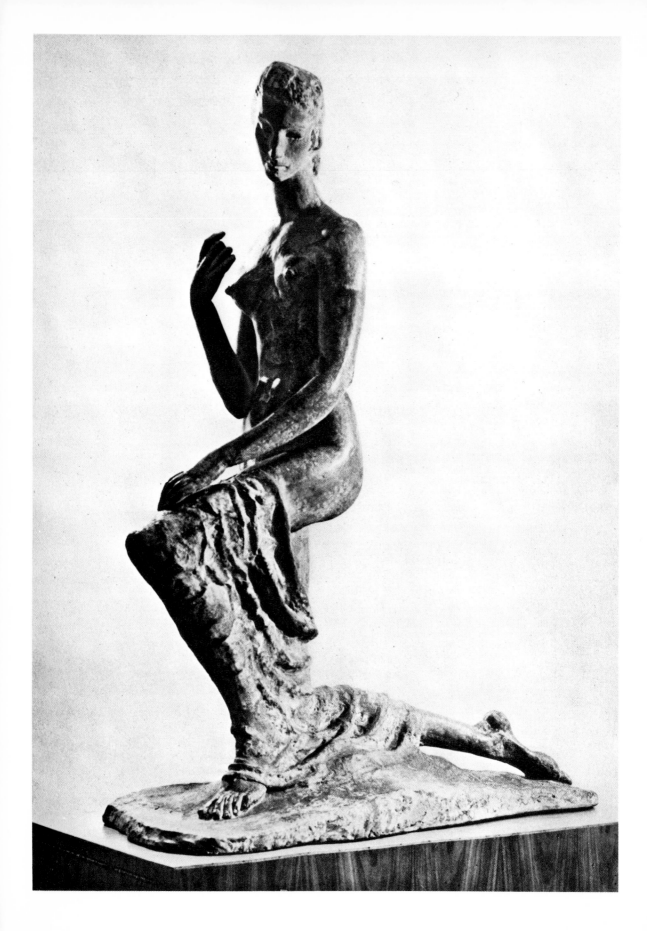

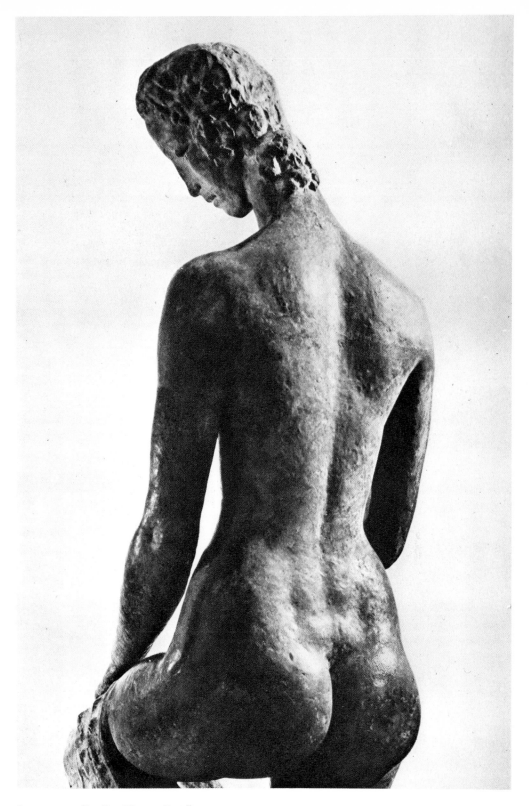

LEHMBRUCK: *Kneeling Woman.* Detail

LEHMBRUCK: *Kneeling Woman.* Three-quarter view

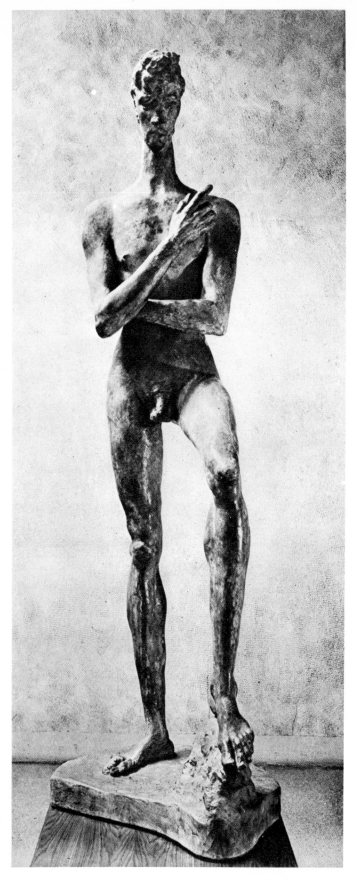

88

WILHELM LEHMBRUCK: *Standing Youth*. 1913. Cast stone, 7′ 8″ high. The Museum of Modern Art, New York, gift of Mrs. John D. Rockefeller, Jr.

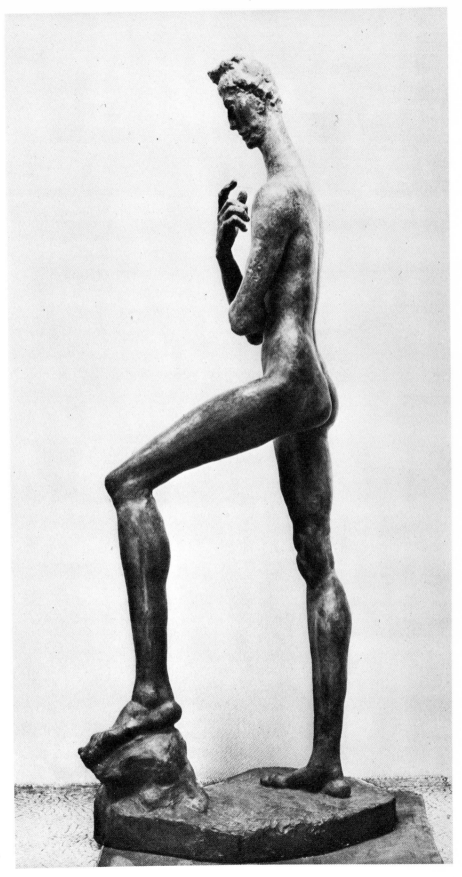

LEHMBRUCK: *Standing Youth.*
Side view

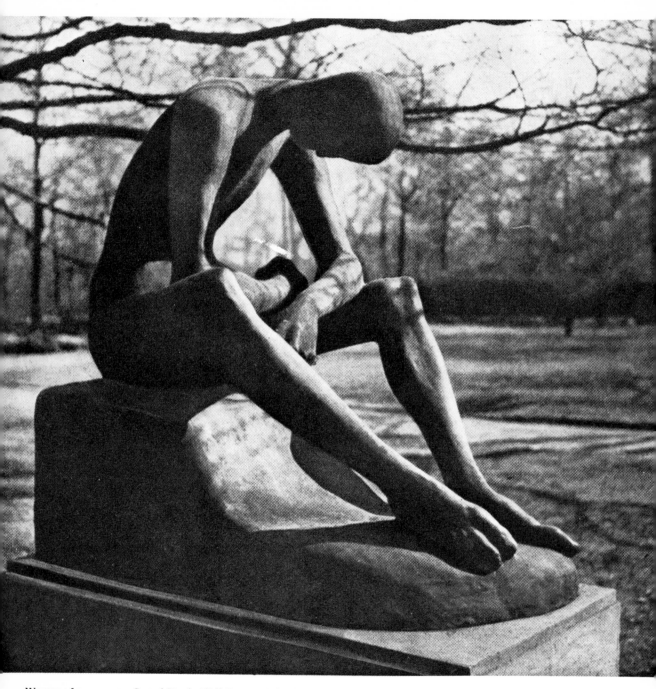

WILHELM LEHMBRUCK: *Seated Youth*. 1918? Bronze, 41½" high. Kunstmuseum, Duisburg, Germany

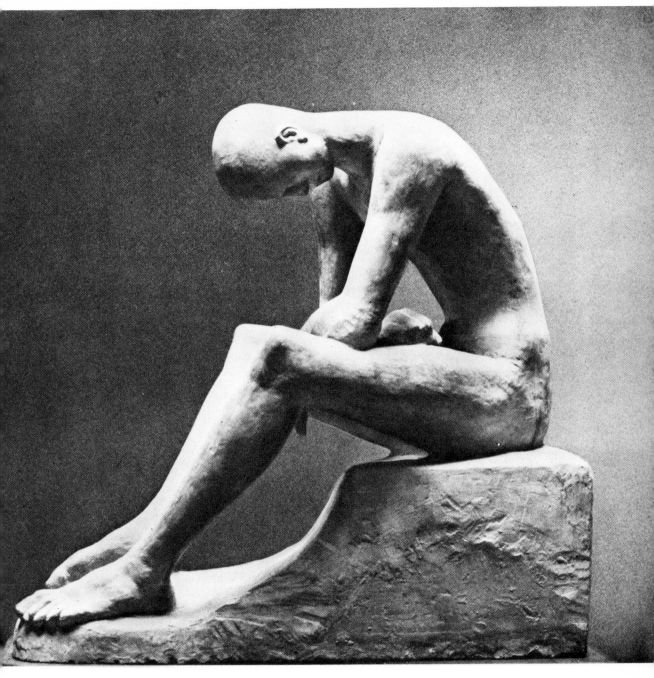

WILHELM LEHMBRUCK: *Seated Youth.* 1918? Cast stone, 41½" high. Städlische Galerie, Frankfurt am Main, Germany

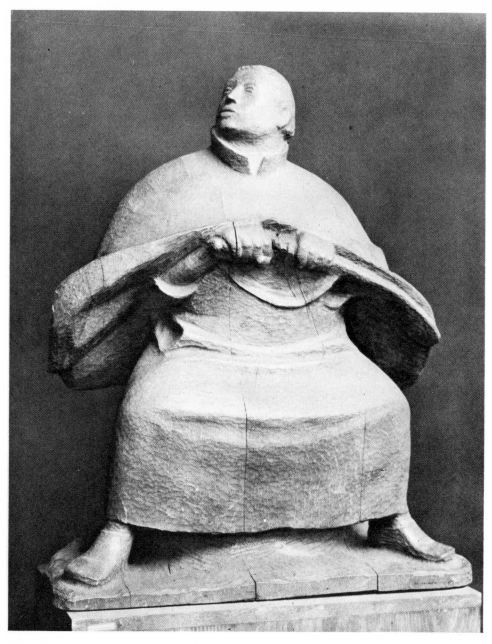

ERNST BARLACH: *Man Drawing a Sword*. 1911. Wood, 31″ high. The Museum of Cranbrook Academy of Art, Bloomfield Hills, Mich.

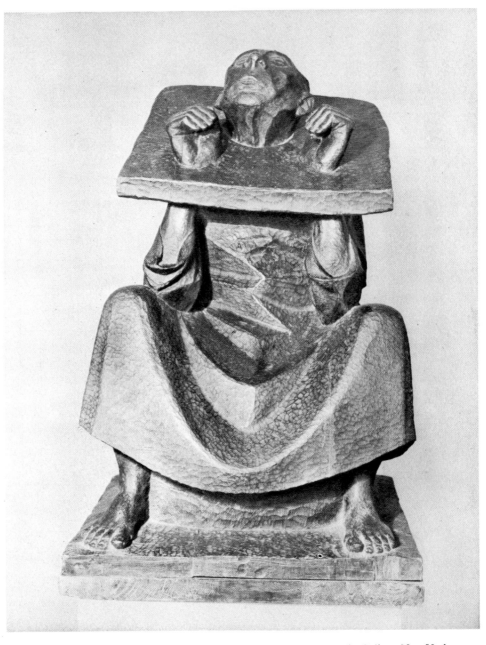

ERNST BARLACH: *Man in the Stocks*. 1920. Wood, 26½″ high. Curt Valentin Gallery, New York

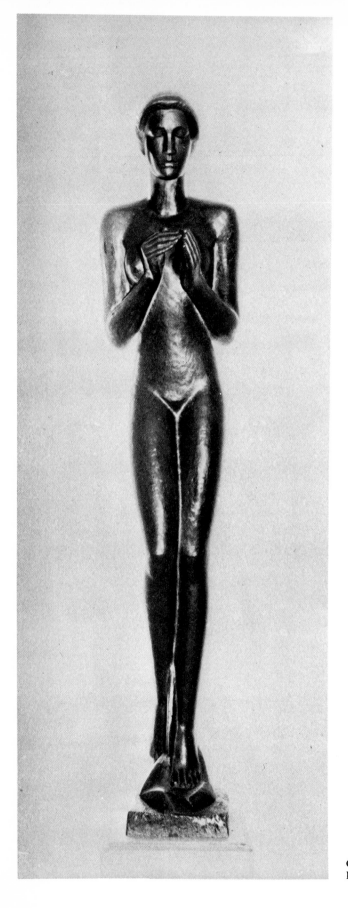

GEORG KOLBE: *Assunta*. 1921. Bronze, 6′ 3″ high. Detroit
Institute of Arts

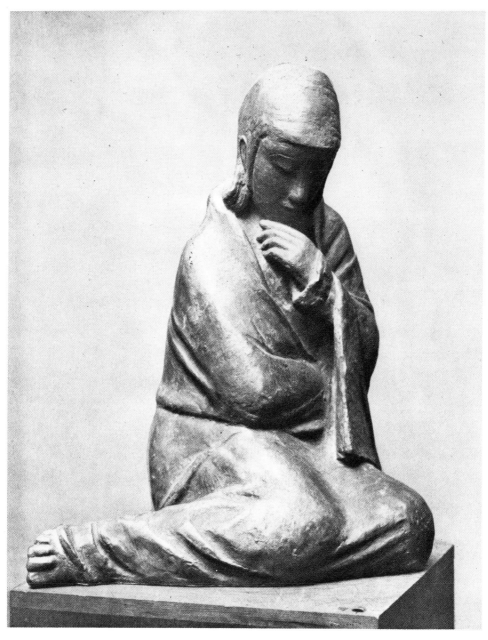

GERHARD MARCKS: *Seated Girl*. 1932. Bronze, 25″ high. Curt Valentin Gallery, New York

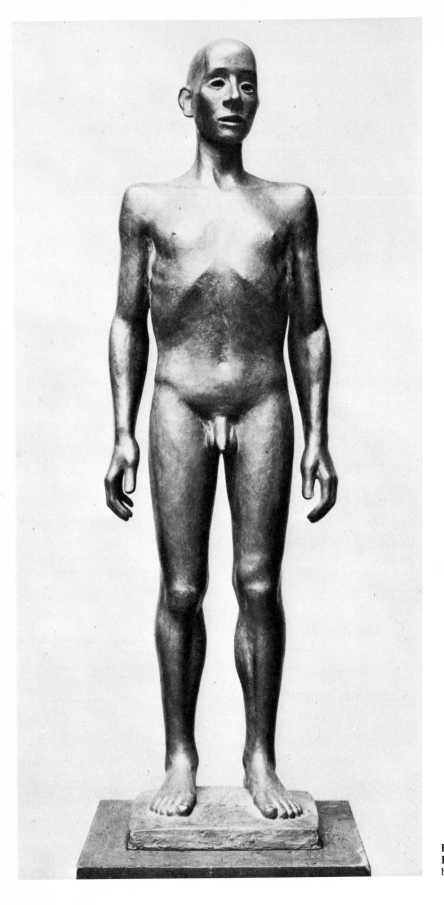

ERNESTO DE FIORI: *The Soldier*. 1918.
Bronze, 50½″ high. Hamburger Kunst-
halle, Germany

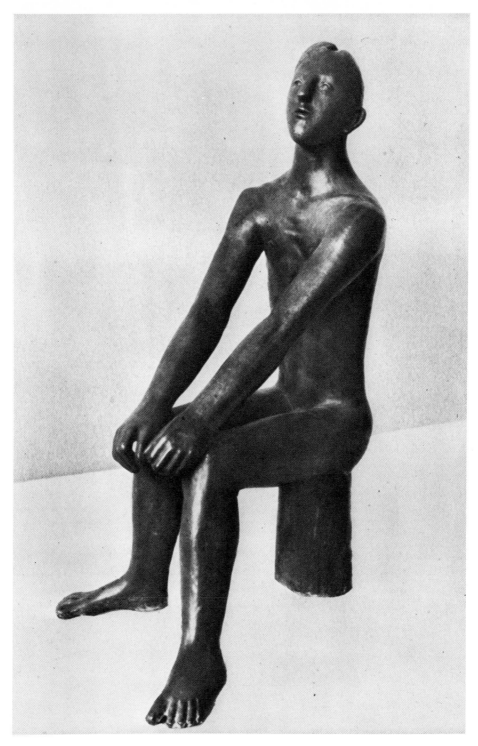

HERMANN BLUMENTHAL: *Man Sitting on a Stump*. 1931–32. Bronze, 40½" high. Estate of Hermann
Blumenthal, Hamburg, Germany, courtesy Dr. Isermeyer

97

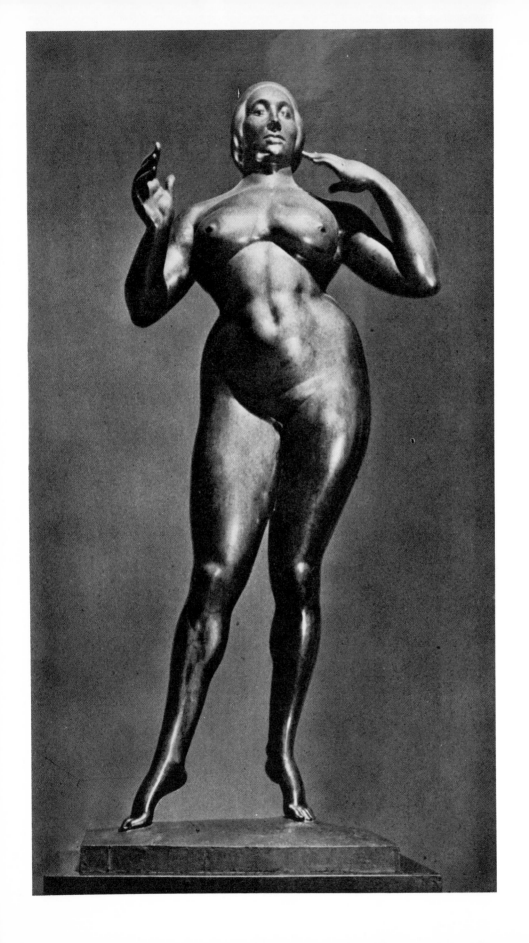

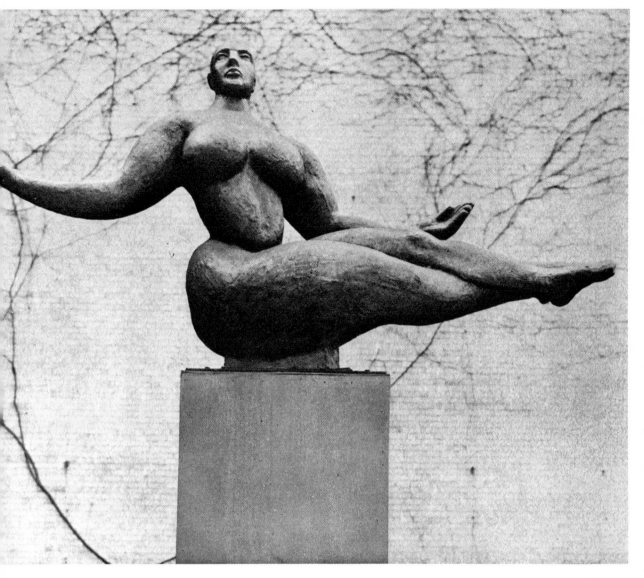

GASTON LACHAISE: *Floating Figure*. 1927. Bronze (cast 1935), 53″ high. The Museum of Modern Art, New York, given anonymously in memory of the artist

99

GASTON LACHAISE: *Standing Woman*. 1912–27. Bronze, 70″ high. Albright Art Gallery, Buffalo, N.Y.

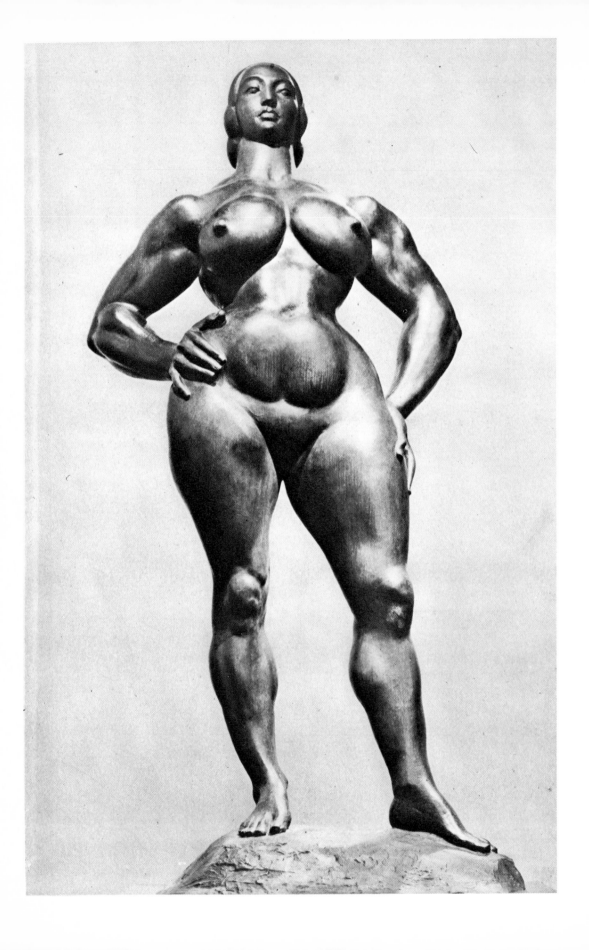

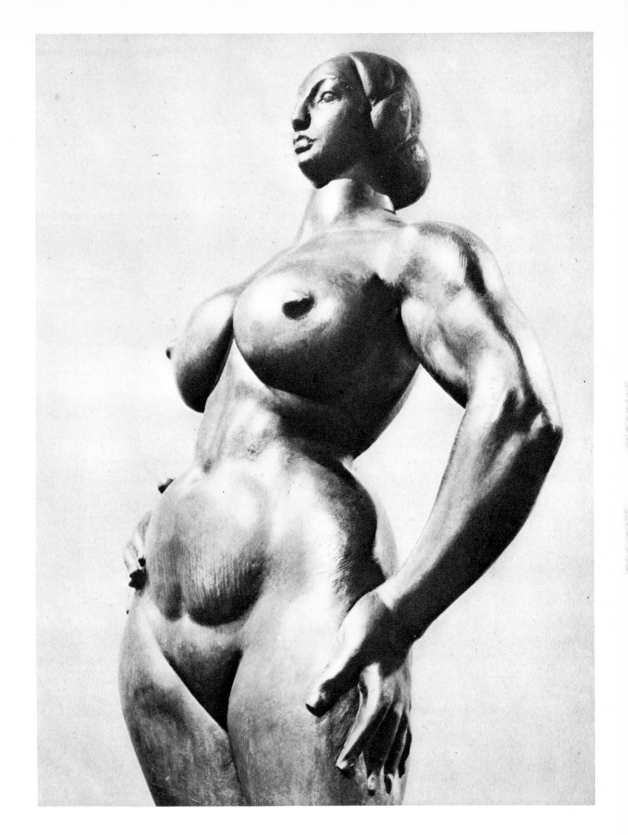

GASTON LACHAISE: *Standing Woman.* 1932. Bronze, 7′ 4″ high. The Museum of Modern Art, New York, Mrs. Simon Guggenheim Fund

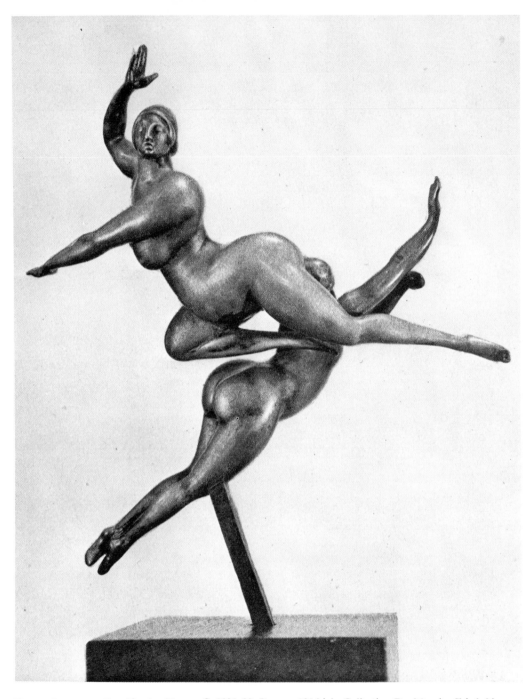

GASTON LACHAISE: *Two Floating Figures*. C. 1925–28. Bronze, 12″ high. Collection Dr. Maurice Fried, New York

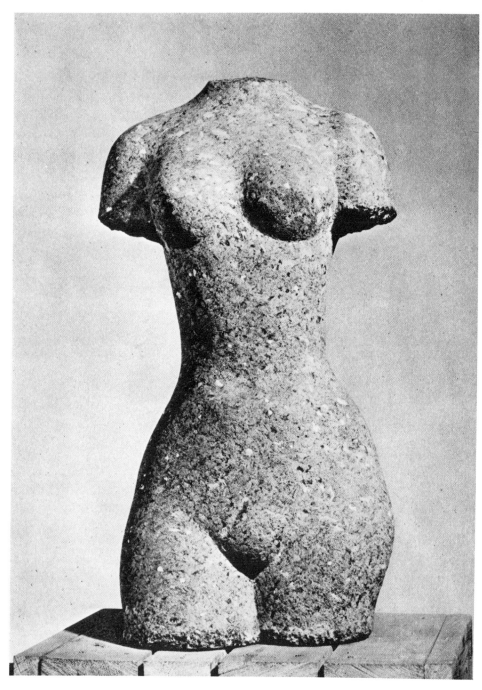

WILLIAM ZORACH: *Torso*. 1932. Labrador granite, 33″ high. The Downtown Gallery, New York

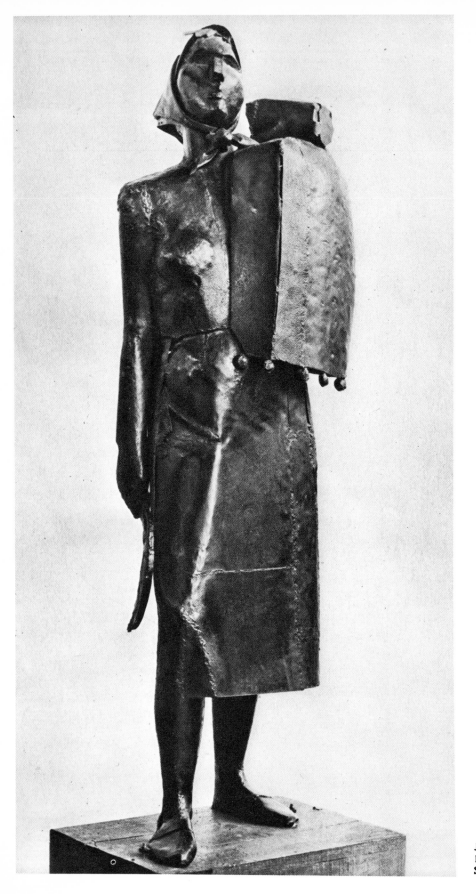

JULIO GONZALEZ: *La Montserrat*
1937. Sheet iron, 65″ high
Stedelijk Museum, Amsterdam

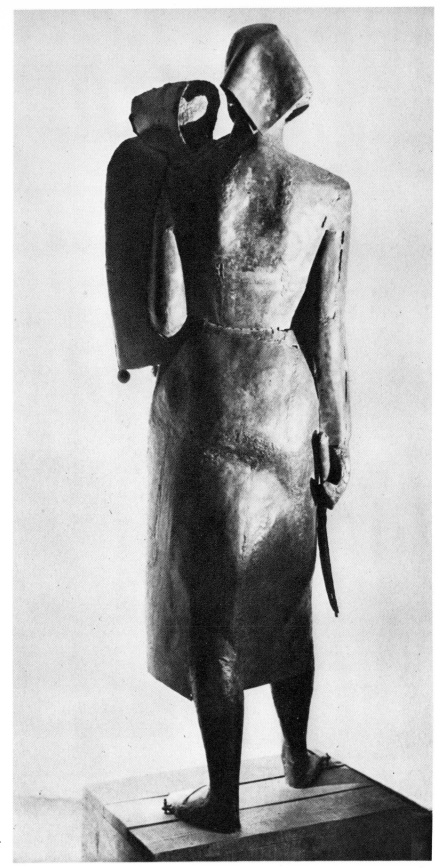

Gonzalez:
La Montserrat. Rear
view

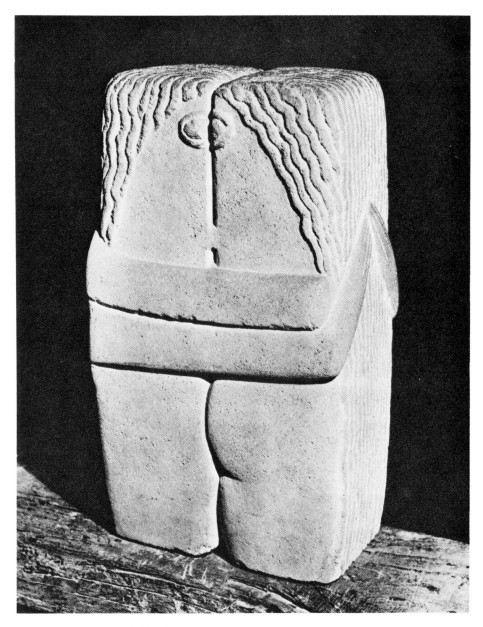

CONSTANTIN BRANCUSI: *The Kiss*. 1908. Stone, 22¾" high. Philadelphia Museum of Art, Louise and Walter Arensberg Collection

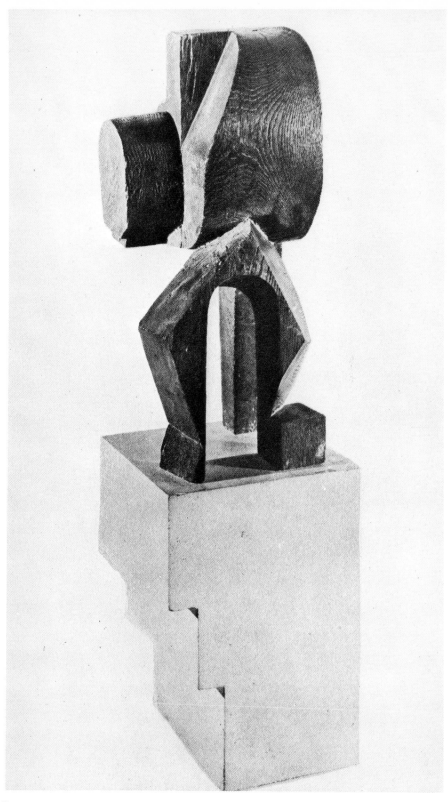

CONSTANTIN BRANCUSI: *The Prodigal Son*. 1914. Wood, 29⅝″ high (with base). Philadelphia Museum of Art, Louise and Walter Arensberg Collection

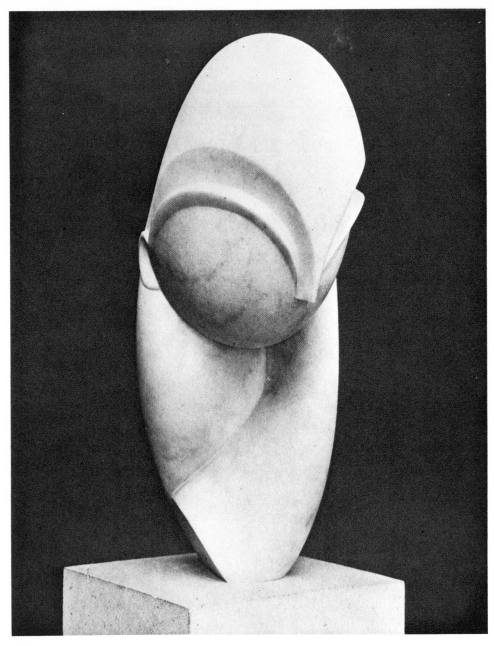

CONSTANTIN BRANCUSI: *Mlle Pogany*. C. 1928–29. Marble on stone base, 27½″ high. The Philadelphia Museum of Art, Louise and Walter Arensberg Collection

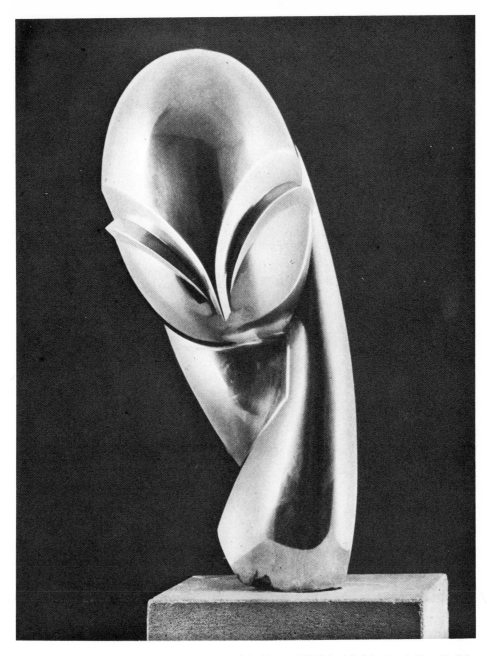

CONSTANTIN BRANCUSI: *Mlle Pogany*. 1920. Polished brass, 17″ high. Albright Art Gallery, Buffalo, N.Y.

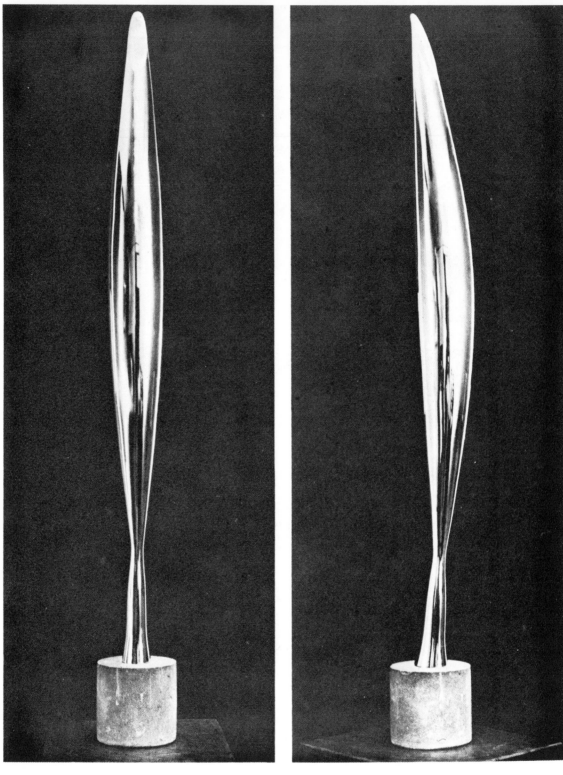

Constantin Brancusi: *Bird in Space*. 1919. Bronze, 54″ high. The Museum of Modern Art, New York

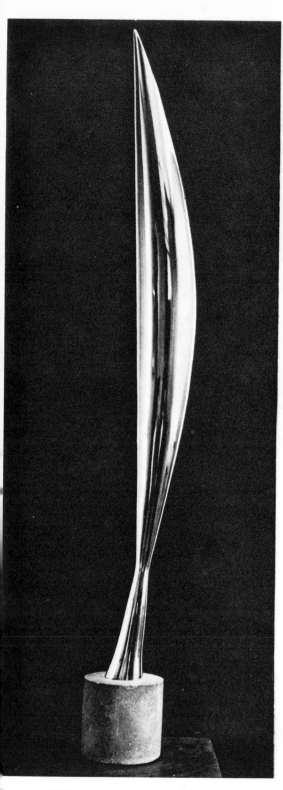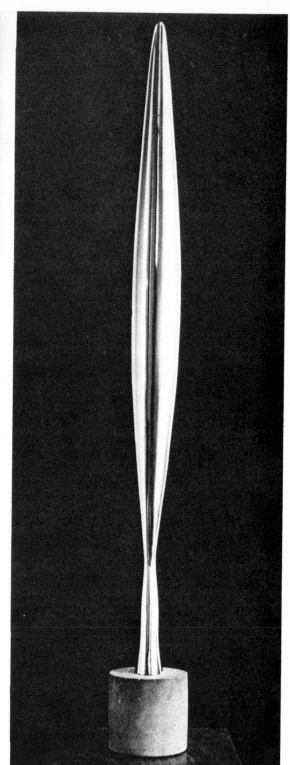

BRANCUSI: *Bird in Space*

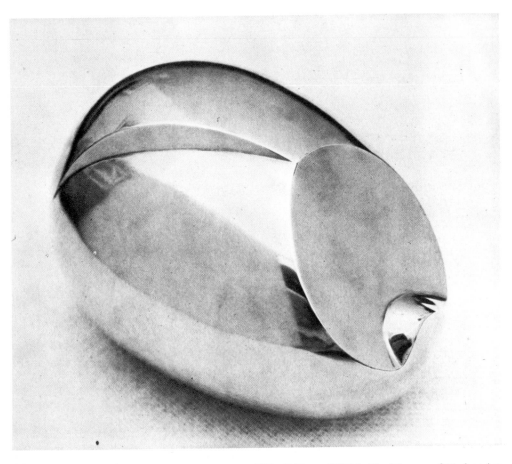

CONSTANTIN BRANCUSI: *The New-Born*. 1915. Bronze (1920), 8¼″ long, 5¾″ high. The Museum of Modern Art, New York, acquired through the Lillie P. Bliss Bequest

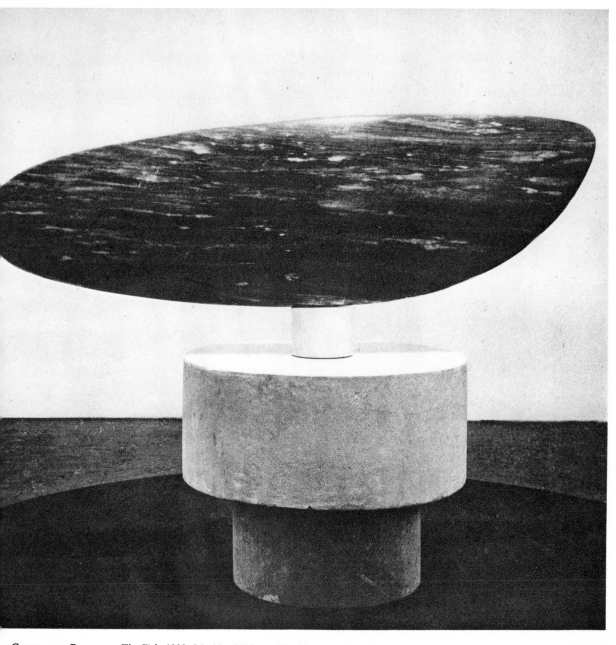

CONSTANTIN BRANCUSI: *The Fish*. 1930. Marble, 71″ long. The Museum of Modern Art, New York, acquired through the Lillie P. Bliss Bequest

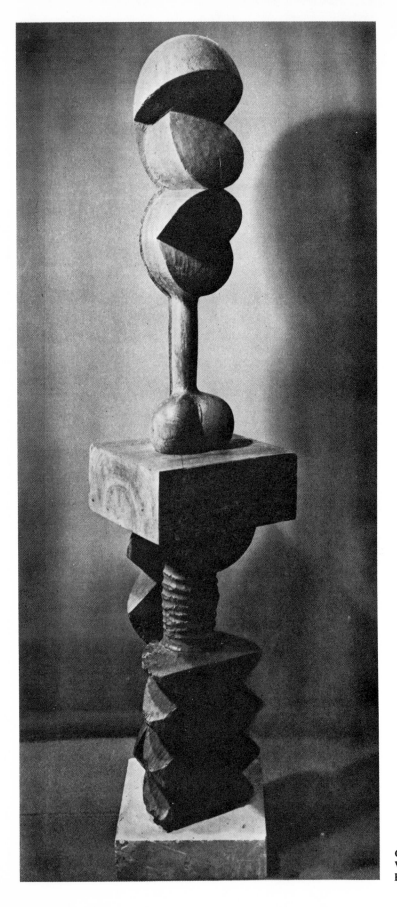

CONSTANTIN BRANCUSI: *Adam and Eve*. 1925.
Wood, 8′ high. Collection Henri Pierre Roché,
Paris

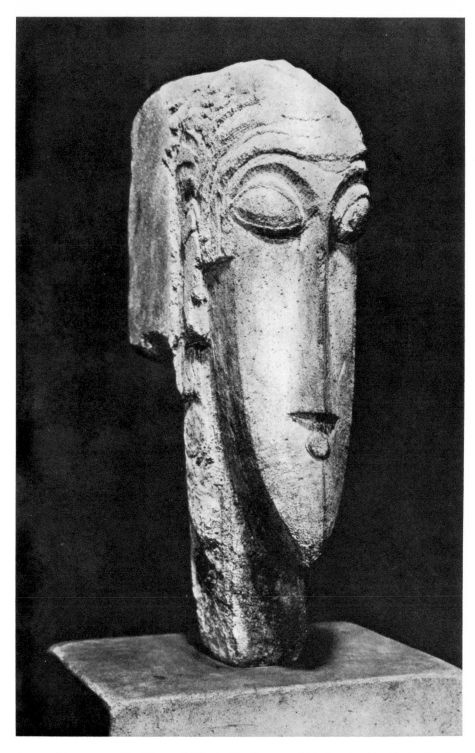

AMEDEO MODIGLIANI: *Head*. Stone, 22¼″ high. The Museum of Modern Art, New York, gift of Mrs. John D. Rockefeller, Jr., in memory of Mrs. Cornelius J. Sullivan

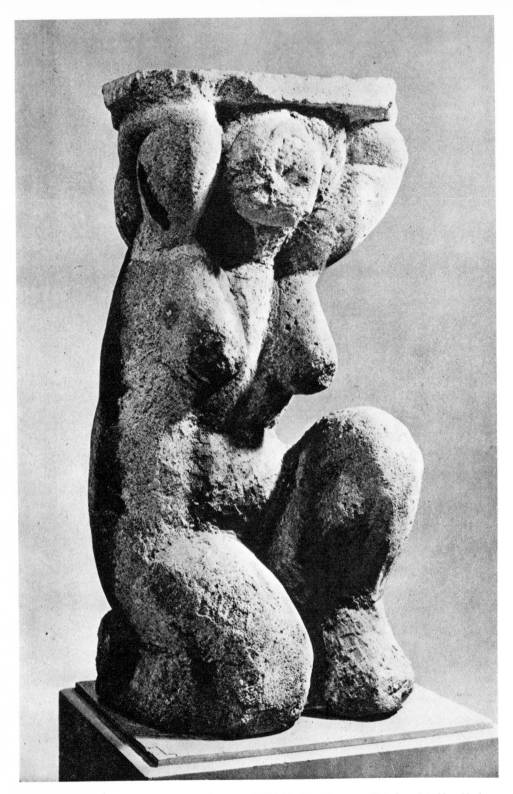

AMEDEO MODIGLIANI: *Caryatid.* C. 1914. Limestone, 36¼″ high. The Museum of Modern Art, New York, Mrs. Simon Guggenheim Fund

HENRI MATISSE: *The Back, III.* 1929? Bronze, 6′ 2⅜″ high.
The Museum of Modern Art, New York, Mrs. Simon Guggenheim Fund

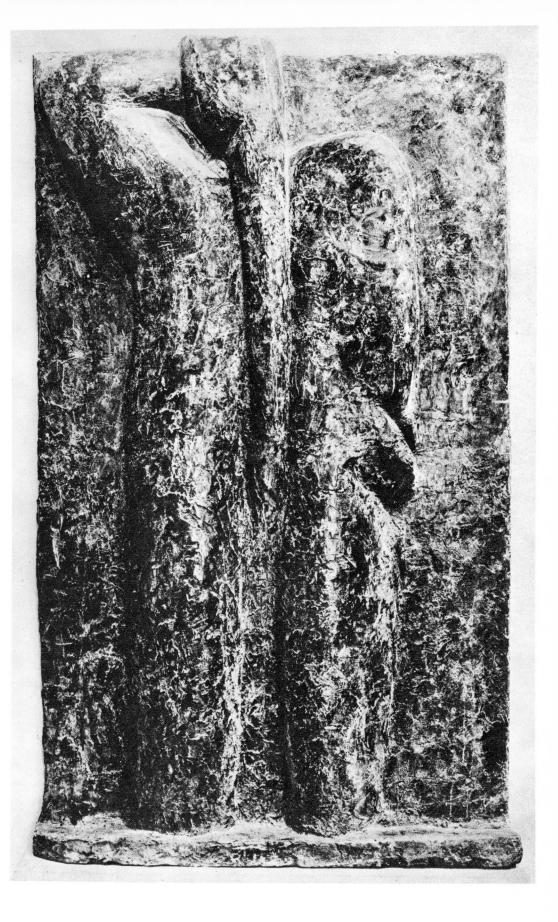

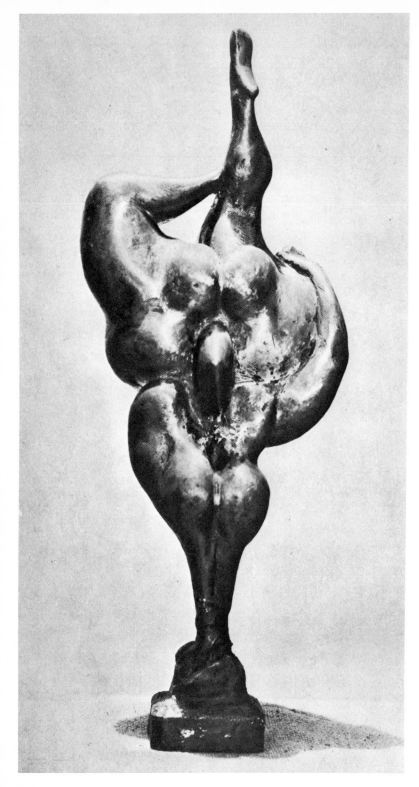

GASTON LACHAISE: *Acrobat*. 1934. Bronze, 19¾" high. Collection unknown

118

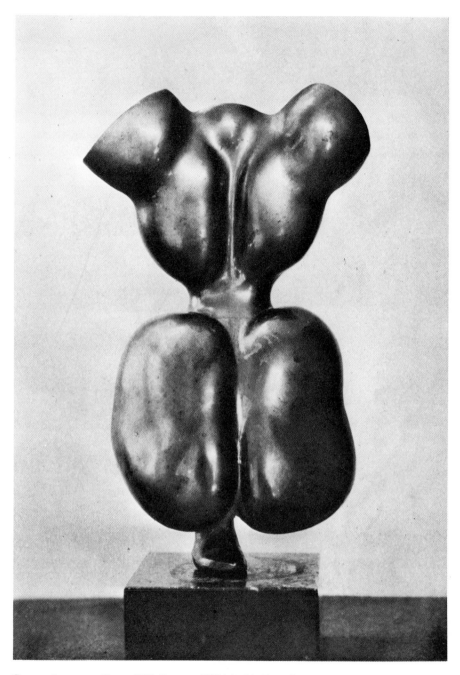

GASTON LACHAISE: *Torso*. 1930. Bronze, 12″ high. M. Knoedler & Co., New York

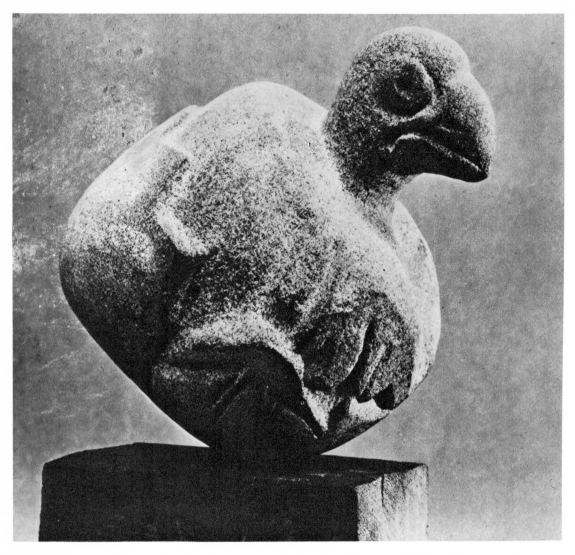

JOHN B. FLANNAGAN: *Triumph of the Egg*. 1937. Granite, 16″ long. The Museum of Modern Art, New York

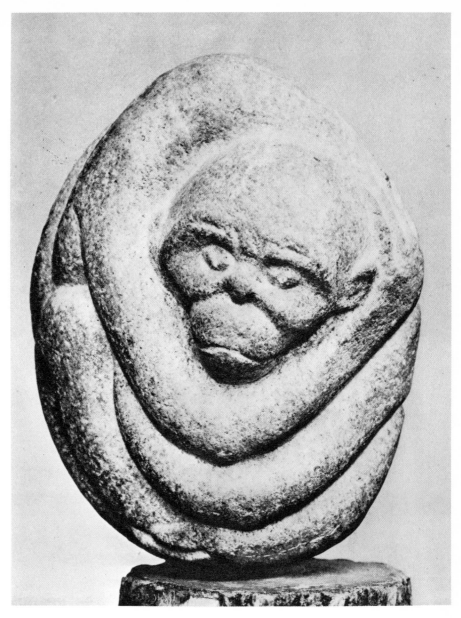

JOHN B. FLANNAGAN: *Monkey*. 1939. Stone, 11½″ high. Collection Robert H. Tannahill, Grosse Pointe Farms, Mich.

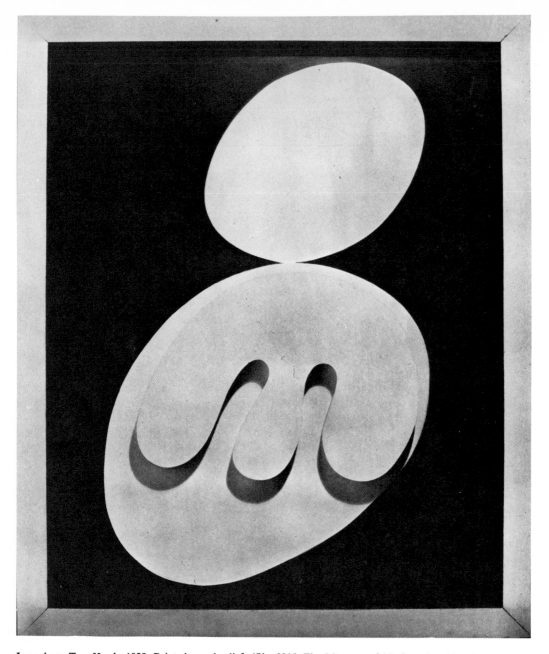

JEAN ARP: *Two Heads*. 1929. Painted wood relief, 47¼×39¼". The Museum of Modern Art, New York

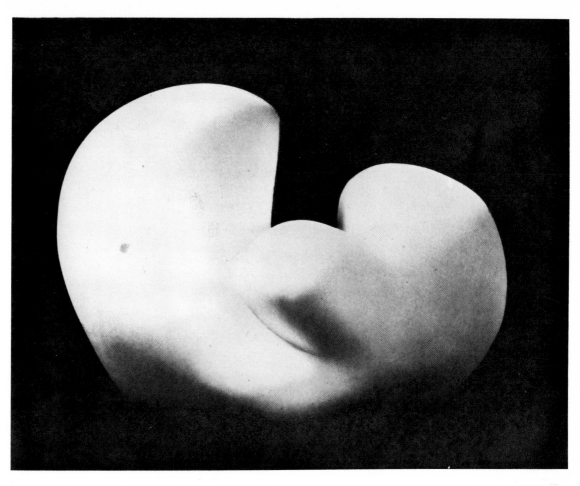

JEAN ARP: *Human Concretion*. 1935. Plaster, 19½″ high. The Museum of Modern Art, New York, gift of the Advisory Committee

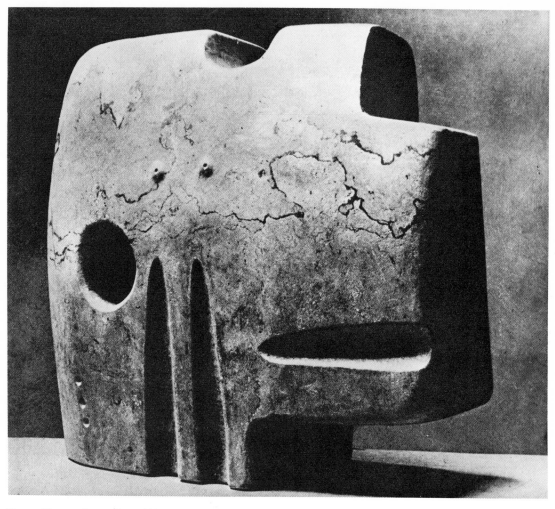

Henry Moore: *Square Form.* 1936. Green Hornton stone. 16″ high. Collection Robert J. Sainsbury, London

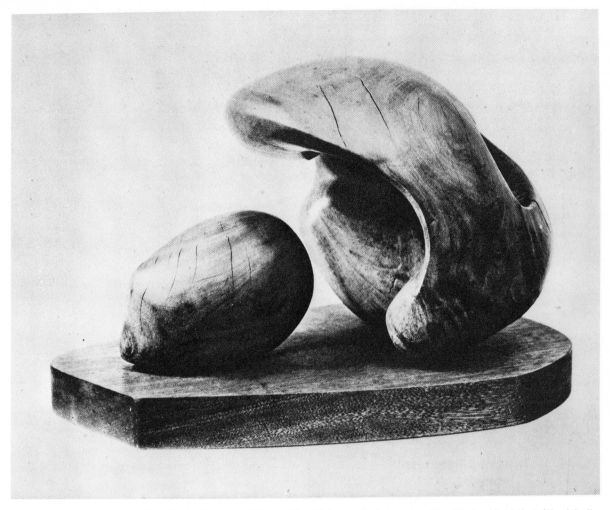

HENRY MOORE: *Two Forms.* 1934. Pynkado wood, 11″ high. The Museum of Modern Art, New York, gift of Sir Michael Sadler

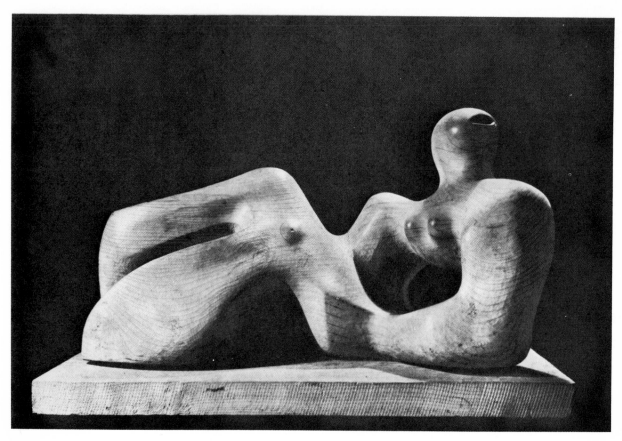

HENRY MOORE: *Reclining Figure*. 1935. Elmwood, 19″ high, 35″ long. Albright Art Gallery, Buffalo, N.Y.

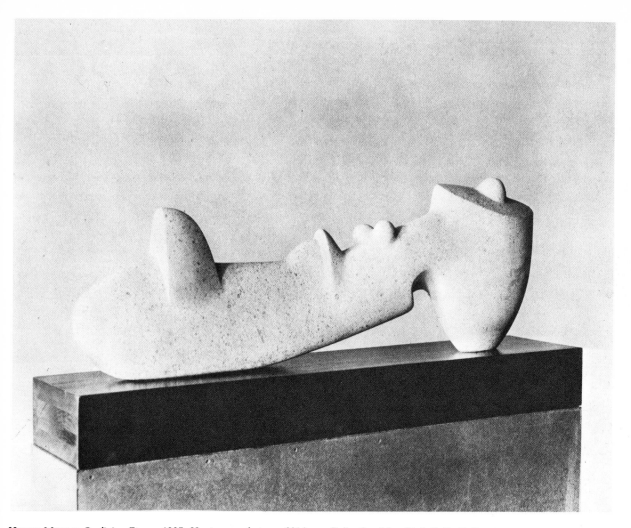

HENRY MOORE: *Reclining Figure.* 1937. Hoptonwood stone, 33″ long. Collection Mrs. F. LeB. B. Dailey, Narragansett, R.I.

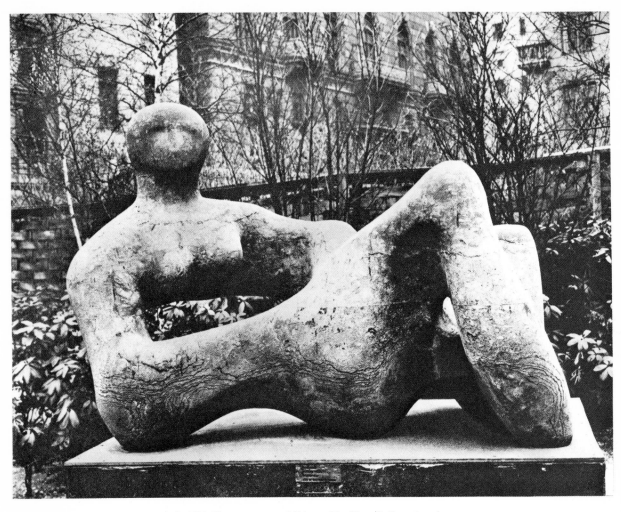

HENRY MOORE: *Recumbent Figure*. C. 1938. Hornton stone, 54″ long. The Tate Gallery, London

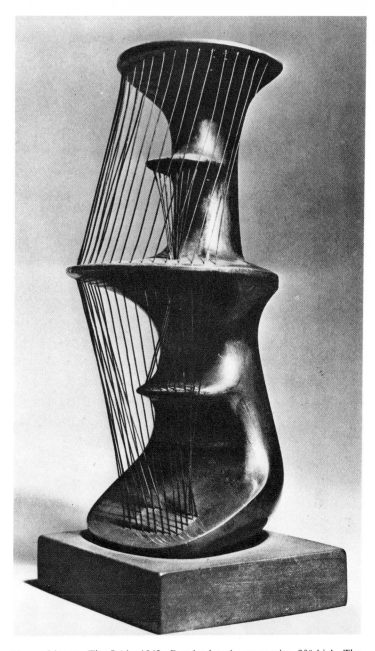

HENRY MOORE: *The Bride*. 1940. Cast lead and copper wire, 9⅜" high. The Museum of Modern Art, New York, acquired through the Lillie P. Bliss Bequest

129

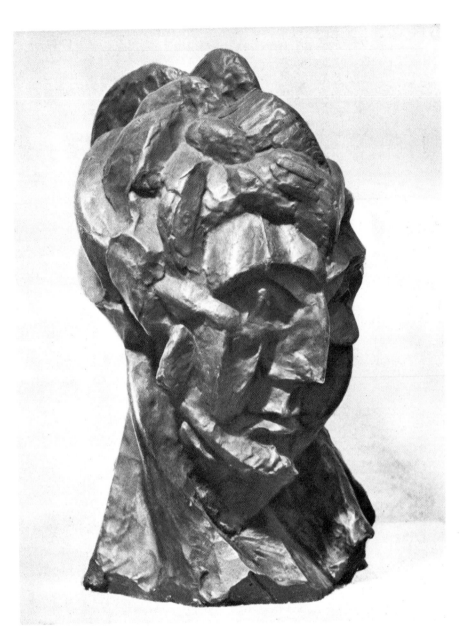

PABLO PICASSO: *Head of a Woman.* 1909. Bronze, 16¼" high. The Museum of Modern Art, New York

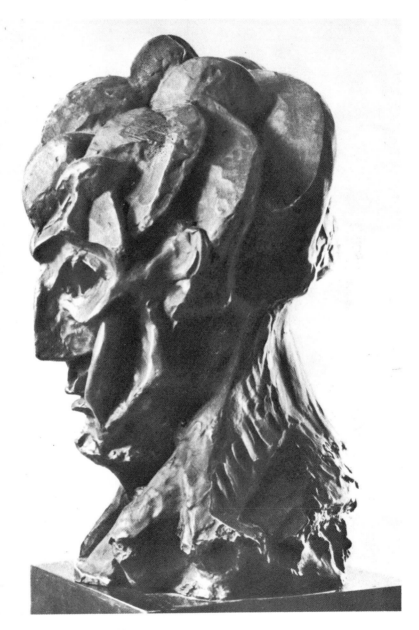

PICASSO: *Head of a Woman*. Side view

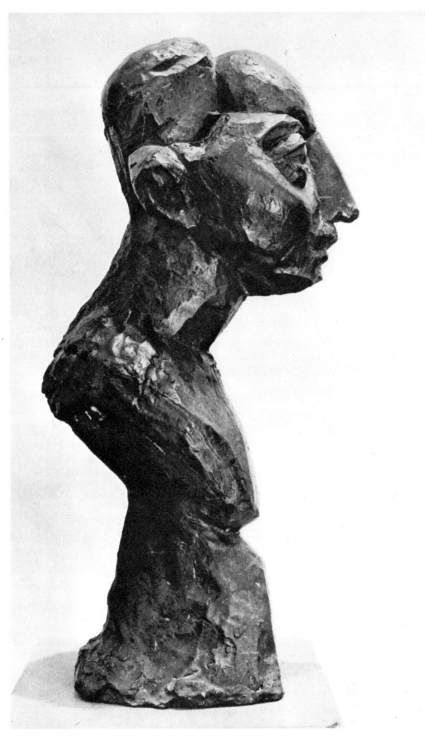

HENRI MATISSE: *Jeannette, V.* 1910–11? Bronze, 22⅞″ high (with base). The Museum of Modern Art, New York

132

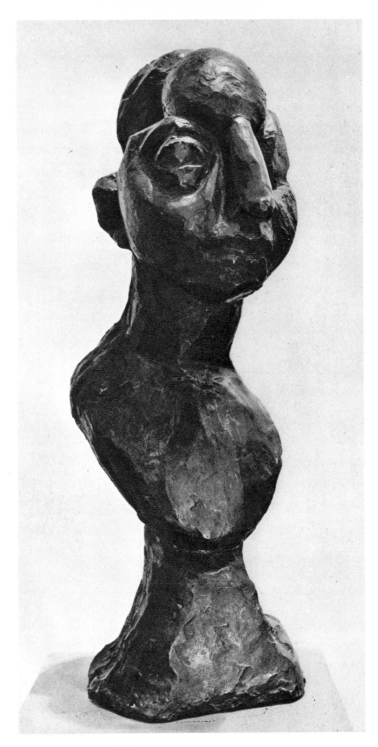

MATISSE: *Jeannette, V.* Three-quarter view

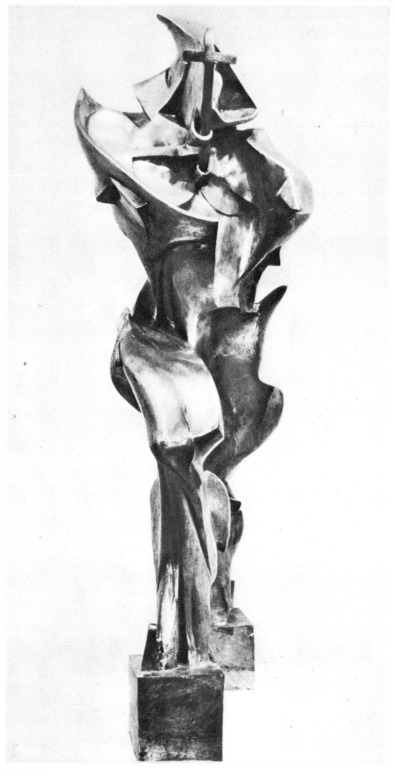

Umberto Boccioni: *Unique Forms of Continuity in Space*. 1913. Bronze, 43½″
high. The Museum of Modern Art, New York, acquired through the Lillie P.
Bliss Bequest

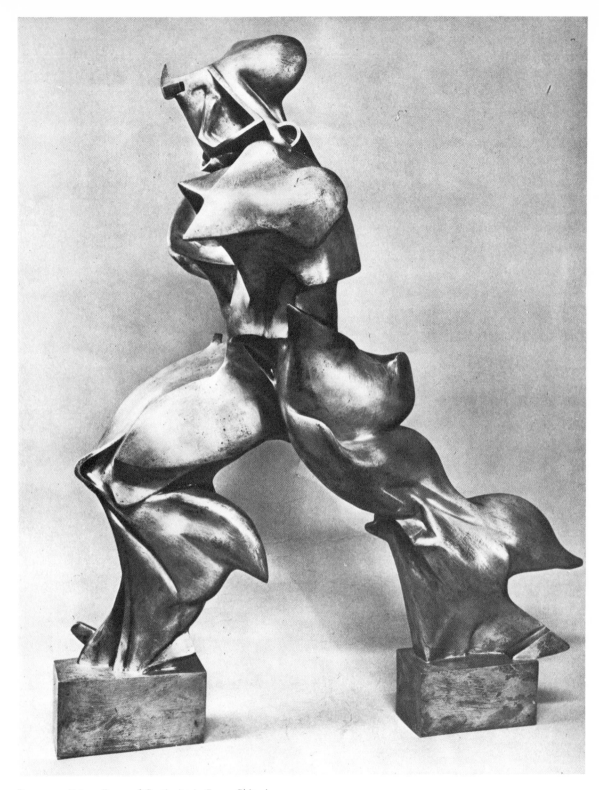

BOCCIONI: *Unique Forms of Continuity in Space.* Side view

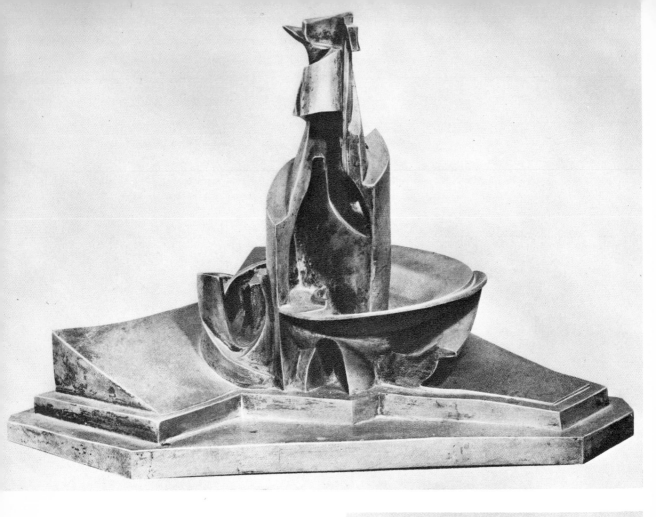

UMBERTO BOCCIONI: *Development of a Bottle in Space*. 1912. Bronze, 15″ high. The Museum of Modern Art, New York, Aristide Maillol Fund

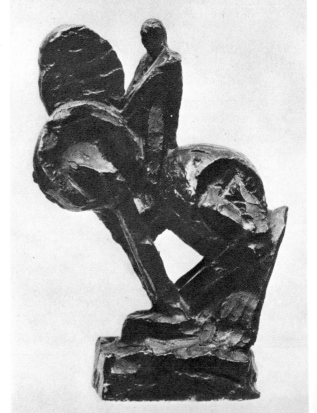

RAYMOND DUCHAMP-VILLON: *Rider*. C. 1913. Bronze, 11″ high. Stedelijk Museum, Amsterdam

136

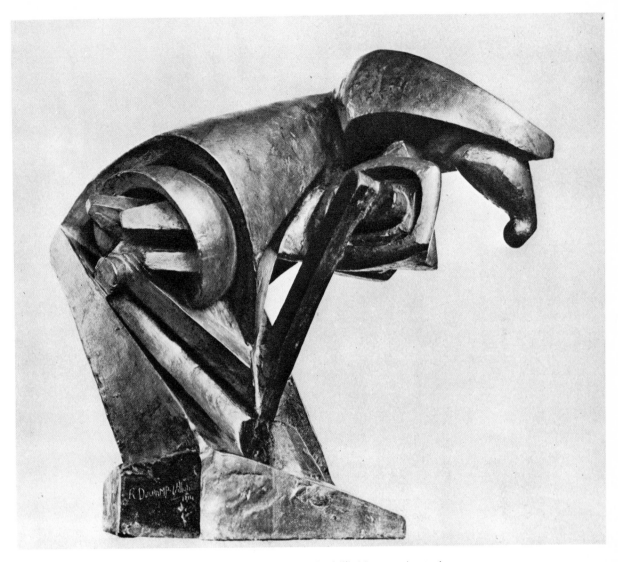

RAYMOND DUCHAMP-VILLON: *The Horse*. 1914. Bronze, 17″ high. Stedelijk Museum, Amsterdam

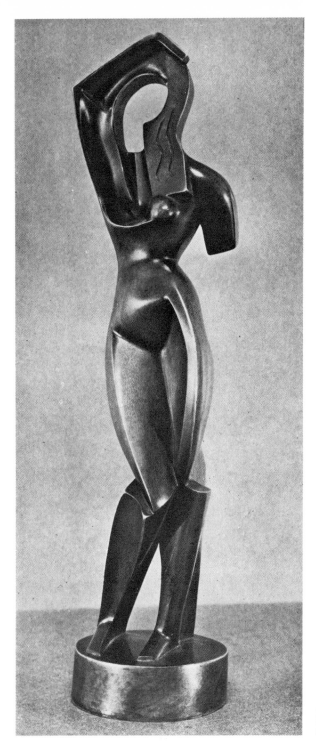

ALEXANDER ARCHIPENKO: *Woman Combing Her Hair.*
1915. Bronze, 13¾″ high. Collection Mr. and Mrs.
George Heard Hamilton, New Haven, Conn.

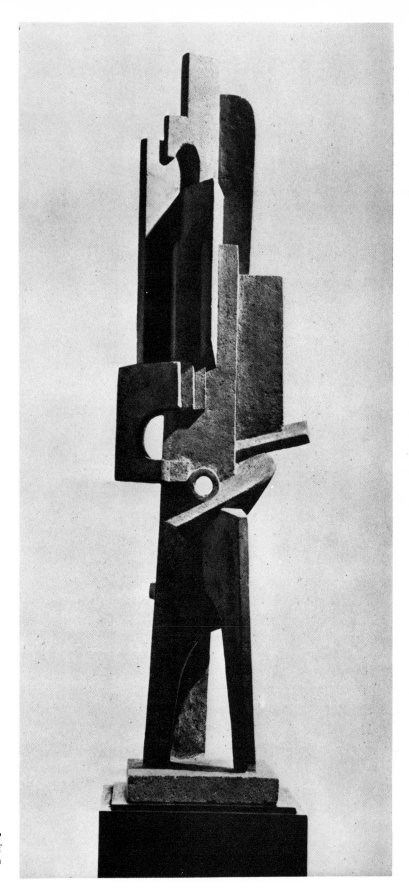

JACQUES LIPCHITZ: *Man with a Guitar*. 1915?
Cast stone, 38¼″ high. The Museum of
Modern Art, New York, Mrs. Simon
Guggenheim Fund

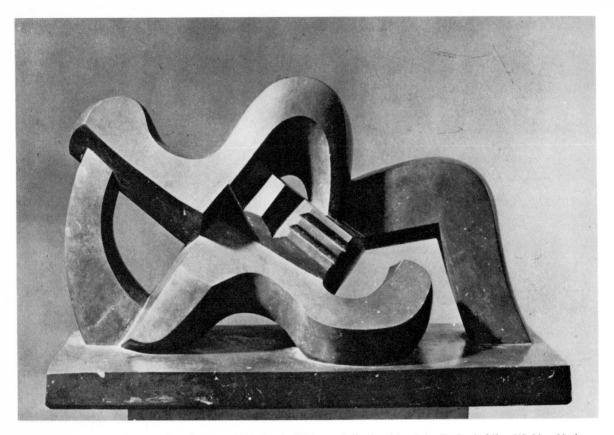

JACQUES LIPCHITZ: *Reclining Nude with Guitar*. 1928. Basalt, 27″ long. Collection Mrs. John D. Rockefeller, III, New York

JACQUES LIPCHITZ: *Figure*. 1926–30. Bronze, 7′ 1¼″ high. The Museum of Modern Art, New York, van Gogh Purchase Fund

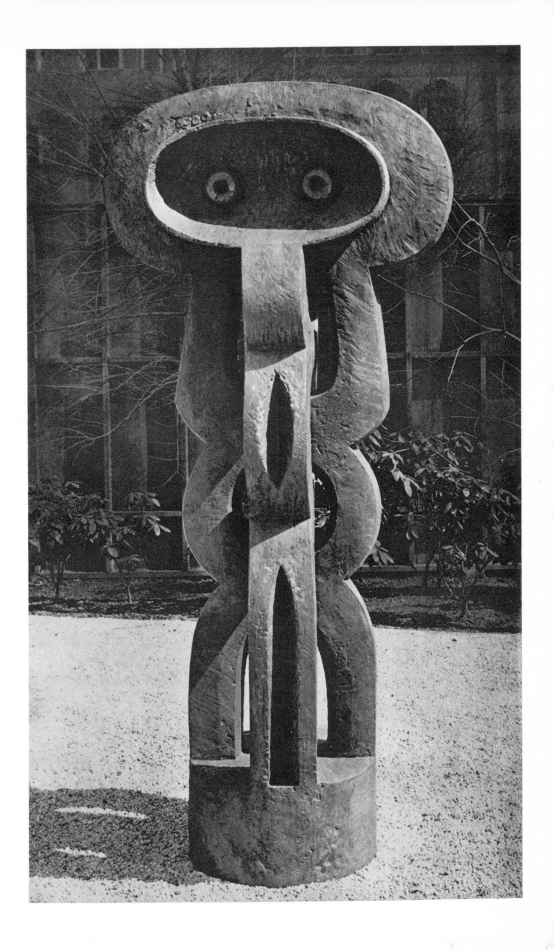

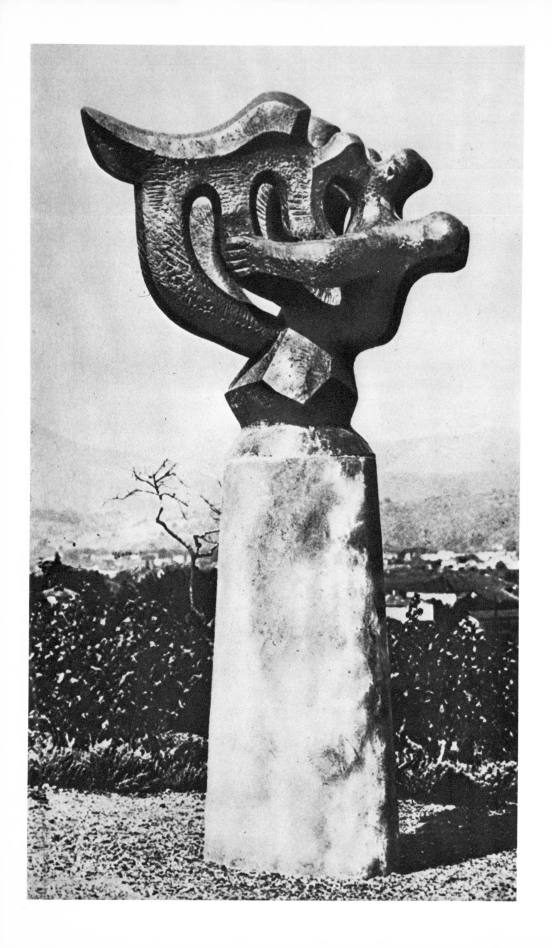

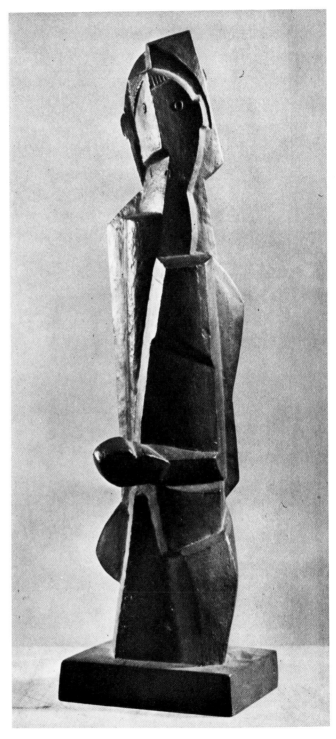

HENRI LAURENS: *Le Grand Poseur*. 1920. Stone, 32″ high. Galerie
Louise Leiris, Paris

JACQUES LIPCHITZ: *Song of the Vowels*. 1931–32. Bronze, 6′ 6¾″ high. Collection Mme Hélène de
Mandrot, Pradet, France

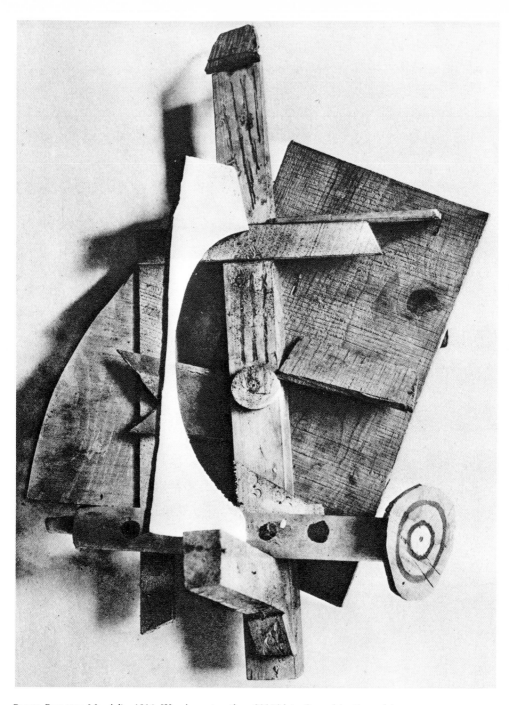

PABLO PICASSO: *Mandolin*. 1914. Wood construction, 23⅝″ high. Owned by the artist

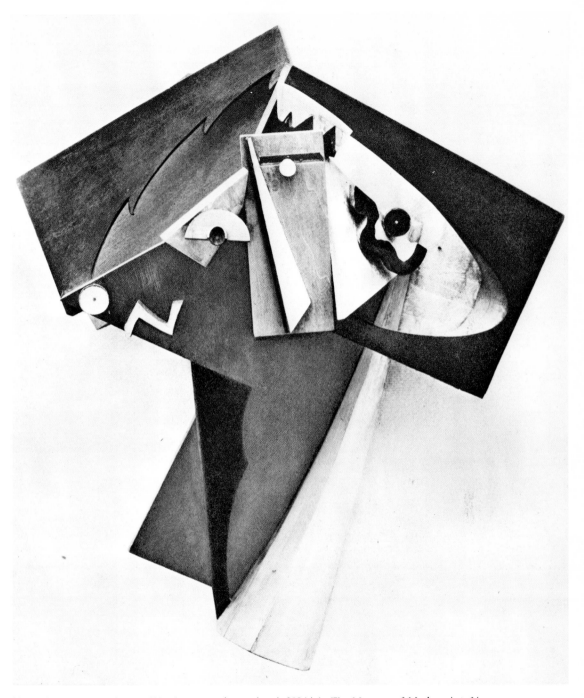

HENRI LAURENS: *Head*. 1918. Wood construction, painted, 20″ high. The Museum of Modern Art, New York, van Gogh Purchase Fund

GEORGES BRAQUE: *Figure*. 1920. Plaster, 7¾″ high. Collection Mrs. Benjamin P. Watson, New York

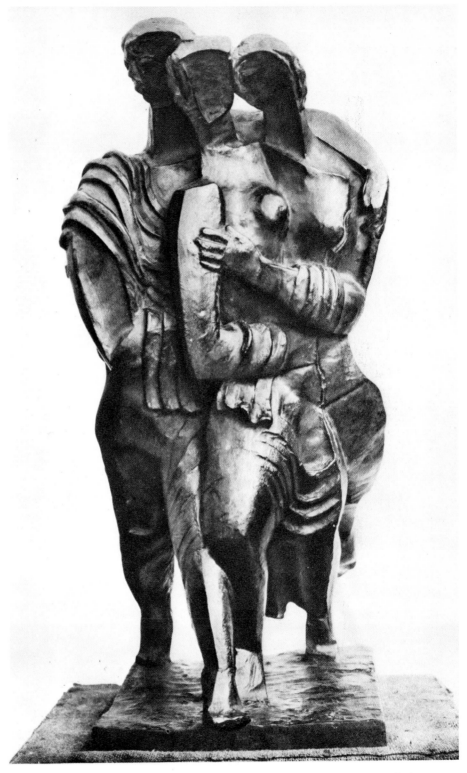

OSSIP ZADKINE: *Maenads*. 1932. Bronze, 29½" high. Musée National d'Art Moderne, Paris

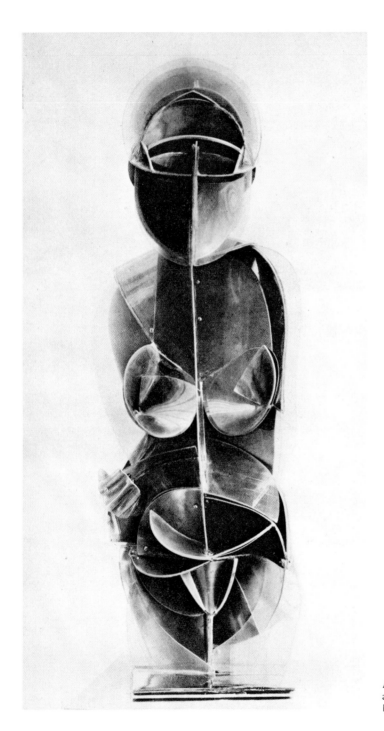

ANTOINE PEVSNER: *Torso*. 1924–26. Brass and plastic. Estate of Miss Katherine S. Dreier

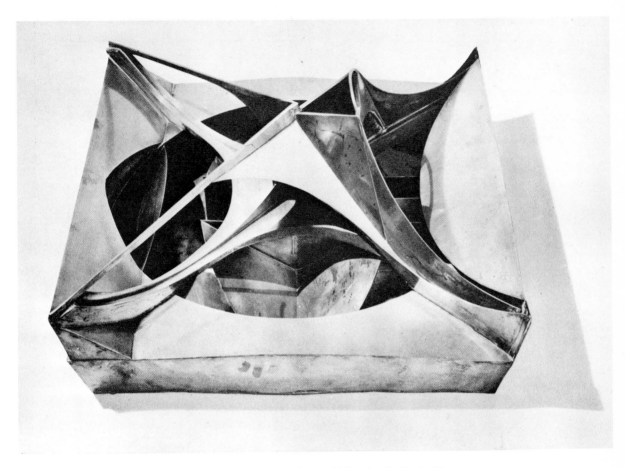

Antoine Pevsner: *Abstraction*. 1927. Brass, 23¾ × 24⅝″. Washington University, St. Louis, Mo.

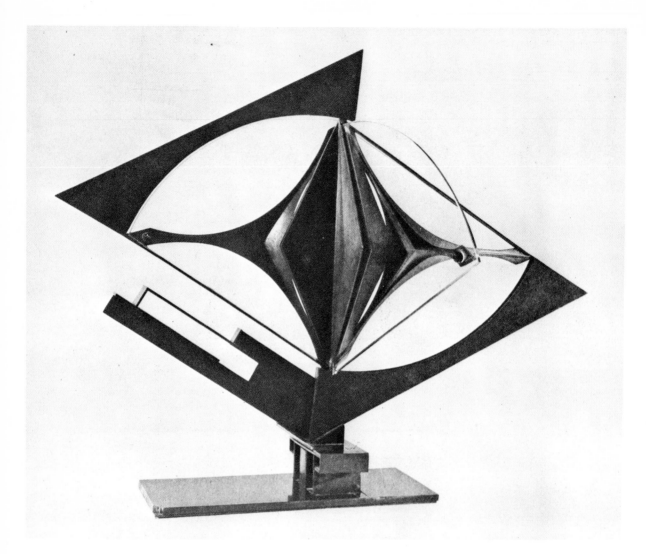

ANTOINE PEVSNER: *Construction.* 1933. Brass, oxidized tin and baccarat crystal on plastic base, 24¾″ high. Owned by the artist

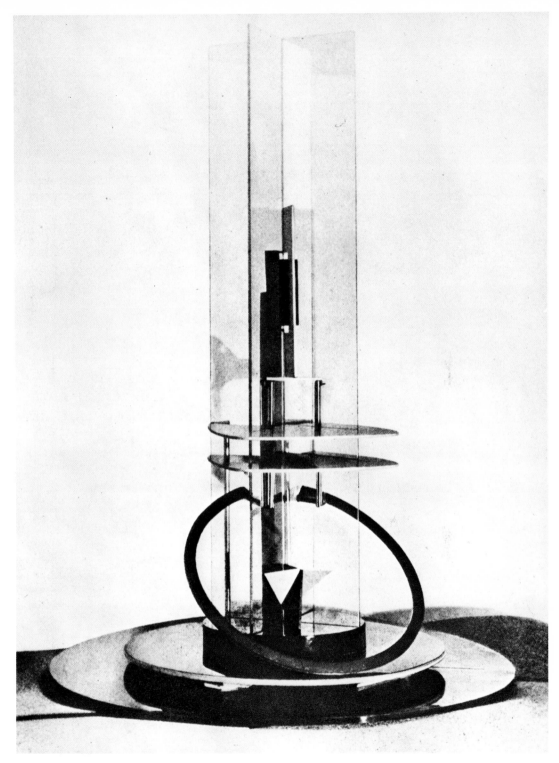

NAUM GABO: *Column*. 1923. Glass, plastic, metal, wood, 41″ high. Owned by the artist

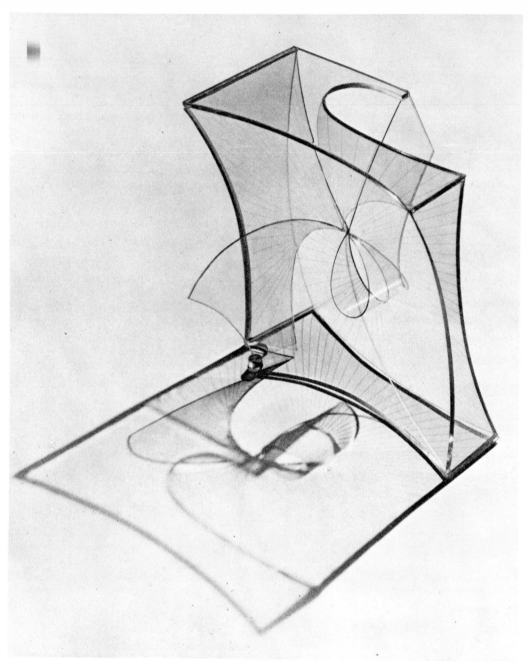

NAUM GABO: *Construction in Space*. 1937. Light blue plastic, 9 × 9″. Vassar College Art Museum, Poughkeepsie, N.Y.

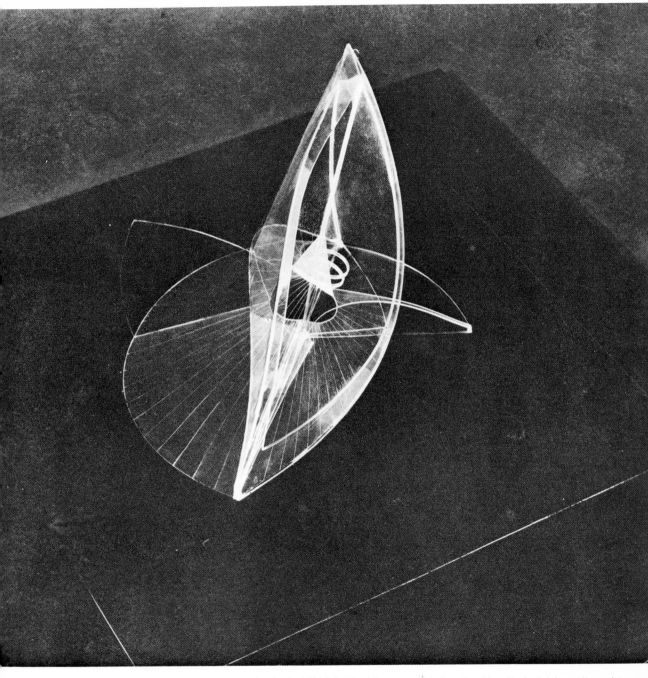

NAUM GABO: *Spiral Theme*. 1941. Construction in plastic, $7\frac{1}{2}''$ high. The Museum of Modern Art, New York, Advisory Committee Fund

153

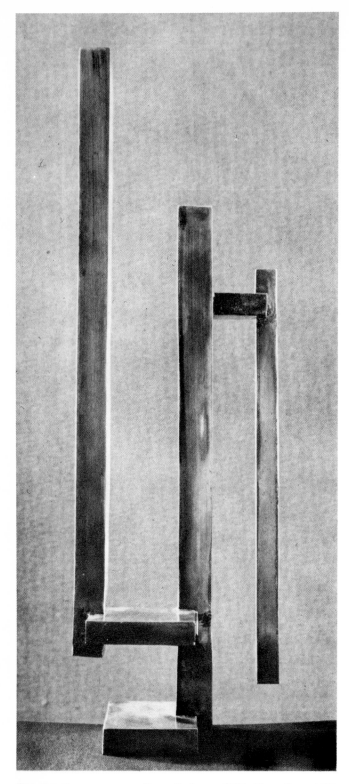

GEORGES VANTONGERLOO: *Space Sculpture*. 1935. New silver, 15¼"
high. Öffentliche Kunstsammlung, Basel

BEN NICHOLSON: *Relief.* 1939. Wood, painted, 32⅝ × 45″. The Museum of Modern Art, New York, gift of H. S. Ede and the artist (by exchange)

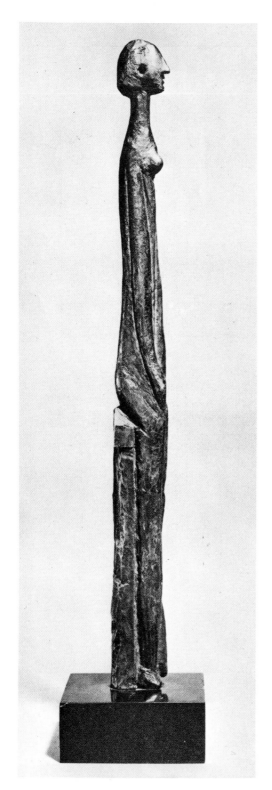

PABLO PICASSO: *Figure*. 1931. Bronze, 23¾″ high. Collection
Mrs. Meric Callery, New York

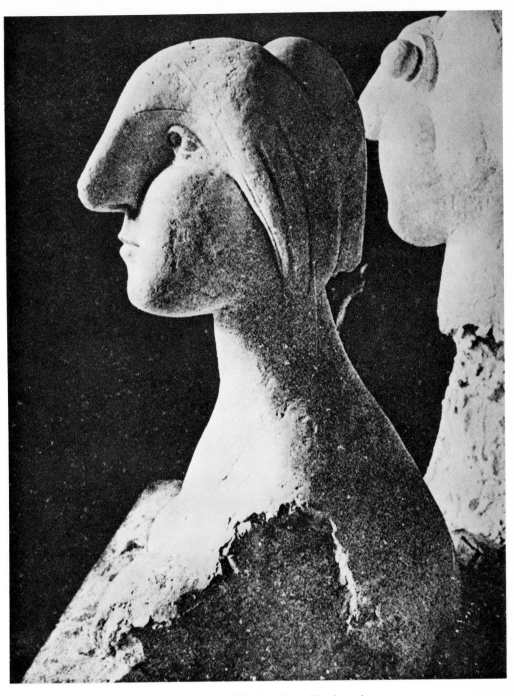

PABLO PICASSO: *Bust of a Woman.* 1932? Plaster, 30¾" high. Owned by the artist

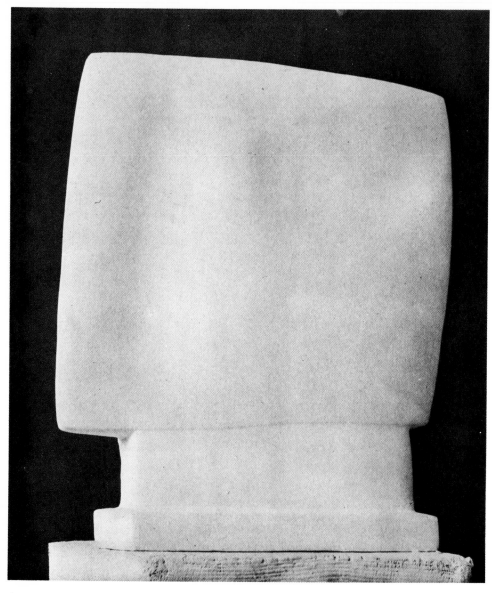

ALBERTO GIACOMETTI: *Head*. 1928. Marble, 15″ high. Stedelijk Museum, Amsterdam

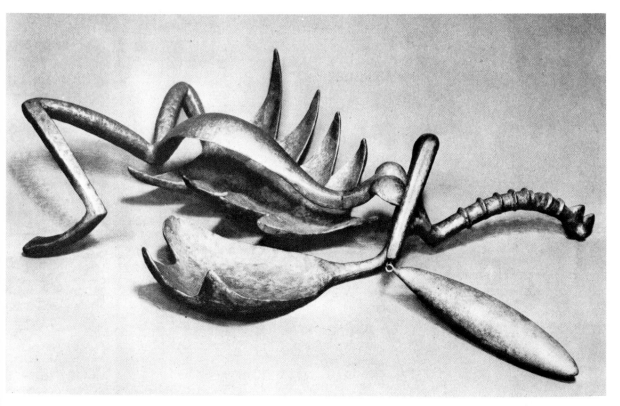

ALBERTO GIACOMETTI: *Slaughtered Woman.* 1932. Bronze, 34½″ long. The Museum of Modern Art, New York

159

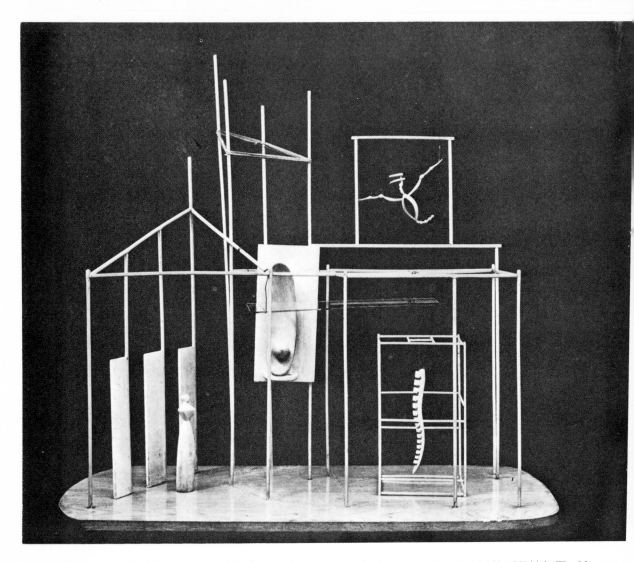

ALBERTO GIACOMETTI: *The Palace at 4 A.M.* 1932–33. Construction in wood, glass, wire, string, $28\frac{1}{4} \times 15\frac{3}{4} \times 25''$ high. The Museum of Modern Art, New York

160

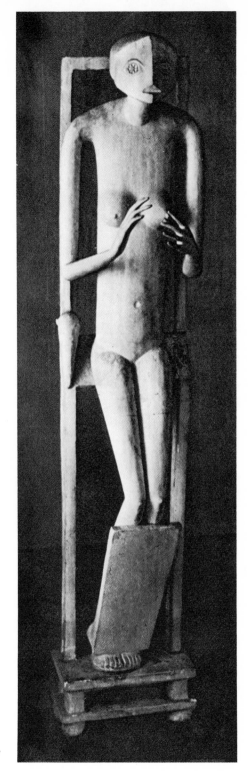

ALBERTO GIACOMETTI: *Hands Holding the Void*. 1934. Original plaster, 60" high. Yale University Art Gallery, New Haven

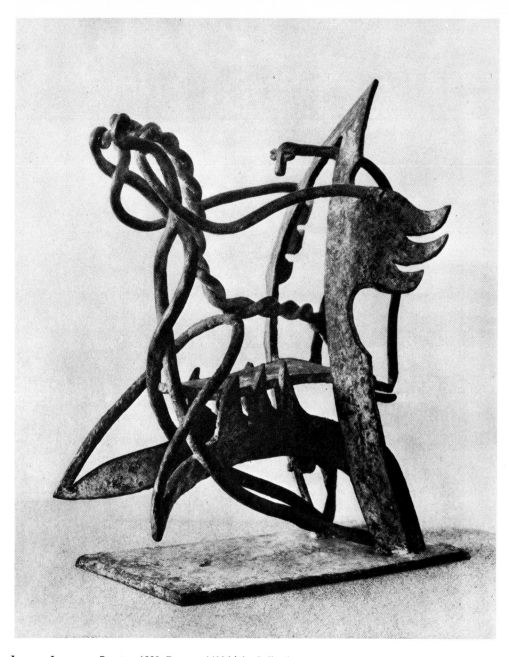

JACQUES LIPCHITZ: *Pegasus*. 1929. Bronze, 14½″ high. Collection Mrs. T. Catesby Jones

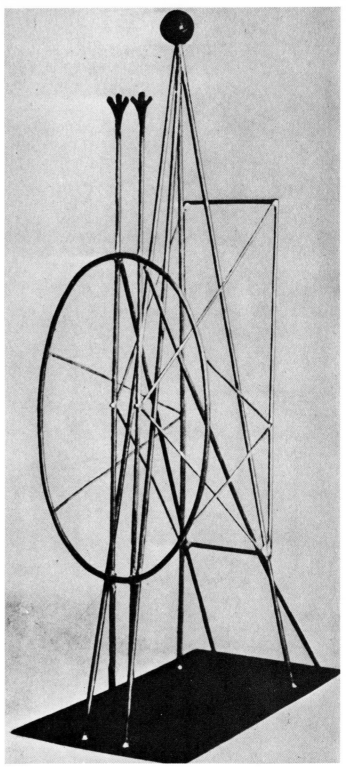

PABLO PICASSO: *Project for a Sculpture*. 1928. Iron. Owned by the artist

163

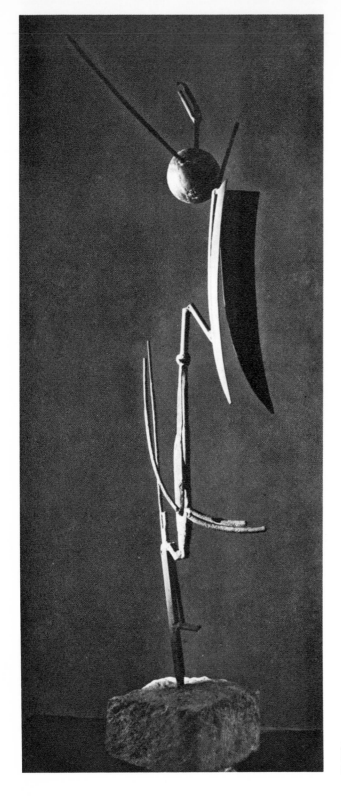

JULIO GONZALEZ: *Angel*. 1933. Wrought iron, 63″ high. Musée National d'Art Moderne, Paris

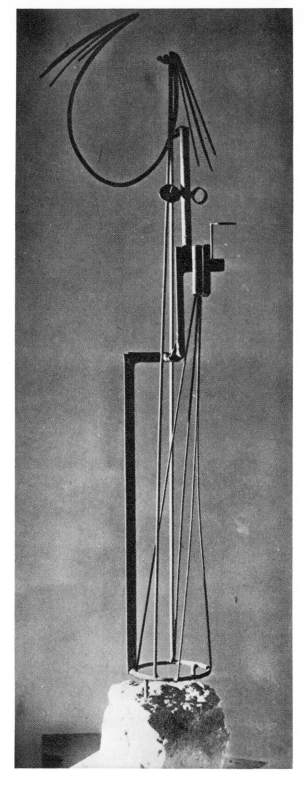

JULIO GONZALEZ: *Maternity*. 1933. Wrought iron, 55″ high. Collection Mme Roberta Gonzalez-Hartung, Paris

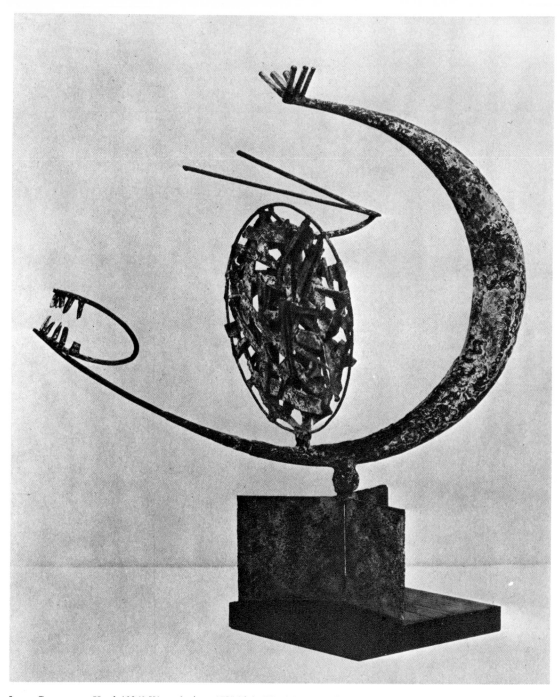

JULIO GONZALEZ: *Head.* 1936? Wrought iron 17¾" high. The Museum of Modern Art, New York

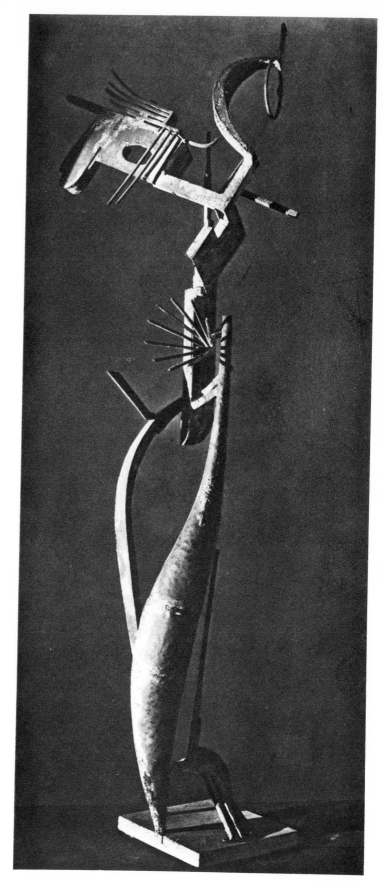

JULIO GONZALEZ: *Woman Combing Her Hair.*
1937. Wrought iron, 6′ 10″ high. Collection Mme
Roberta Gonzalez-Hartung, Paris

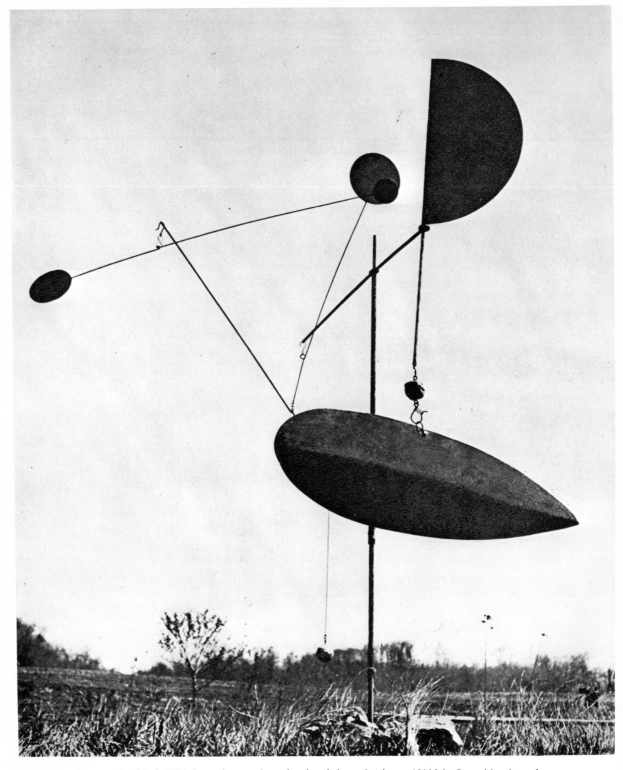

ALEXANDER CALDER: *Steel Fish*. 1934. Iron, sheet steel, steel rod and sheet aluminum, 10′ high. Owned by the artist

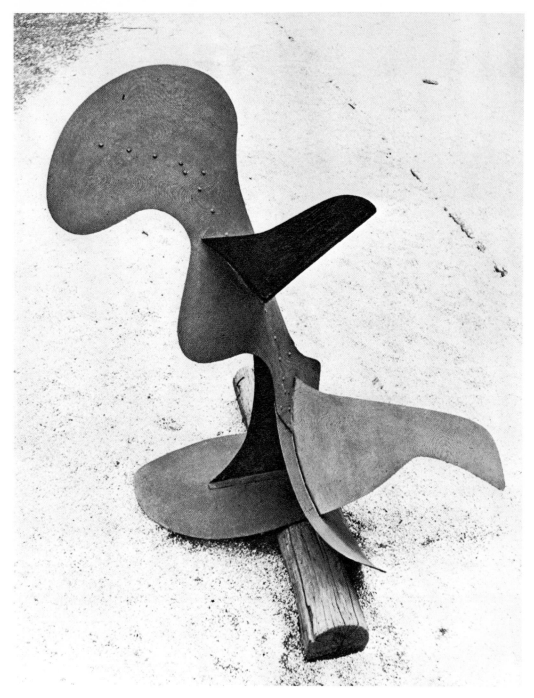

ALEXANDER CALDER: *Whale*. 1937. Sheet steel, 6′ 6″ high. The Museum of Modern Art, New York, gift of the artist

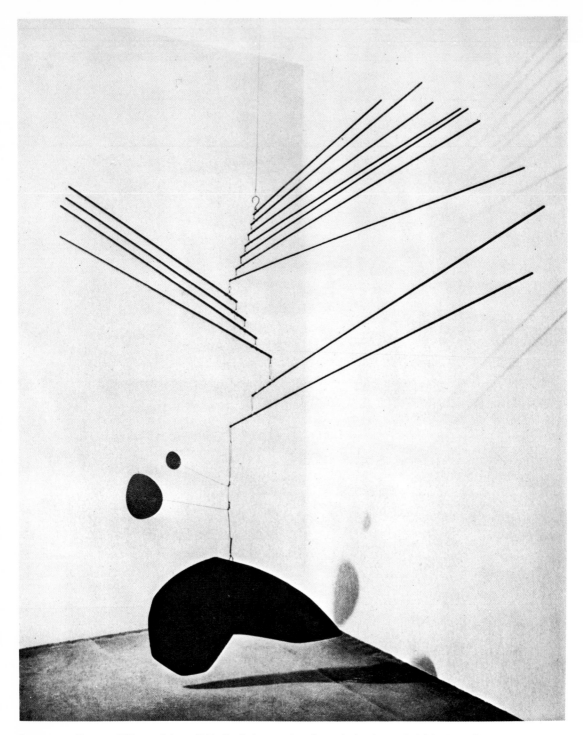

ALEXANDER CALDER: *Thirteen Spines.* 1940. Steel sheet, rods, wire and aluminum, 7′ high. Owned by the artist

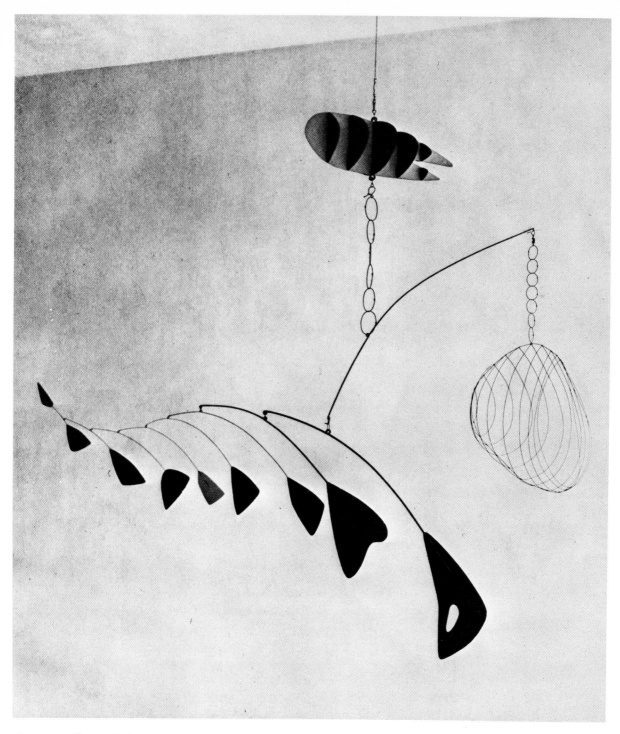

ALEXANDER CALDER: *Lobster Trap and Fish Tail*. 1939. Steel wire and sheet aluminum, c. 15′ long. The Museum of Modern Art, New York

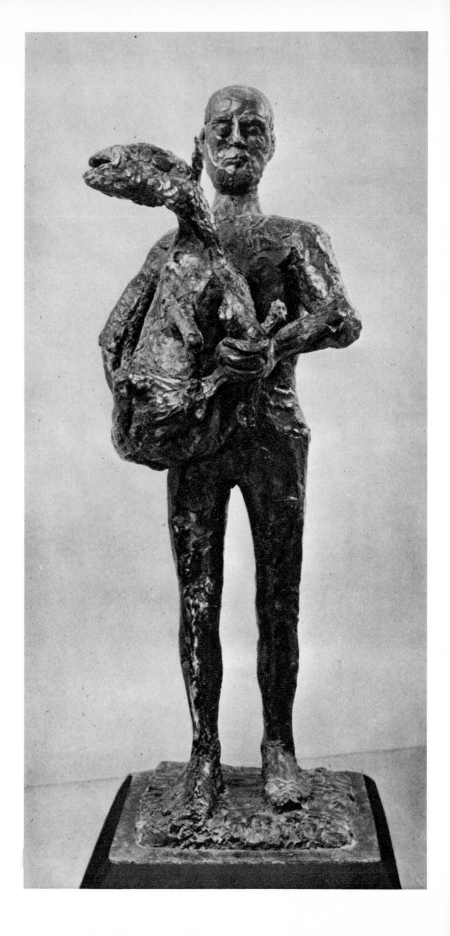

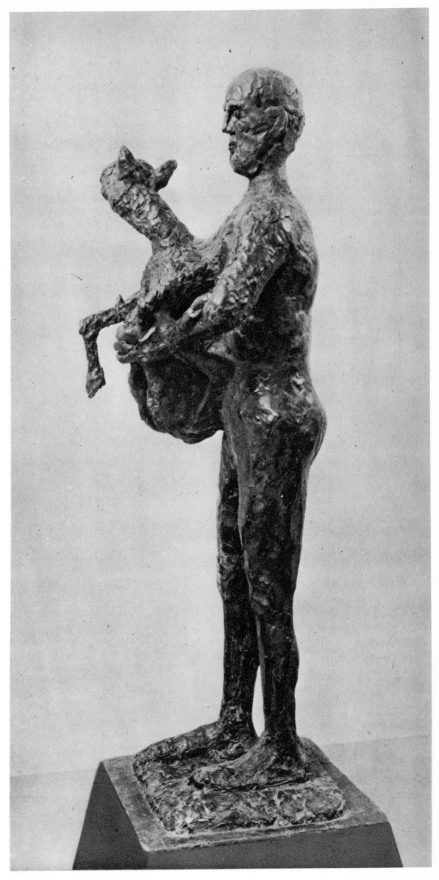

PABLO PICASSO: *Shepherd Holding a Lamb*. 1944. Bronze, 7′ 4″ high. Collection Mr. and Mrs. R. Sturgis Ingersoll, Penllyn, Pa.

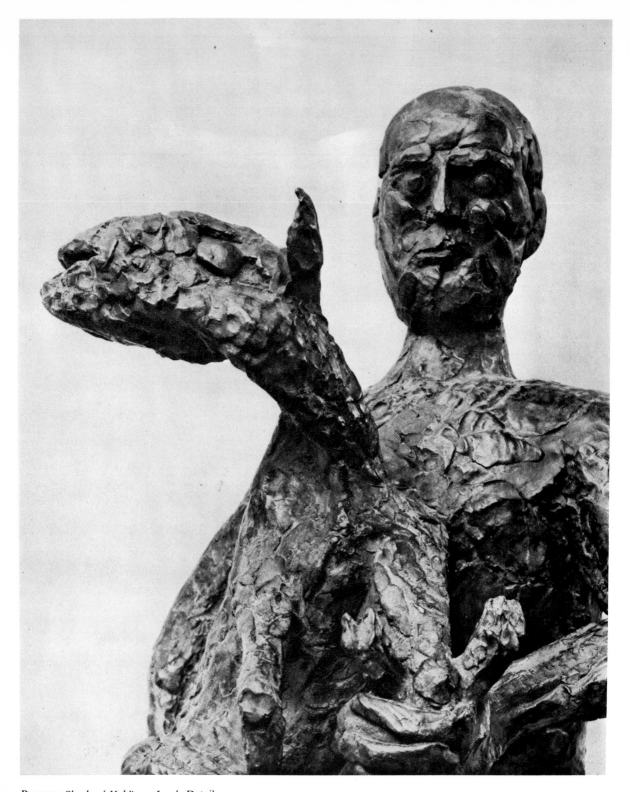

PICASSO: *Shepherd Holding a Lamb*. Detail

174

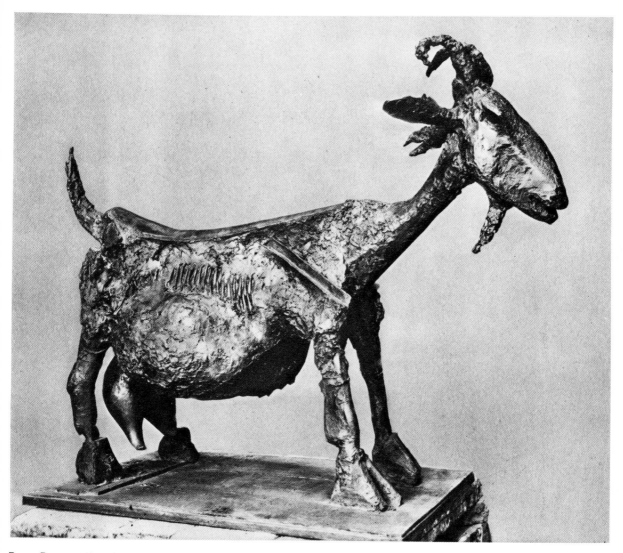

PABLO PICASSO: *Goat*. 1951. Bronze, 58″ long. Curt Valentin Gallery, New York

PABLO PICASSO: *Skull.* 1943. Bronze, 11½″ high. Owned by the artist

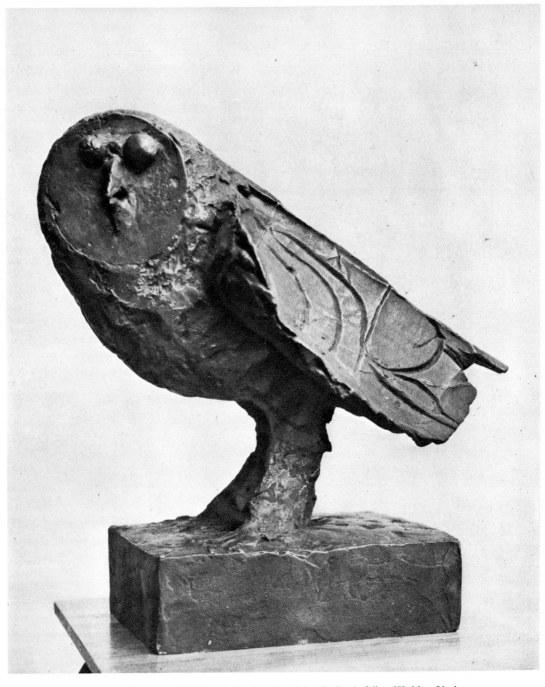

PABLO PICASSO: *Owl*. 1950. Bronze, 14¼″ high. Collection Mrs. John D. Rockefeller, III, New York

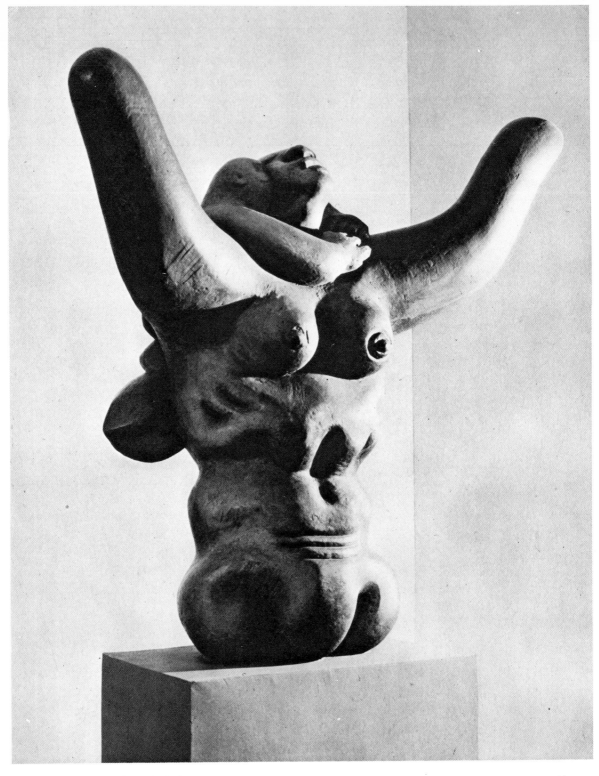

JACQUES LIPCHITZ: *Mother and Child, II.* 1941–45. Bronze, 50″ high. The Museum of Modern Art, New York, Mrs. Simon Guggenheim Fund

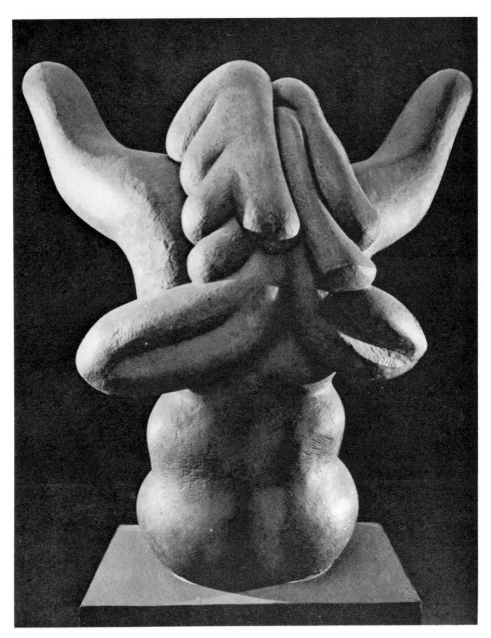

LIPCHITZ: *Mother and Child, II.* Rear view

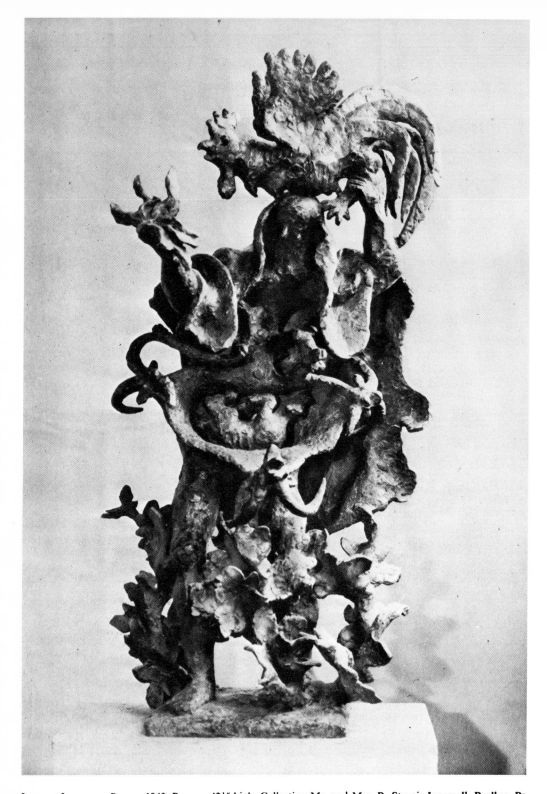

JACQUES LIPCHITZ: *Prayer*. 1943. Bronze, 42½″ high. Collection Mr. and Mrs. R. Sturgis Ingersoll, Penllyn, Pa.

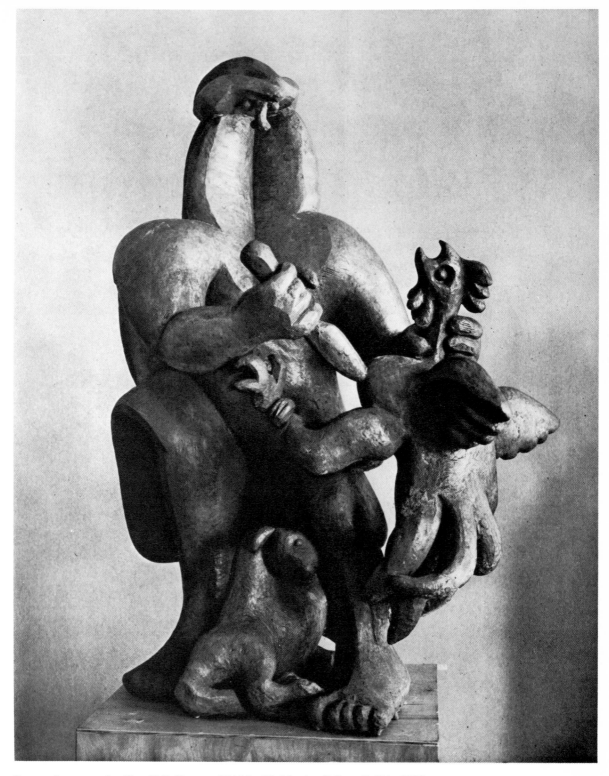

JACQUES LIPCHITZ: *Sacrifice*. 1948. Bronze, 49″ high. Albright Art Gallery, Buffalo, N.Y.

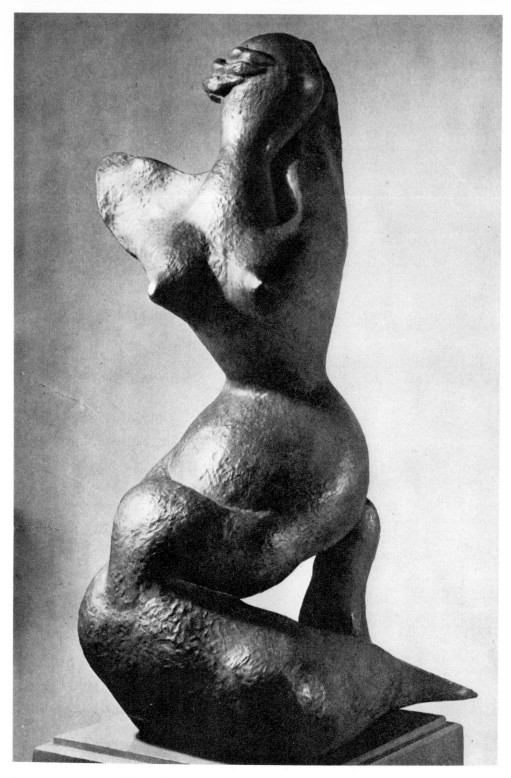

HENRI LAURENS: *Mermaid.* 1945. Bronze, 45¼″ high. Curt Valentin Gallery, New York

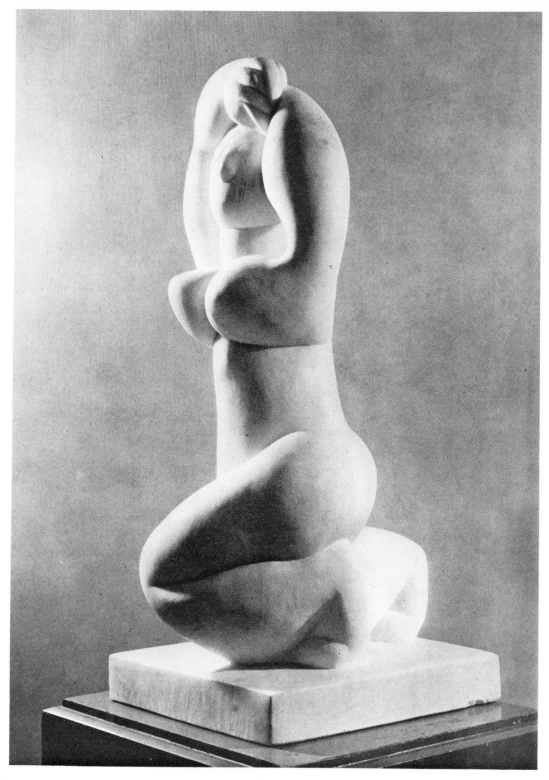

HENRI LAURENS: *Luna*. 1948. Marble, 35¾″ high. Curt Valentin Gallery, New York

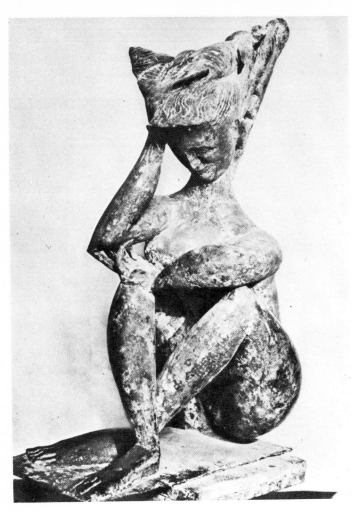

PERICLE FAZZINI: *Seated Woman*. 1947.
Bronze, 37⅞″ high. Owned by the artist

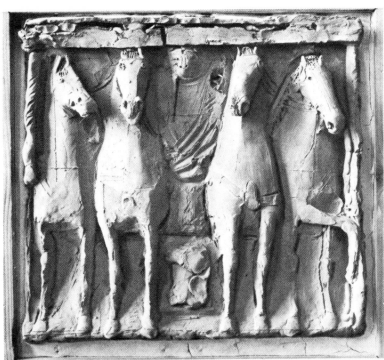

MARINO MARINI: *Quadriga*. 1941.
Terra cotta, 13×15″.
Öffentliche Kunstsammlung, Basel

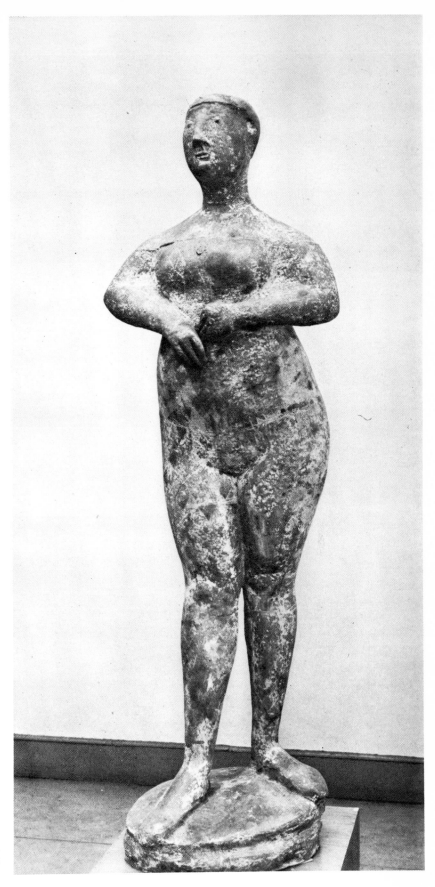

MARINO MARINI: *Dancer*. 1949.
Bronze, 68″ high. Curt Valentin
Gallery, New York

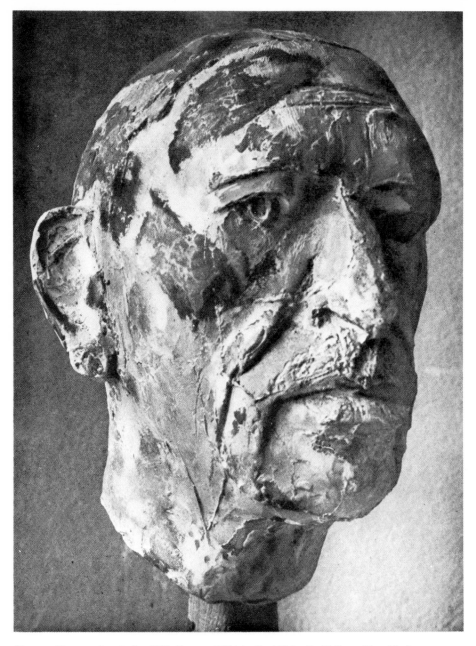

Marino Marini: *Stravinsky*. 1950. Bronze, 9″ high. Curt Valentin Gallery, New York

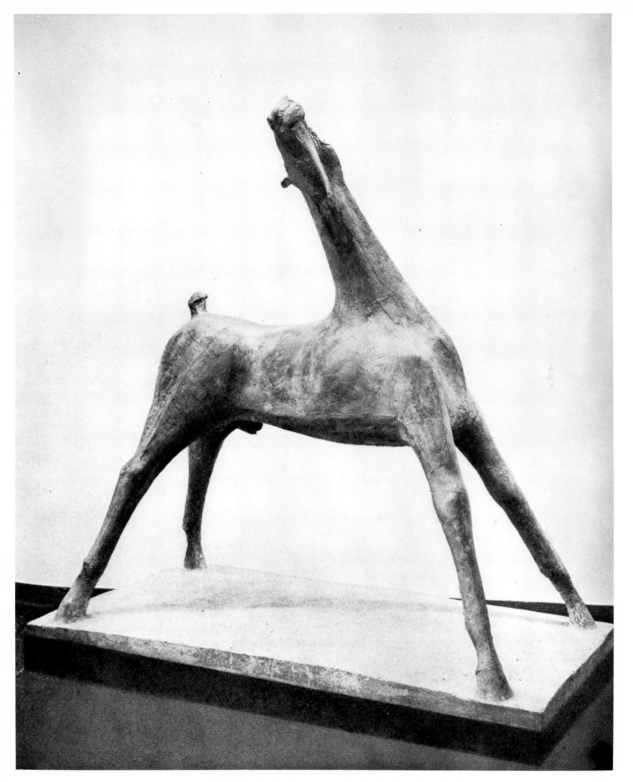

MARINO MARINI: *Horse*. 1951. Bronze, c. 7′ 3″ high. Collection Nelson A. Rockefeller, New York

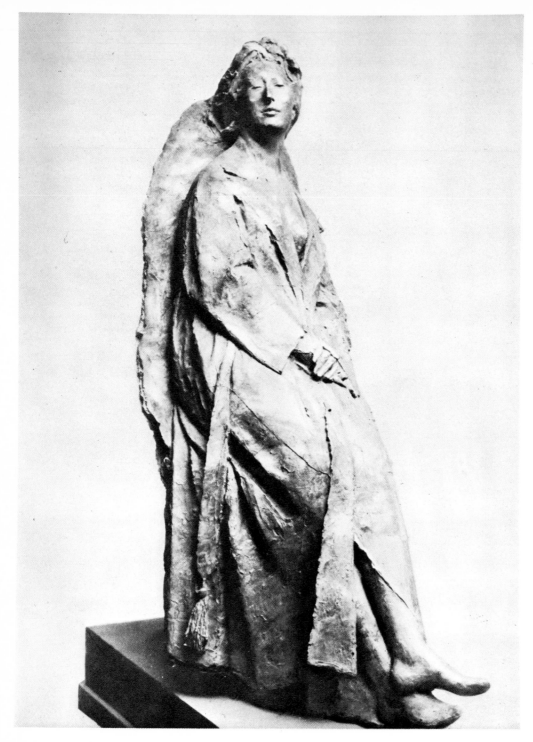

GIACOMO MANZÙ: *Portrait of a Lady*. 1946. Bronze, 28" high. Collection Mrs. Alice Lampugnani, Milan

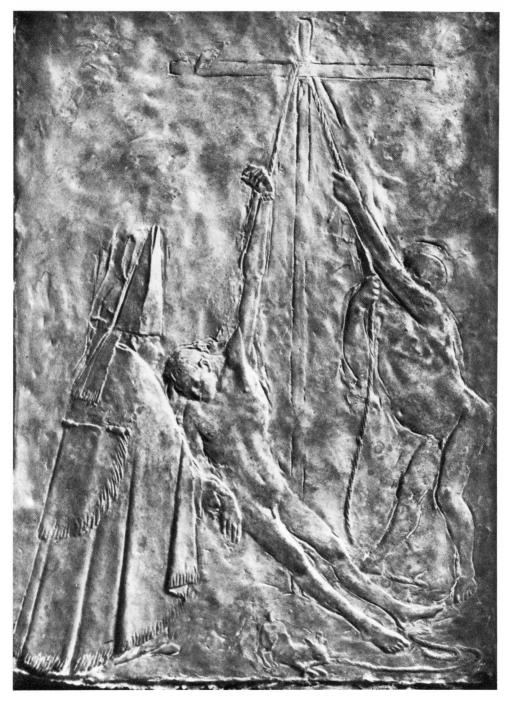

Giacomo Manzù: *Cardinal and Deposition*. 1941-42. Bronze, 21 × 16″. Collection Riccardo Gualino, Rome

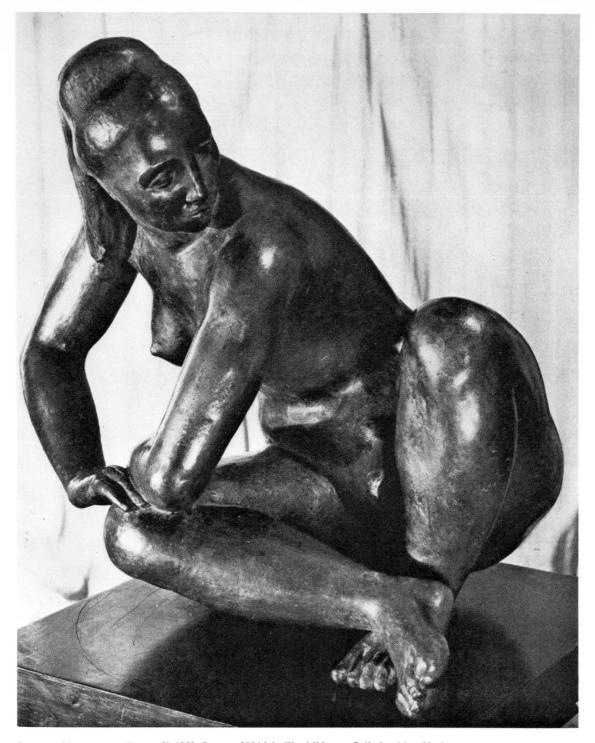

ORONZIO MALDARELLI: *Bianca, II*. 1950. Bronze, 28″ high. The Midtown Galleries, New York

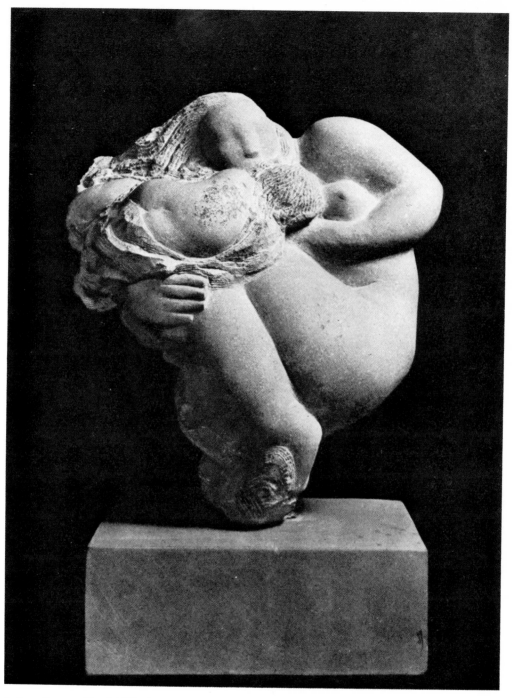

JOSÉ DE CREEFT: *Cloud.* 1939. Green stone, 17¼" high. The Whitney Museum of American Art, New York

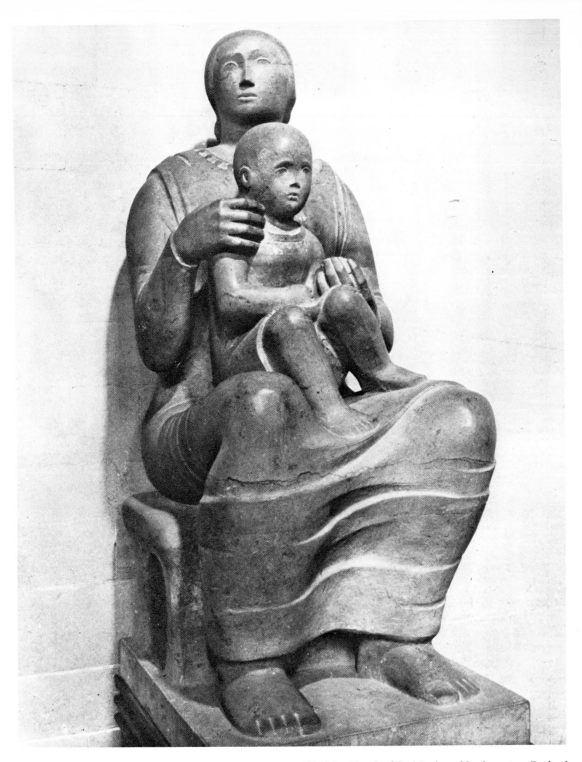

HENRY MOORE: *Madonna and Child*. 1943-44. Hornton stone, 59″ high. Church of St. Matthew, Northampton, England

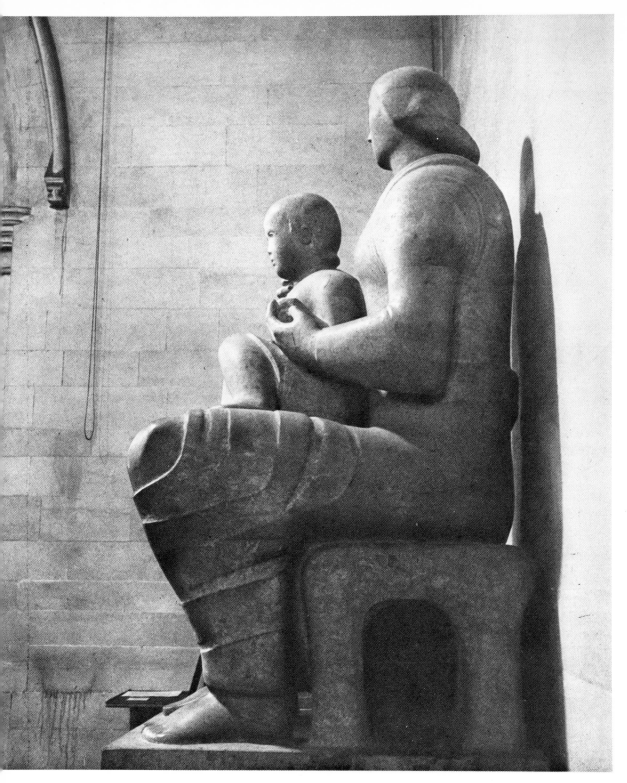

HENRY MOORE: *Madonna and Child*. Side view

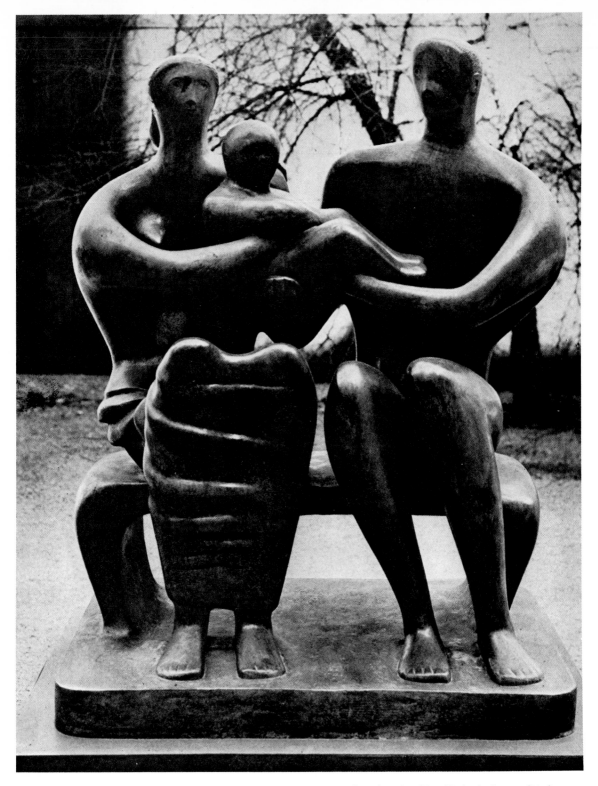

HENRY MOORE: *Family Group*. 1945–49. Bronze, 59¼" high. The Museum of Modern Art, New York, A. Conger Goodyear Fund

HENRY MOORE: *Double Standing Figure*. 1950. Bronze, 7′ 3″ high. Curt Valentin Gallery, New York

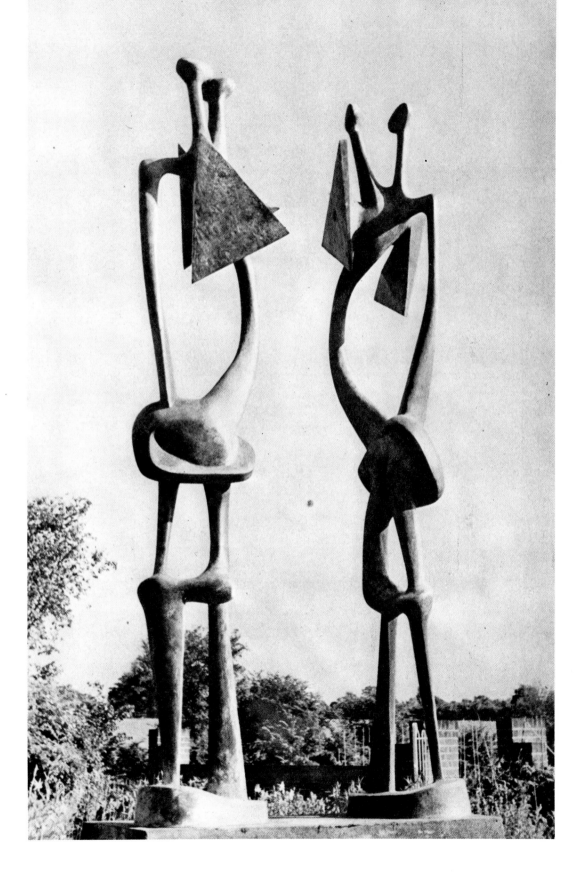

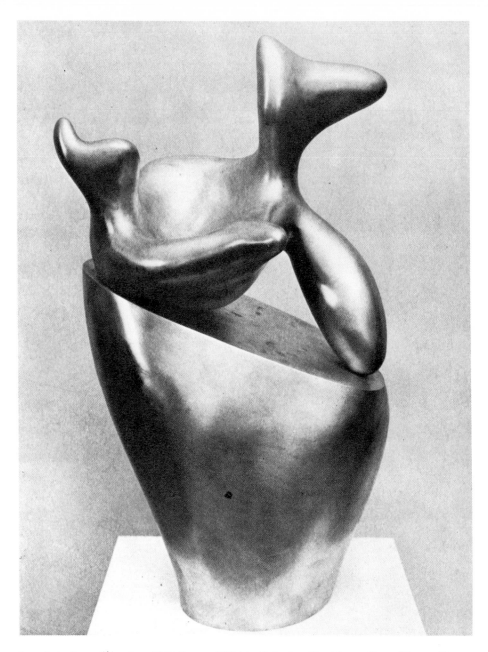

JEAN ARP: *Coupe Chimerique*. 1947. Bronze, 31″ high. Collection Mrs. George Henry Warren, New York

Barbara Hepworth: *Cosden Head*. 1949. Blue marble, 24″ high. City Museum and Art Gallery, Birmingham, England

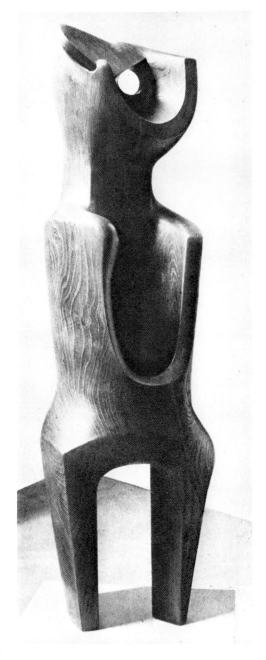

197

Bernard Meadows: *Standing Figure*. Winter 1950–51. Elmwood, 61″ high. Collection Arts Council of Great Britain

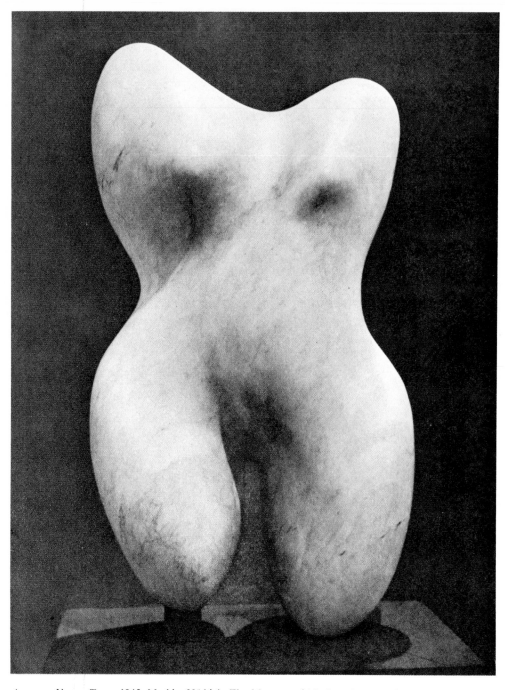

ALBERTO VIANI: *Torso*. 1945. Marble, 38″ high. The Museum of Modern Art, New York

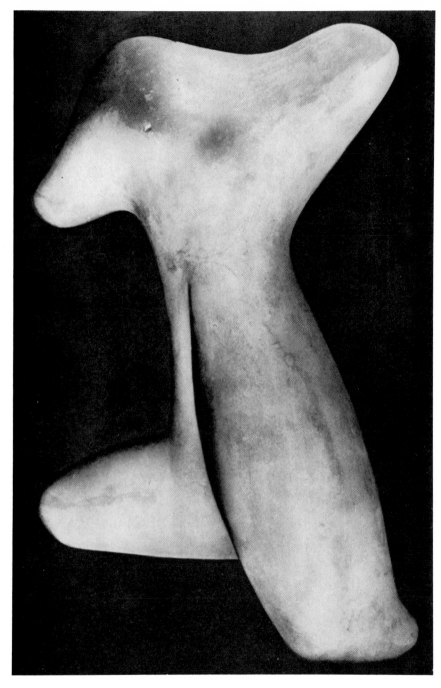

BERNARD HEILIGER: *Seraph.* 1950. Cement, 24¾" high. Owned by the artist

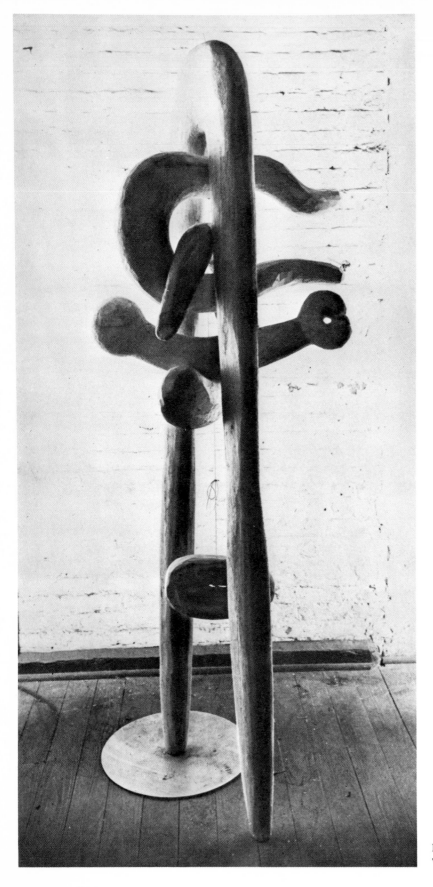

ISAMU NOGUCHI: *Cronos*. 1949. Balsa
wood, 76″ high. Egan Gallery, New York

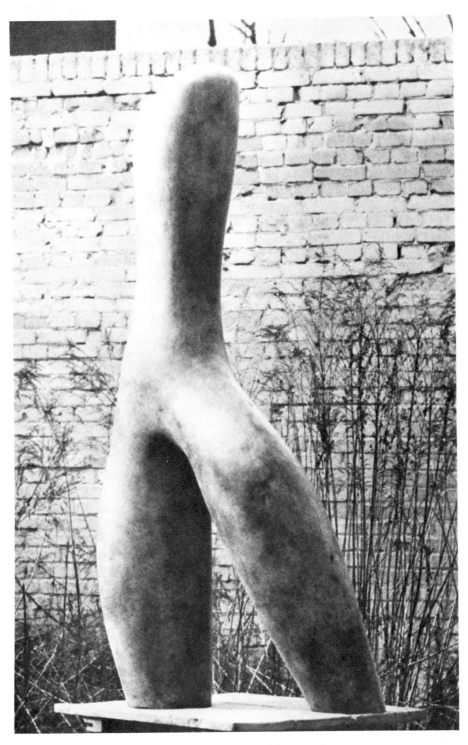

KARL HARTUNG: *Figure*. 1950. Bronze, 55″ high. Owned by the artist

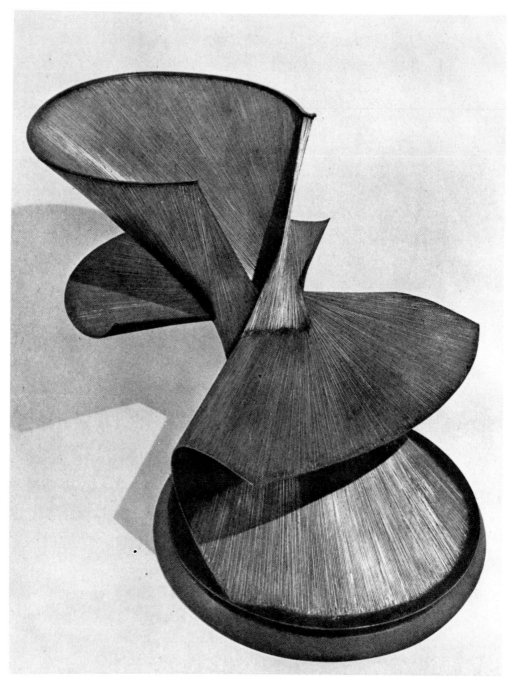

ANTOINE PEVSNER: *Developable Column*. 1942. Brass and oxidized bronze, 20¾″ high. The Museum of Modern Art, New York

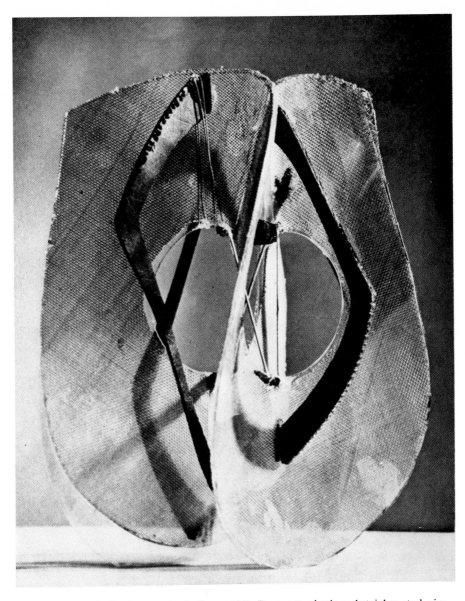

NAUM GABO: *Study for Construction in Space*. 1951. Brass net, plastic and stainless steel wire, 6″ high. Owned by the artist

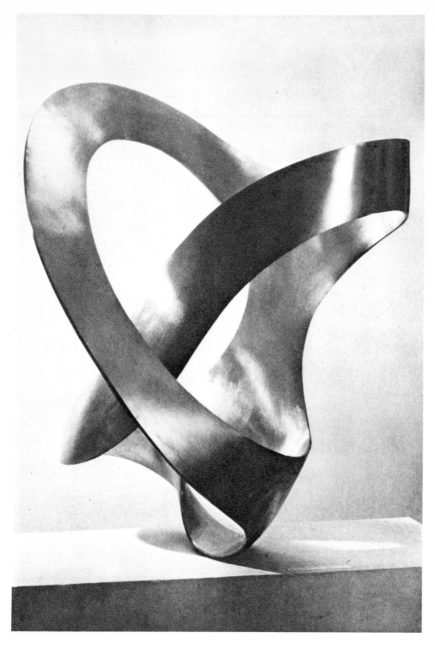

MAX BILL: *Tripartite Unity*. 1947–48. Chrome-nickel steel, 46″ high. Museu de Arte Moderna, São Paulo, Brazil

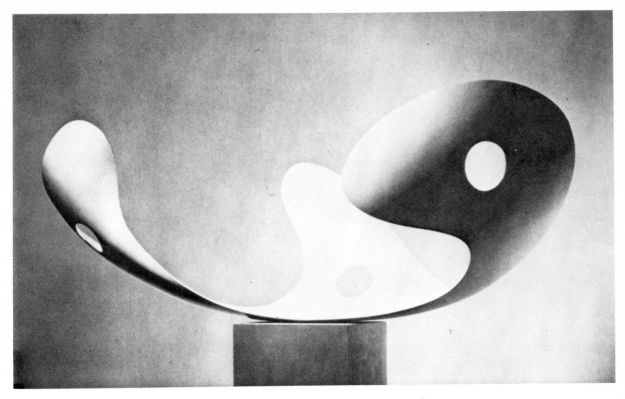

Josᴇ́ ᴅᴇ Rɪᴠᴇʀᴀ: *Yellow Black*. 1946–47. Aluminum, painted, 60″ long. Owned by the artist

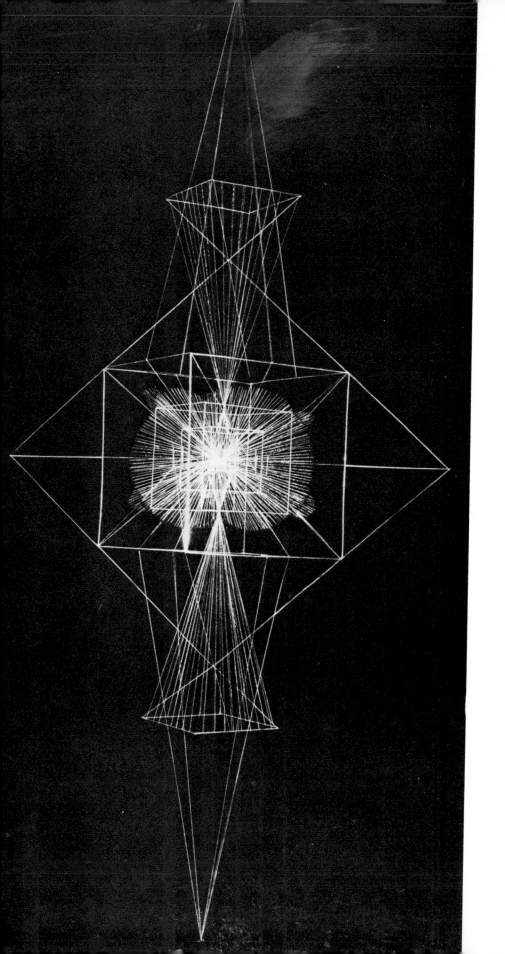

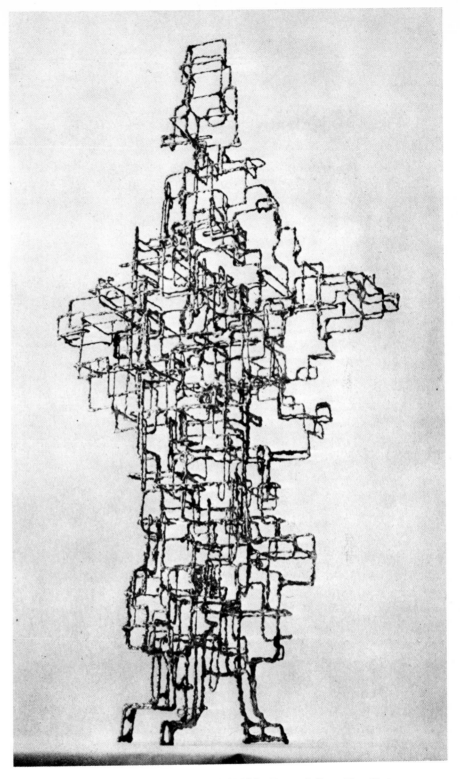

IBRAM LASSAW: *Monoceros*. 1952. Bronze, 46¾″ high. Kootz Gallery, New York

RICHARD LIPPOLD: *Variation No. 7: Full Moon*. 1949–50. Nickel-chromium wire, stainless steel wire and brass rods, 10′ high. The Museum of Modern Art, New York, Mrs. Simon Guggenheim Fund

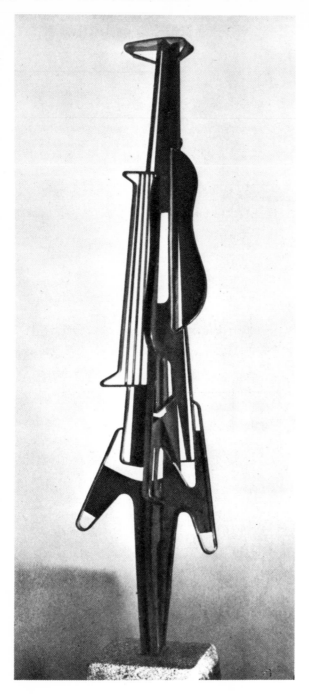

HANS UHLMANN: *Figuration*. 1951. Iron, 6′ 6¾″ high. Owned by the artist

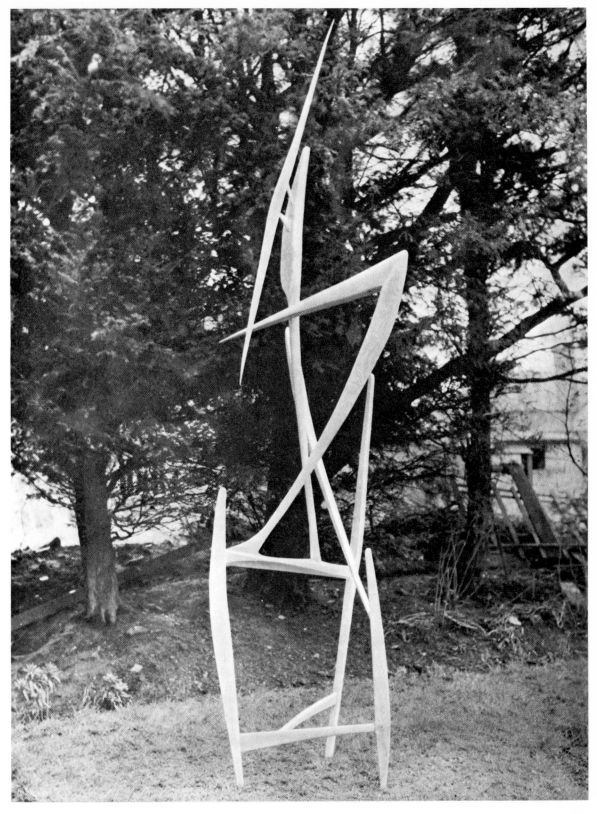

ROBERT ADAMS: *Apocalyptic Figure*. Winter, 1950–51. Ash, 10′ high. Collection Arts Council of Great Britain

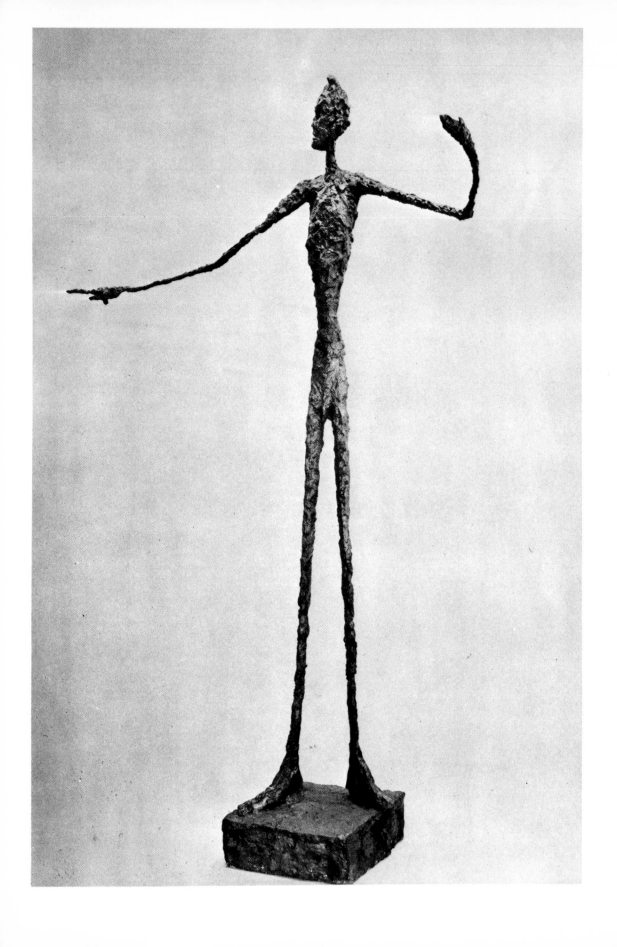

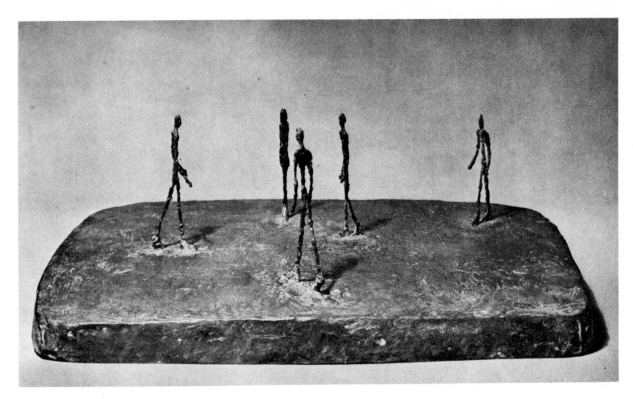

ALBERTO GIACOMETTI: *City Square*. 1948. Bronze, 8½″ high, 25″ long. The Museum of Modern Art, New York

211

ALBERTO GIACOMETTI: *Man Pointing*. 1947. Bronze, 70½″ high. Collection Mrs. John D. Rockefeller, III, New York

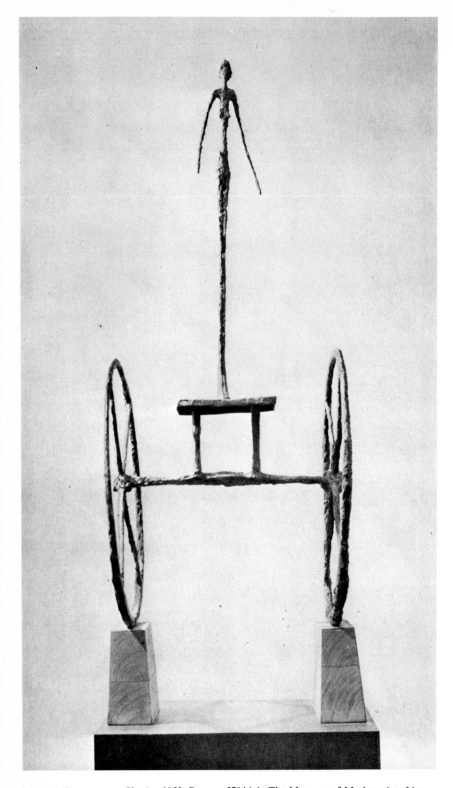

ALBERTO GIACOMETTI: *Chariot*. 1950. Bronze, 57" high. The Museum of Modern Art, New York

212

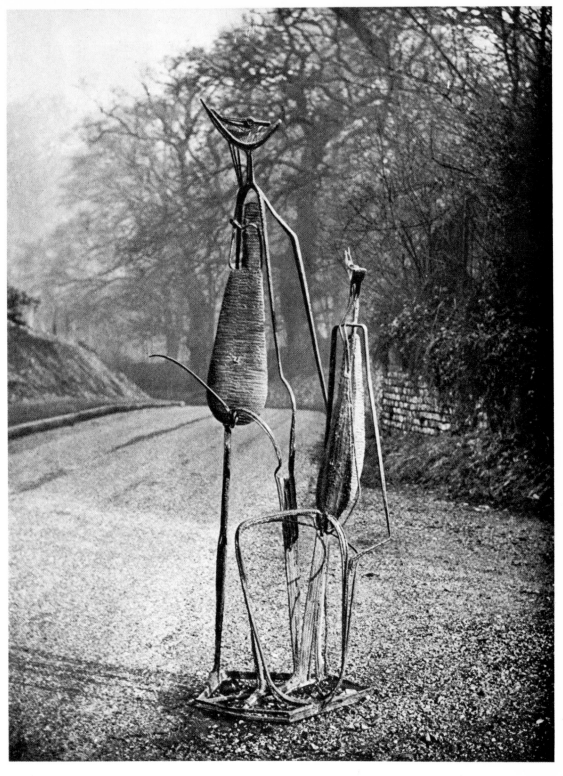

REG BUTLER: *Girl and Boy*. Winter, 1950–51. Iron, 6′ 9″ high. Collection Arts Council of Great Britain

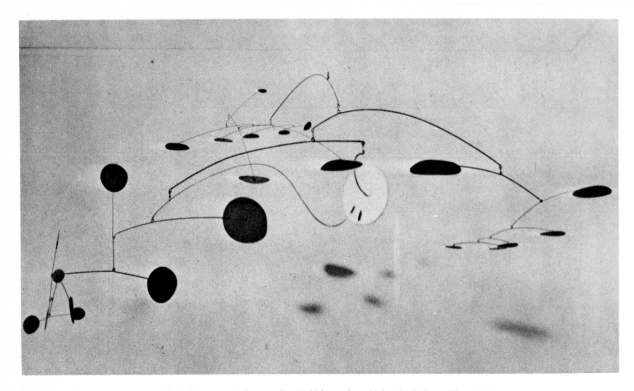

ALEXANDER CALDER: *Streetcar*. 1951. Sheet metal, brass, wire, 9′ 8″ long. Curt Valentin Gallery, New York

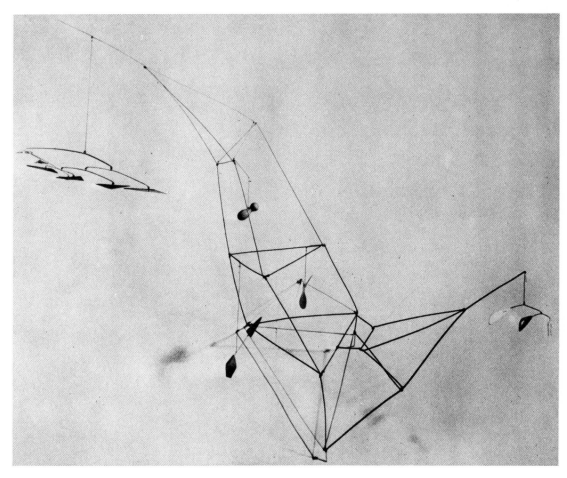

ALEXANDER CALDER: *Bifurcated Tower*. 1950. Sheet metal, steel wire, wood and string, 6′ 8½″ long, 57″ wide. Curt Valentin Gallery, New York

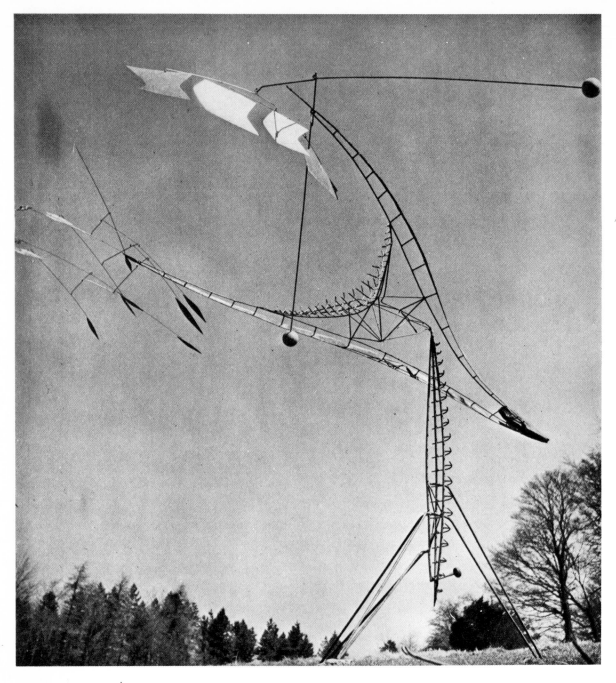

LYNN CHADWICK: *The Fisheater*. Winter, 1950–51. Copper and brass, 8′ high, 16′ in diameter. Collection Arts Council of Great Britain

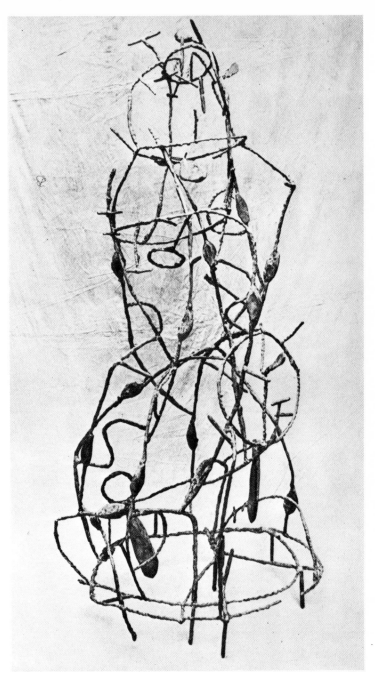

Eduardo Paolozzi: *The Cage*. Winter, 1950–51. Bronze, 6′ high. Collection Arts Council of Great Britain

WILLIAM TURNBULL: *Mobile-Stabile*. 1949. Bronze, base 26 × 18″. Owned by the artist

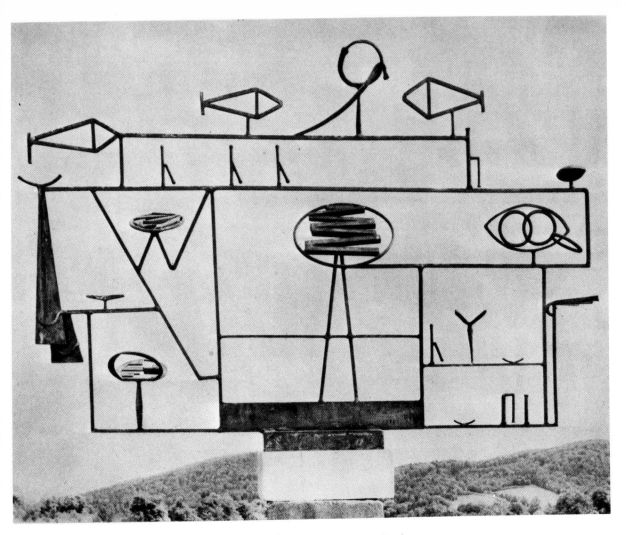

DAVID SMITH: *The Banquet*. 1951. Steel, 53⅛" × 6' 11". The Willard Gallery, New York

219

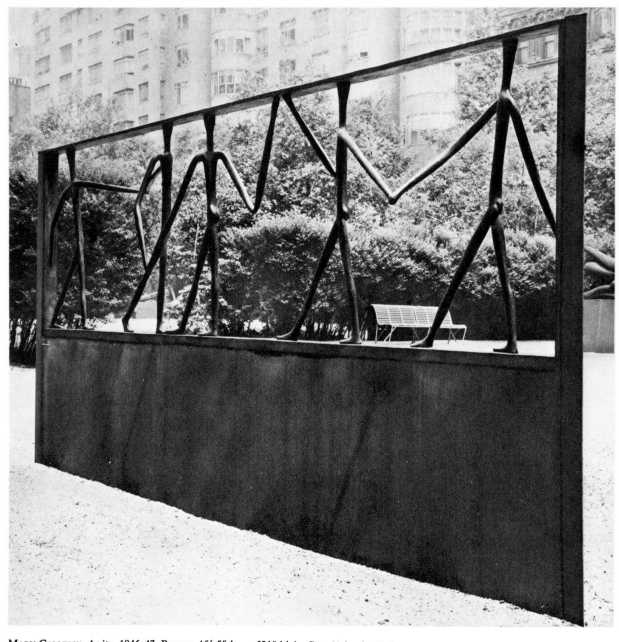

MARY CALLERY: *Amity*. 1946–47. Bronze, 15′ 5″ long, 52½″ high. Curt Valentin Gallery, New York

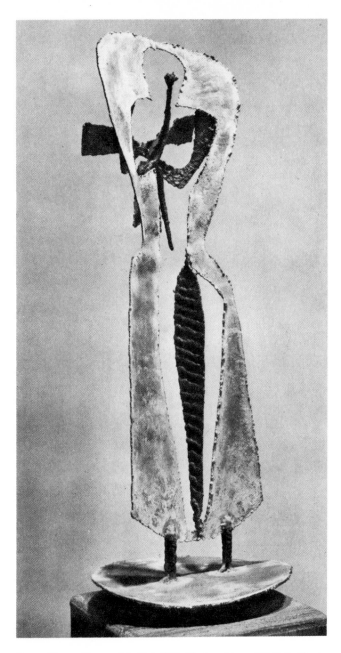

DAVID HARE: *Figure with Bird.* 1951. Steel and iron, 35″ high. Kootz Gallery, New York

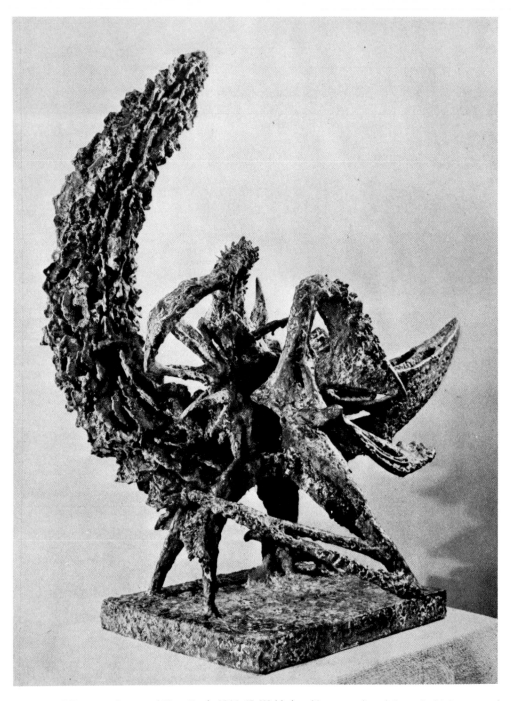

THEODORE J. ROSZAK: *Spectre of Kitty Hawk.* 1946–47. Welded and hammered steel, brazed with bronze and brass, 40¼″ high. The Museum of Modern Art, New York

HERBERT FERBER: "*. . . and the bush was not consumed.*" 1951. Soldered copper, brass, lead and tin, 12′ 8″ × 7′ 10″. Congregation B'nai Israel, Milburn, N.J.

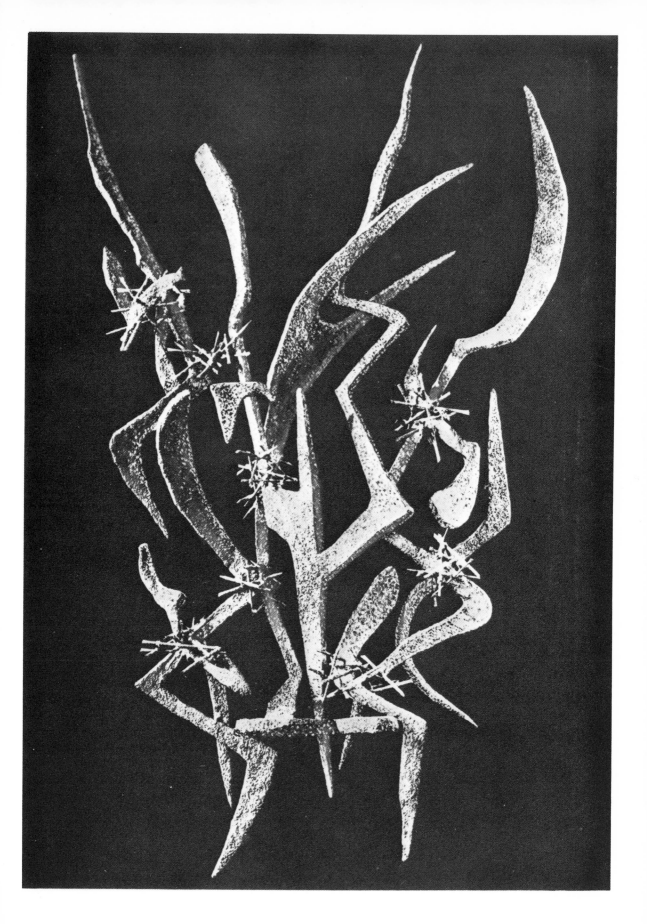

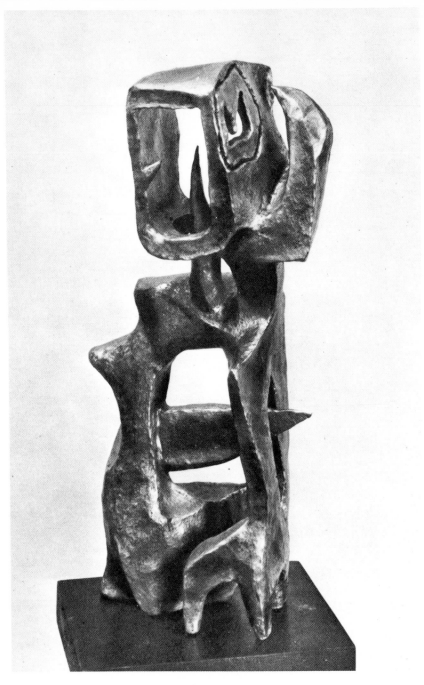

SEYMOUR LIPTON: *Cerberus*. 1947. Lead construction, 23″ high. Betty Parsons Gallery, New York

DAMS, ROBERT. British.

rn Northampton, 1917. Entered Northampton
hool of Art at 16. First one-man show, 1947. Fre-
ent sojourns in Paris; U.S., 1950. Arts Council com-
ission, 1951, for Festival of Britain.

ustrated p. 209.

RCHIPENKO, ALEXANDER. American.

rn Kiev, Russia, 1887. Studied 1902–08, first in
ussia then Paris. Associated with cubists, experimented
th unconventional materials, one of first to explore
ssibilities of concave surfaces and voids in three-
mensional sculpture. Berlin, 1921–23. Settled U.S.,
23. Lives in New York and Woodstock.

ustrated p. 138.

RP, JEAN (HANS). French.

rn Strasbourg, 1888. Studied painting, Weimar, 1907.
et *Blue Rider* group Munich, 1912. One of founders
dada, Zurich, 1916. Began abstract wood reliefs
cuted by jig-saw about 1917. Settled in Meudon,
ance, 1926; participated in surrealist movement;
rked increasingly in sculpture in the round. Second
ly to Brancusi in influence on organic abstract
lpture. Lives in France and Switzerland.

ist's statement p. 40.
ustrated pp. 122, 123, 196.

RLACH, ERNST. German.

rn near Hamburg, 1870. Studied Hamburg and
esden, 1888–1895. Paris, 1895–96: impressed by the
rk of van Gogh. Visited South Russia, 1910. Style
med principally under influence of Russian folk-
vings and Gothic sculpture. Worked mainly in
od. Settled permanently Güstrow, North Prussia,

1910. During 20's executed memorials in Güstrow, Kiel
and Magdeburg. Influential also as graphic artist. Died
1938.

Illustrated pp. 92, 93.

BILL, MAX. Swiss.

Born Winterthur, 1908. Studied Zurich School of Arts
and Crafts and Bauhaus, Dessau. Member of Paris
Abstraction-Création group, 1932–36. Works in strictly
geometrical abstract style. Lives in Zurich.

Illustrated p. 204.

BLUMENTHAL, HERMANN. German.

Born Essen, 1905. Apprenticed four years to sculptor in
stone. Studied Berlin Academy, 1925–31. Worked in
Berlin. Visited Italy, 1931–32 and 1936. Died 1942.

Illustrated p. 97.

BOCCIONI, UMBERTO. Italian.

Born Reggio, Calabria, 1882. Studied with Balla in
Rome and at Academy of the Brera in Milan. Met
Marinetti, 1909. The most gifted of the futurists, he
participated in the movement as painter, sculptor and
theorist. *Technical Manifesto of Futurist Sculpture*,
published in 1912, advocated principally sculpture of
movement, the opening up of forms and their fusion in
space. Died Verona, 1916.

Artist's Statement p. 41.
Illustrated pp. 134, 135, 136.

BOURDELLE, ANTOINE. French.

Born Montauban, 1861. Father cabinetmaker, uncle
stonecutter. Studied Ecole des Beaux-Arts, Toulouse.
To Paris, 1885; studied briefly with Falguière. Entered

P

studio of Rodin where he remained for many years, working as chief assistant. Countered influence of Rodin's impressionism with stylizations drawn from archaic and Gothic art. Influential as a teacher. Died 1929.

Illustrated pp. 56, 57.

BRANCUSI, CONSTANTIN. Rumanian.

Born Craiova, Rumania, 1876. Attended local art school; trained also in cabinetmaking. Studied Bucharest Academy until 1902. Settled permanently Paris, 1904. Studied Ecole des Beaux-Arts under Mercier; left 1906 at advice of Rodin. Early work influenced by Rodin. Pioneer in use of abstract forms; influenced by primitive art, principally in wood carvings. Since about 1910, style perfected and expanded, but virtually unchanged. Has been a pervasive influence on twentieth-century sculpture. Lives in Paris.

Artist's Statement p. 40.
Illustrated pp. 60, 106–114.

BRAQUE, GEORGES. French.

Painter-sculptor. Born Argenteuil, 1882. Worked in fauve style, 1905–07. With Picasso evolved cubism, 1908–14. Cubist paper constructions, c. 1912. Built sculpture studio Paris, 1939. Has devoted considerable time to sculpture since. Lives in Paris and Normandy.

Illustrated p. 146.

BUTLER, REG. British.

Born Hertfordshire, 1913. Trained as an architect, R.I.B.A., 1937. Arts Council commission, 1951, for Festival of Britain.

Illustrated p. 213.

CALDER, ALEXANDER. American.

Born Philadelphia, 1898. Studied engineering, later painting. First sculpture wood carvings, c. 1926–27. Wire portraits and figures, 1928–29. First *mobiles* (moving abstract constructions of wire and sheet metal) 1931. Painting of Mondrian and Miro principal influence. Since 1938 has worked also in stationary sheet-metal constructions. Before World War II divided time between France and U.S. Lives in Roxbury, Conn.

Illustrated pp. 168–171, 214, 215.

CALLERY, MARY. American.

Born New York, 1903. Studied, U.S. and France. Li in Paris, 1930–40. First American exhibition, 19 Lives in New York.

Illustrated p. 220.

CHADWICK, LYNN. British.

Born London, 1914. Trained as an architect. A Council commission, 1951, for Festival of Britain. Li in Chiltenham.

Illustrated p. 216.

DE CREEFT, JOSÉ. American.

Born Guadalajara, Spain, 1884. At 12 apprenticed bronze foundry, Barcelona. To Paris, 1905. Stud Académie Julian, worked as stonecutter. Early in car became exponent of direct handling of materi Settled U.S., 1927. Lives in New York.

Illustrated p. 191.

DEGAS, EDGAR. French.

Painter-sculptor. Born Paris, 1834. Formal training Paris supplemented by long sojourns in Italy, 1854– Met Manet, 1862. Active as painter in impressio group from the beginning. About 1866 began mode small figures in wax as studies for paintings. Exhib costumed wax figure of dancer in impressionist gr exhibition, 1881. Sculpture not publicly exhibited ag continued modeling throughout his life. Died 1917.

Illustrated p. 62.

DESPIAU, CHARLES. French.

Born Mont-de-Massan, 1874. Father and grandfa master stuccoists. Decided on sculpture at 16. To Pa c. 1891; studied Ecole des Arts Décoratifs and Ecole Beaux-Arts. Learned stonecutting from an arti Began exhibiting 1902. From 1907–14 served as exe tant in stone for Rodin, reserving time for own we Personal style, formed in opposition to prevailing t c. 1904, virtually unchanged throughout career. preference a modeler. Lifelong interest in por heads, often uncommissioned. Died Paris, 1946.

Illustrated pp. 64, 65.

UCHAMP-VILLON, RAYMOND. French.

rn Damville, 1876. Brother of Marcel Duchamp and ques Villon. Gave up medical studies for sculpture 1898. Self-taught. Early work influenced by Rodin; bism point of departure for work after 1912. Con-rned also with architecture; designed exhibition house r Salon d'Automne, 1912. Served as army doctor in orld War I. Died Cannes, 1918.

ustrated pp. 136, 137.

STEIN, JACOB. British.

rn New York, 1880. Worked in bronze foundry 1901, idied evenings Art Students League with George Gray rnard. Paris, 1902–06; attended Ecole des Beaux-ts. Settled England *c.* 1906, later becoming British bject. First important commission, 1907; first por-its, 1908. Paris, 1912, knew Brancusi, Modigliani. fluenced by vorticism and African art. Has worked as rver in architectural sculpture and large-scale figure ces, as modeler in portraits. Lives in London.

ustrated pp. 70, 71.

AZZINI, PERICLE. Italian.

rn Grottamara, 1913. Father master woodworker. ained in family trade, began carving in wood. To me at 16, attended free drawing classes at Academy. lf-taught as sculptor. Began exhibiting *c.* 1934. ember of post-war group *Fronte nuovo delle arti.* ves in Rome.

ustrated p. 184.

ERBER, HERBERT. American.

rn New York, 1906. Studied dentistry and oral rgery; art training, Beaux Arts Institute of Design, w York. First sculpture show, 1937. Has since become e of the principal exponents of abstract expressionism sculpture. Works in soldered metal. Executed large-ale architectural construction for synagogue exterior, 51–52. Lives in New York.

ustrated p. 223.

DE FIORI, ERNESTO. German.

Born Rome, 1884. Studied painting Munich Academy, 1903–04. Hodler influence. Paris, 1911: impressed by work of Maillol, turned from painting to sculpture. Became German citizen, 1914; settled Berlin. Moved permanently to Brazil, 1936. Died São Paulo, 1945.

Illustrated p. 96.

FLANNAGAN, JOHN B. American.

Born Fargo, North Dakota, 1895. Studied painting 1914–17, Minneapolis Institute of Arts. Began carving in wood *c.* 1922 with encouragement of Arthur B. Davies. After 1928 worked exclusively as sculptor. Pre-ferred direct carving as method, fieldstone as material. Gave up stonecutting in 1939 for reasons of health; turned to metal, working directly on unfinished bronze casts. Died by suicide, 1942.

Illustrated pp. 120, 121.

GABO, NAUM. American.

Born Briansk, Russia, 1890. Brother of Antoine Pevsner. Entered University of Munich, 1909: studied mathematics, physics, engineering. Norway, 1914–17 with Pevsner: compartmented reliefs influenced by cubism. Moscow, 1917–21: projects for monuments on constructivist principles; issued joint manifesto with Pevsner, 1920. Worked subsequently in Germany, 1922–32; Paris, 1932–37; London, 1937–46. To U.S., 1946. Lives in Woodbury, Conn.

Artist's Statement p. 44.
Illustrated pp. 151–153, 203.

GIACOMETTI, ALBERTO. Swiss.

Born Stampa, Switzerland, 1901. Son of noted Swiss painter, Giovanni Giacometti. Studied sculpture, 1919, Ecole des Arts et Métiers, Geneva. Italy, 1920–22. To Paris, 1922. Worked several years in studio of Bourdelle. After 1926 quasi-abstract constructions with quality of objects. Joined surrealists about 1930. Worked from model 1935–40, beginning of long series of elongated heads and figures. Lives in Paris.

Artist's Statement p. 45.
Illustrated pp. 158–161, 210–212.

GONZALEZ, JULIO. Spanish.

Born Barcelona, 1876. Father and grandfather master goldsmiths. Instructed in metal-working from childhood by father; at 16 won gold medal Barcelona Exposition, 1892. Studied painting, Barcelona School of Fine Arts. Settled in Paris about 1900. Active principally as a painter until 1927. Worked thereafter in fantastic forged-iron constructions, returning from time to time to more realistic style. Instructed Picasso in metal techniques, 1930–32. *La Montserrat* exhibited Spanish Pavilion, Paris Exposition, 1937. Died Arcueil, 1942.

Illustrated pp. 104, 105, 164–167.

HARE, DAVID. American.

Born New York, 1917. Worked first in color photography. First sculpture 1942, with surrealist work of Giacometti as point of departure. France, 1951–52.

Illustrated p. 221.

HARTUNG, KARL. German.

Born Hamburg, 1908. Paris, 1929–32; Florence, 1932–33; Hamburg, 1933–36. Since 1950 professor Hochschule für Bildende Künste, Berlin.

Illustrated p. 201.

HEILIGER, BERNARD. German.

Born Stettin, 1915. Studied 1931–34, Werkschule, Stettin; Berlin Academy, 1935–37. Paris, 1938–39. Has lived in Berlin since 1945. Appointed professor Hochschule für Bildende Künste, Berlin, 1949.

Illustrated p. 199.

HEPWORTH, BARBARA. British.

Born Wakefield, Yorkshire, 1903. Studied 1919–23, Leeds School and Royal College of Art, London. Italy three years, turned from modeling to carving. First exhibition, 1929. Influenced by Moore and Arp. Worked in purely abstract forms from *c.* 1934 to 1947. Lives in St. Ives, Cornwall.

Illustrated p. 197.

KOLBE, GEORG. German.

Born Waldheim, 1877. Studied painting, Dresde Academy and Munich. Visited Paris, 1898. Turned t sculpture in Rome, 1898–1900. Settled Berlin, 190 Became one of the most popular German sculptor executing over fifteen public monuments. Died Novem ber, 1947.

Illustrated p. 94.

LACHAISE, GASTON. American.

Born Paris, 1882. Studied Bernard Palissy craft an technical school, 1895–98 and Ecole des Beaux-Art 1898–1903. Began exhibiting, Paris salon at 16. Settle permanently in U.S., 1906. Until 1920 worked full tim as sculptor's assistant, first in Boston with Kitson, lat New York with Manship. First major work, *Standir Woman*, 1912–27. Portraits of contributors to the *Dic* 1919–25. Figure style of unique vitality and pow summarized in *Floating Woman* (1927) and *Wome* (1932). Architectural sculpture: reliefs for Rockefell Center, 1931 and 1935. First public commission, Fai mount Park Art Association, Philadelphia, 1935. Die October, 1935.

Illustrated pp. 98–102, 118, 119.

LASSAW, IBRAM. American.

Born Alexandria, Egypt, 1913. Studied Clay Club an Beaux Arts Institute of Design, New York. Constructio since mid 30's. Has worked intensively in brazed met: Lives in New York.

Illustrated p. 207.

LAURENS, HENRI. French.

Born Paris, 1885. Apprenticed as sculptor-decorato worked later as ornamental stonecutter. Introduced cubism by Braque, 1911. Worked in cubist style, 191 25: still-life constructions, reliefs and sculpture in t round, experiments in polychromy. After 1925 mo direct contact with natural forms. Lives in Paris.

Artist's Statement p. 43.
Illustrated pp. 143, 145, 182, 183.

228

LEHMBRUCK, WILHELM. German.

Born Duisburg-Meiderich, Germany, 1881. Father a miner. Studied Düsseldorf Academy, 1901–07. Visited Italy, 1905. Paris, 1910–14: first influenced by Maillol. About 1911 began working in the elongated proportions which became characteristic of his style. First retrospective exhibition, Paris, 1914. Berlin, 1914–17. Zurich, 1917–18. Died by suicide, Berlin, 1919.

Artist's Statement, p. 40.
Illustrated pp. 83–91.

LIPCHITZ, JACQUES. French.

Born Druskieniki, Poland, 1891. Father building contractor. Made sculpture from age of 8. To Paris, 1909. Studied Académie Julian; learned stonecutting, modeling and casting in various commercial ateliers. Style changed radically about 1914 under combined influence of African Negro art and cubism. First "transparent" sculpture, 1927. After 1930 cubist iconography replaced by more violent, sometimes mythological themes. Style shows increasing concern with movement and relations of solids and voids. Settled in U.S., 1941. Major architectural commission, façade relief, Ministry of Education, Rio de Janeiro, 1944. Lives in Hastings-on-Hudson.

Artist's Statement, p. 42.
Illustrated pp. 139–142, 162, 178–181.

LIPPOLD, RICHARD. American.

Born Milwaukee, Wisconsin, 1915. Studied industrial design School of Art Institute of Chicago, 1933–37. Worked as industrial designer, 1937–41. Began working as a sculptor, 1942. Wire constructions, geometric in form, evocative in feeling. Lives in New York.

Artist's Statement, p. 46.
Illustrated p. 206.

LIPTON, SEYMOUR. American.

Born New York, 1903. Studied dentistry. First sculpture show, 1938. Since 1944 has worked in abstract-expressionist style, first in solid forms, later in soldered metal constructions. Lives in New York.

Illustrated p. 224.

MAILLOL, ARISTIDE. French.

Born Banyuls, 1861. To Paris; studied painting Ecole des Beaux-Arts with Gérôme and Cabanel. Influenced by Gauguin and Maurice Denis. About 1887 returned to Banyuls to set up tapestry workshop; made wood carvings as pastime. Threatened by blindness, gave up tapestry design *c.* 1899. Turned seriously to sculpture at age of 40. First one-man show, Vollard, 1902. *Mediterranean* exhibited Salon d'Automne, 1905. Visited Greece, 1906. Classical repose and serenity of his figure style broke influence of Rodin's impressionism. Died 1944.

Artist's Statement, p. 39.
Illustrated pp. 72–82.

MALDARELLI, ORONZIO. American.

Born Naples, 1892. To U.S., 1900. Studied Cooper Union, National Academy of Design, Beaux Arts Institute of Design, New York. Europe, 1931–32: forms treated more abstractly. Now works in the tradition of Maillol. Lives in New York.

Illustrated p. 190.

MANZÙ, GIACOMO. Italian.

Born Bergamo, 1908. Youngest in family of 12; father convent sacristan. Apprenticed at 11 to carver and gilder; worked later as assistant to stucco worker. To Verona, 1928, for military service; frequented Academy, soon worked independently. Formative influences Maillol, Donatello, Medardo Rosso. Mature style dates from 1934. Crucifixion reliefs, 1939–43, criticized by both Fascists and Church. Now completing Stations of the Cross for Sant' Eugenio, Rome. Lives in Milan.

Illustrated pp. 188, 189.

MARCKS, GERHARD. German.

Born Berlin, 1889. From 1907 worked in studio of Richard Scheibe. Director of ceramics, Bauhaus, Weimar, 1920–25. Traveled Greece, Italy, France. Settled in Mecklenburg, 1933. After World War II taught Hamburg (1946-50); important commissions Lubeck, Cologne, Hamburg. Lives in Cologne.

Illustrated p. 95.

MARINI, MARINO. Italian.

Born Pistoia, 1901. Studied Florence Academy under naturalist Trentacosta. Worked as painter and draftsman until 1928. Paris, 1928–29. Has traveled in Greece and many European countries, though not appreciably influenced by contemporary sculpture outside Italy. Won recognition in 30's for portraits and figures of wrestlers and acrobats. Worked in Switzerland, 1942–46. Primarily a modeler. Lives in Milan.

Illustrated pp. 184–187.

MARTINI, ARTURO. Italian.

Born Treviso, 1889. Apprenticed in ceramic workshop; later studied sculpture in Treviso and Munich under Hildebrand. Visited Paris, 1911 and 1914. Uninfluenced by cubism or other group movements. Works reproduced *Valori Plastici*, 1921. Subsequent work marked by restless changes of style. Influential as teacher, Venice Academy. Repudiated sculpture for painting at end of life; his rationale, *La Scultura Lingua Morta*, published posthumously. Died 1947.

Artist's Statement, p. 39.
Illustrated pp. 68, 69.

MATISSE, HENRI. French.

Painter-sculptor. Born Le Cateau, 1869. As leader of the fauves became decisive figure in French painting, *c.* 1905. First sculpture, 1899, under influence of Barye and Rodin. Studied briefly with Bourdelle, 1900. Exhibited 13 bronzes and terra cottas, Salon d'Automne, 1908. Has turned to sculpture frequently during subsequent career, working always as modeler. Lives in Nice.

Illustrated pp. 58, 59, 117, 132, 133.

MEADOWS, BERNARD. British.

Born Norwich, 1915. Studied Norwich School of Art, 1934–36; Royal College of Art, London, 1938–40, 1946–48. From 1936 until recently, studio assistant to Henry Moore. Arts Council commission, 1951, for Festival of Britain.

Illustrated p. 197.

MODIGLIANI, AMEDEO. Italian.

Painter-sculptor. Born Leghorn, Italy, 1884. Studie painting, Italy. Settled Paris, 1906. From about 1909–1 worked almost exclusively at sculpture, first wit instruction from Brancusi. Influenced also by Africa Negro carvings. Died 1920.

Illustrated pp. 115, 116.

MOORE, HENRY. British.

Born Yorkshire, England, 1898. Father, coal mine Trained first as school teacher. Studied Leeds Schoo 1919–21; Royal College of Art, London, 1921–2 Visited France and Italy, 1925. Writings of Roger Fr and African and pre-Columbian sculpture initi influences. First one-man show and first public com mission, 1928. Work increasingly abstract during 30's figure style built on fluid transitions from solids t voids. During World War II, war artist: undergroun shelter drawings. Post-war commissions; Church c St. Matthew, Northampton; Darlington Hall Memoria Arts Council for Festival of Britain. Lives in Her fordshire.

Artist's Statement, p. 41.
Illustrated pp. 124–129, 192–195.

NICHOLSON, BEN. British.

Born Denham, 1894. Parents both painters. Studie briefly Slade School of Art. Worked first as painte Paris, 1932–34. Since 1932, abstract relief sculptur Member of *Abstraction-Création* group, Paris, 1933–3 Co-editor with J. L. Martin and Naum Gabo of *Circl* 1937. Lives in St. Ives, Cornwall.

Illustrated p. 155.

NOGUCHI, ISAMU. American.

Born Los Angeles, 1904. Childhood, Japan. Abandone pre-medical studies for sculpture, New York, 1924 Worked as assistant to Brancusi, Paris, 1927–29. T U.S., 1929; exhibited abstract metal constructions China and Japan, 1929–31; studied terra-cotta tech niques. Large-scale architectural sculpture: colore

ement relief, Rodriguez Market, Mexico City, 1936; luminum relief, Rockefeller Center, 1938. During 40's, eries of large interlocking constructions, principally in tone. Traveled Mediterranean and Far East, 1949–50. Tow lives in Japan.

Illustrated p. 200.

AOLOZZI, EDUARDO. British.

orn Edinburgh, 1924. Studied Edinburgh College of rt and Slade School, London. Arts Council com- ission, 1951, for Festival of Britain.

Illustrated p. 217.

EVSNER, ANTOINE. French.

orn Orel, Russia, 1886. Brother of Naum Gabo. tudied Kiev, later St. Petersburg. Paris, 1911 and 913–14; influenced by cubism. Norway, 1914–17. Ioscow, 1917–22: active in Russian constructivist 1ovement; issued joint manifesto with Gabo, 1920. ettled Paris, 1923. Worked principally in transparent nd opaque plastics, turning to metal during 30's. Lives 1 Paris.

rtist's Statement, p. 44.
Iustrated pp. 148–150, 202.

ICASSO, PABLO. Spanish.

ainter-sculptor. Born Málaga, Spain, 1881. Carved, odeled and constructed sculpture occasionally during rly career: 1899–1905, modeled heads and figures; Negro" period, 1907, wood carvings; cubism, 1912–14, ibist still-life constructions. Turned again to sculpture,)29–34, working in many directions, notably metal mstructions with technical instruction from Gonzalez. et up sculpture studio at Boisgèloup, 1933; began orking in larger scale. Since 1941 has again devoted mnsiderable time to sculpture. Lives in Vallauris, rance.

Iustrated pp. 61, 130, 131, 144, 156, 157, 163, 172–177.

ENOIR, AUGUSTE. French.

ainter-sculptor. Born Limoges, 1840. Apprenticed to *orcelain painter, later studied painting Ecole des Beaux-

Arts. Active in organization of impressionist group, 1874. First sculpture, *c.* 1907, during visit of Maillol. Later more ambitious work executed by sculptor- assistant, *c.* 1915–16. Experiments in own kiln with colored terra cotta. Sculpture not exhibited until after painter's death. Died, 1919.

Illustrated p. 63.

DE RIVERA, JOSÉ. American.

Born New Orleans, 1904. Self-taught as sculptor. Began working in abstract style, *c.* 1940. First sculpture exhibition, 1947. Lives in New York.

Illustrated p. 205.

RODIN, AUGUSTE. French.

Born Paris, 1840. Began studying at age of 14, first at La Petite Ecole, later under Barye. Refused admittance three times to Ecole des Beaux-Arts. Worked over ten years in decorator's atelier executing architectural ornament; then as sculptor's assistant. Brussels, 1871– 76: architectural sculpture, first recognition. Visited Italy to study Michelangelo, Germany to see Gothic cathedrals. Still unknown in France, returned to Paris, exhibited *Age of Bronze* in Salon of 1877. Accused of casting figure from model; three years of litigation to disprove charges. Second major work, *St. John the Baptist*, begun 1877. Competed unsuccessfully for monument to war of 1870 with *The Defense*. First public commission, 1880, portal for Musée des Arts Décoratifs (*Gate of Hell*). Reputation established within following decade. Principal monuments: *The Burghers of Calais*, 1884–86; *Balzac Monument*, 1892–96. Joint exhibition with Monet, 1889. Retrospective exhibition, Paris Exposition, 1900. Died Meudon, 1917.

Artist's Statement, p. 38.
Illustrated pp. 49–55.

ROSSO, MEDARDO. Italian.

Born Turin, 1858. Worked briefly as painter until 1880. Entered Brera Academy, Milan, 1881; dismissed, 1883. Paris, 1884–85: worked in atelier of Dalou, met Rodin; first impressionist sculpture. Returned Paris, 1889,

231

where he spent most of active career. Principal exponent of impressionism in sculpture: themes drawn from everyday life, summary modeling suggests fleeting impressions, particular light and atmosphere. Said to have influenced Rodin in *Balzac, c.* 1893. Works not extensively exhibited in Italy until 1910. Greatly admired by the futurists; has influenced such younger Italian sculptors as Manzù. Died Milan, 1928.

Illustrated pp. 66, 67.

ROSZAK, THEODORE J. American.

Born Posen, Poland, 1907. Studied Columbia University, and National Academy of Design, Art Institute of Chicago. Europe, 1929–31. Worked first as painter. Abstract constructions, *c.* 1935–45, severely geometric in form, impersonal in finish. Marked change of style after 1945: molten forms in welded and brazed metal, violent or cataclysmic in theme. Lives in New York.

Artist's Statement, p. 46.
Illustrated p. 222.

SMITH, DAVID. American.

Born Decatur, Indiana, 1906. Attended Ohio, Notre Dame and George Washington Universities; worked one year Studebaker Factory, South Bend, Indiana. Studied painting Art Students League, work oriented by cubism, Mondrian and Kandinsky. Example of Gonzalez suggested use of iron and forge for sculpture. First steel sculpture, 1933, set up workshop in Terminal Iron Works, Brooklyn. Since 1941 has lived in Bolton Landing, New York.

Illustrated p. 219.

TURNBULL, WILLIAM. British.

Born 1922. Studied Slade School, London. Paris, 1948–50. First sculpture exhibition, 1950. Lives in London.

Illustrated p. 218.

UHLMANN, HANS. German.

Born Berlin, 1900. Trained as engineer. Turned sculpture, 1925. France, 1929. Since 1950, profess Berlin Academy. Lives in Berlin.

Illustrated p. 208.

VANTONGERLOO, GEORGES. Belgian.

Born Antwerp, 1886. Studied Brussels and Antwe Academies (architecture and sculpture). Participate 1917–22 in Dutch de Stijl movement as sculptor ar theorist. Abstract constructions of interlocking pri matic forms, sometimes titled with mathematic equations. Later settled in Paris, active in *Abstractio Création* group. Lives in Paris.

Illustrated p. 154.

VIANI, ALBERTO. Italian.

Born Quistello, 1906. Studied Venice Academ assistant in sculpture to Arturo Martini, 1944–4 Member of post-war *Fronte Nuovo delle Arti.* No works in the tradition of Arp. Lives in Venice.

Illustrated p. 198.

ZADKINE, OSSIP. French.

Born Smolensk, Russia, 1890. Formal training beg London Polytechnic School at 17. Settled permanent Paris, 1909; studied Ecole des Beaux-Arts. Began dire carving in stone and wood, 1911. Early work influenc by Brancusi, later by cubism. New York, 1941–4 Lives in Paris.

Illustrated p. 147.

ZORACH, WILLIAM. American.

Born Eurburg, Lithuania, 1887. Family settled Clev land, 1891. Studied painting Cleveland School of D sign; National Academy of Design, N.Y., 1908–1 Paris, 1910–12. Turned seriously to sculpture, *c.* 192 An advocate of direct carving. Lives in New York.

Illustrated p. 103.

Owing to the number of sculptors in this work, and for reasons of space, the listing below has been limited largely to books. Wherever possible, titles in the museum library quoted by the author, or those containing bibliographies have been preferred. On the assumption that the *Art Index* (N.Y.) and similar indices will guide the serious reader to accessible material, magazine articles and exhibition items have been noted only when no equally acceptable reference was known. In these instances, unindexed periodicals have been favored.

<div align="center">

BERNARD KARPEL

Librarian, Museum of Modern Art

</div>

GENERAL WORKS

Critical Books

1 BARR, ALFRED H., JR. Cubism and abstract art. 249 p. ill. N.Y., Museum of modern art, 1936. *Bibliography.*

2 CIRCLE. International survey of constructive art; editors: J. L. Martin, B. Nicholson, N. Gabo. p. 77–123 ill. London, Faber & Faber, 1937.

3 GIEDION-WELCKER, CAROLA. Modern plastic art. 161 p. ill. Zurich, Girsberger, 1937. (New edition, N.Y., Wittenborn, Schultz, 1953.) *Bibliography.*

4 NEW YORK. MUSEUM OF MODERN ART. [Symposium: The new sculpture] n.p. 1952. Unpublished typescript record of a discussion by H. Ferber, R. Lippold, I. Noguchi, T. Roszak, D. Smith. Moderator: A. C. Ritchie.

5 READ, HERBERT. Art now, an introduction to the theory of modern painting and sculpture. 144 p. ill. London, Faber and Faber, 1948.

6 RITCHIE, ANDREW C. Abstract painting and sculpture in America. 159 p. ill. N.Y., Museum of modern art, 1951. *Bibliography.*

7 SEYMOUR, CHARLES, JR. Tradition and experiment in modern sculpture. 86 p. ill. Washington, D.C., American university press, 1949.

Historical and National Studies

8 BARR, ALFRED H., JR. German painting and sculpture. 43 p. ill. N.Y., Museum of modern art, 1931. *Includes Barlach, de Fiori, Kolbe, Marcks.*

9 BERN, KUNSTHALLE. Sculpteurs contemporains de l'école de Paris, 14 février–29 mars. 18 p. ill. 1948. *Bibliographies. Includes Arp, Giacometti, Gonzalez, Lipchitz, Zadkine.*

10 CARRIERI, RAFFAELE. Pittura, scultura d'avanguardia (1890–1950) in Italia. 345 p. ill. Milano, Conchiglia, 1950. *Bibliography.*

11 GISCHIA, LEON & VÉDRÈS, NICOLE. La sculpture en France depuis Rodin. 182 p. ill. Paris, du Seuil, 1945.

12 KUHN, ALFRED. Die neuere Plastik. 2. Aufl. 128 p. ill. München, Delphin, 1922.

13 RAMSDEN, E. H. Twentieth-century sculpture. 42 p. ill. London, Pleiades, 1949.

14 ROTHSCHILD, LINCOLN. Sculpture through the ages. p. 208–50 ill N.Y., McGraw-Hill, 1942.

15 SCHNIER, JACQUES. Sculpture in modern America. 224 p. ill. Berkeley & Los Angeles, University of California, 1948.

16 SOBY, JAMES T. & BARR, ALFRED H., JR. Twentieth-century Italian art. 144 p. ill. N.Y. Museum of modern art, 1949. *Bibliography.*

17 VALENTINER, WILHELM R. Origins of modern sculpture. 180 p. ill. N.Y., Wittenborn, Schultz, 1946.

Biographical Surveys

18 BASLER, ADOLPHE. La sculpture moderne en France. 169 p. ill. Paris, Crès, 1928.

19 CASSON, STANLEY. Some modern sculptors. 119 p. ill. London, Oxford, 1928. *Includes Rodin, Bourdelle, Despiau, Epstein.*

20 CASSON, STANLEY. XXth century sculptors. 130 p. ill. London, Oxford, 1930. *Includes Kolbe, Archipenko, Zadkine.*

21 FIERENS, PAUL. Sculpteurs d'aujourd'hui. 22 p. ill. Paris, Chroniques du jour; London, Zwemmer, 1933. *Includes Epstein, Moore, Flannagan, Lachaise, Brancusi, Despiau, Laurens, Lipchitz, Maillol, Zadkine, Martini.*

22 HENTZEN, ALFRED. Deutsche Bildhauer der Gegenwart. 126 p. ill. Berlin, Rembrandt, 1934. *Biographical notes.*

23 JAKOVSKI, ANATOLE. Six essais. 37 p. ill. Paris, Povolozky [1933?] *Includes Arp, Calder, Pevsner.*

24 MILLER, DOROTHY C., ed. Fourteen Americans. 80 p. ill. N.Y., Museum of modern art, 1946. *Includes Hare, Noguchi, Roszak.*

25 READ, HERBERT. Unit 1: the modern movement in English architecture, painting and sculpture. 124 p. ill. London, Cassell, 1934. *Includes Hepworth, Moore, Nicholson.*

Pictorial Collections

26 BRUMMÉ, C. LUDWIG. Contemporary American sculpture. Foreword by William Zorach. 156 p. ill. N.Y., Crown, 1948. *Bibliography.*

27 COURTFR, ELODIE. Modern sculpture. 8 p. 40 plates. N.Y., Museum of modern art, 1948. (Teaching portfolio, no. 1.)

28 EINSTEIN, CARL. Die Kunst der 20. Jahrhunderts. 2. Aufl. 576 p. ill. Berlin, Propyläen, 1928. *Includes Maillol, de Fiori, Lehmbruck, Brancusi, Barlach, Archipenko, Lipchitz, Laurens.*

Technical Works

29 MOHOLY-NAGY, LÁSZLÓ. The new vision. p. 41–55. ill. N.Y., Wittenborn, 1946. *Other editions*: 1928, 1930.

30 RICH, JACK C. The materials and methods of sculpture. 416 p. ill. N.Y., Oxford, 1947. *Bibliography.*

31 STRUPPECK, JULES. The creation of sculpture. 260 p. ill. N.Y., Holt, 1952. *Bibliography.*

Periodicals (Special Illustrated Numbers)

32 ART D'AUJOURD'HUI. no. 3 Jan. 1951. *"Cinquante années de sculpture."*

33 AXIS. no. 3 July 1935. *Contemporary sculpture: Brancusi, Moore, Hepworth, Calder.*

34 DOCUMENTS. L'art allemand contemporain; numéro spécial. Offenbourg en Bade, 1951. *"La sculpture," par Alfred Hentzen.*

35 LE POINT. no. 12 Dec. 1937. *"La sculpture."*

36 TIGER'S EYE. no. 4 June 1948. *"The ides of art: 14 sculptors write"*: Arp, Calder, Callery, Ferber, Giacometti, Grippe, Hare, Lippold, Lipchitz, Lipton, Noguchi, Phillips, Smith, Zadkine.

37 TWENTIETH CENTURY. v. 2, no. 1 1939. *"Sculpture," also in French edition (XXᵉ Siècle). Additional articles: nos. 1–5/6.*

INDIVIDUAL ARTISTS

ARCHIPENKO

38 HILDEBRANDT, HANS. Alexandre Archipenko, son oeuvre. 65 p. ill. Berlin, Ukrainske Slowo, 1923.

39 Alexander Archipenko—sculptor. *Index of Twentieth-Century Artists* 3 no. 6: 249–52 Mar. 1934. *Bibliography.*

ARP

40 ARP, HANS. On my way. 147 p. ill. N.Y., Wittenborn, Schultz, 1948. *Bibliography.*

41 The Dada Painters and Poets, ed. by Robert Motherwell. 388 p. ill. N.Y., Wittenborn, Schultz, 1951. *Bibliography.*

BARLACH

42 CARLS, CARL D. Ernst Barlach, das plastische, graphische und dichterische Werk. 78 p. ill. Berlin, Rembrandt, 1931.

BILL

43 BILL, MAX. The mastery of space. ill. *XXᵉ Siècle* 2 no. 1: [5–14] 1939.

44 SCHMIDT, G. Max Bill. ill. *XXᵉ Siècle* (n.s.) no. 1: 73–74 1951.

BLUMENTHAL

45 ISERMEYER, CHRISTIAN-ADOLF. Der Bildhauer Hermann Blumenthal. 14 p. ill. Berlin, Mann. 1947.

BOCCIONI

46 BOCCIONI, UMBERTO. Pittura, scultura futuriste; dinamismo plastico. 469 p. ill. Milan, Poesia, 1914.

47 BOCCIONI, UMBERTO. Manifeste technique de la sculpture futuriste, 11 avril 1912. ill. Cahiers d'Art 25: 50–61 1950. *Also published in bibl. 46.*

BOURDELLE

48 BOURDELLE, EMILE A. L'oeuvre d'Antoine Bourdelle. 6 pts. in-folio. ill. Paris, Librairie de France, n.d. *Bibliography in catalog: A. Bourdelle–G. Giacometti, 14 juin–20 juli. Basel, Kunsthalle, 1952.*

BRANCUSI

49 BRANCUSI, CONSTANTIN. Aphorisms; réponses. ill. *This Quarter* no. 1: 235–36 1925.

49a BRUMMER GALLERY, New York. Brancusi exhibition. 44 p. ill. 1926. *Preface by P. Morand; statements and extracts.*

50 GIEDION-WELCKER, CAROLA. Constantin Brancusi. ill. *Horizon* 19 no. 11: 193–202 Mar. 1949.

BRAQUE

51 FUMET, STANISLAS. Sculptures de Braque. 14 p. ill. Paris, Damase, 1951.

52 HOPE, HENRY R. Georges Braque. 170 p. ill. N.Y., Museum of modern art, 1949. *Bibliography.*

CALDER

53 SWEENEY, JAMES J. Alexander Calder. 2. rev. ed. 80 p. ill. N.Y., Museum of modern art, 1951. *Bibliography.*

DE CREEFT

54 CAMPOS, JULES. José de Creeft. 32 p. ill. N.Y., Herrmann, 1945.

DEGAS

55 REWALD, JOHN, ed. Degas: works in sculpture, a complete catalogue. 144 p. ill. N.Y., Pantheon, 1944. *Bibliography.*

DESPIAU

56 DESHAIRS, LÉON. C. Despiau. [92] p. 80. ill. Paris, Crès, 1930. *List of works, 1898–1929.*

DUCHAMP-VILLON

57 PACH, WALTER. Raymond Duchamp-Villon, sculpteur (1876–1918). 85 p. ill. Paris, Povolozky, 1924.

EPSTEIN

58 BLACK, ROBERT. The art of Jacob Epstein. 251 p. ill. Cleveland, N.Y., World, 1942.

DE FIORI

59 BARDI, P. M. Ernesto de Fiori. 23 p. ill. Milano, Hoepli, 1950. *Bibliography:*

FLANNAGAN

60 MILLER, DOROTHY C., ed. The sculpture of John B. Flannagan. 40 p. ill. N.Y., Museum of modern art, 1942.

GABO

61 GABO, NAUM & PEVSNER, ANTON. Extraits d'une lettre. ill. *Réalites Nouvelles* no. 1: 63–64 1947.

62 OLSEN, RUTH & CHANIN, ABRAHAM. Naum Gabo, Antoine Pevsner. Introduction by Herbert Read. 83 p. ill. N.Y., Museum of modern art, 1948. *Bibliography.*

GIACOMETTI

63 MATISSE, PIERRE, GALLERY. Alberto Giacometti, exhibition of sculptures, paintings, drawings. Introduction by J.-P. Sartre and a letter from Alberto Giacometti, Jan. 19 to Feb. 14. 47 p. ill. N.Y., 1948.

64 PONGE, FRANCIS. Réflexions sur les statuettes, figures & peintures d'Alberto Giacometti. ill. *Cahiers d'Art* 26: 74–90 1951.

GONZALEZ

65 BRUGIÈRE, P.-G. Julio Gonzalez, les étapes de l'oeuvre. ill. *Cahiers d'Art* 27 no. 1: 19–31 July 1952.

65a DEGAND, LÉON. Julio Gonzalez, 1876–1942. ill. *Art d'Aujourd'hui* no. 6 : [16–20] Jan. 1950.

HARE

66 SARTRE, JEAN-PAUL. N-dimensional sculpture [by David Hare] *in* Kootz, Samuel M., Gallery. Women, a collaboration of artists and writers. p. [33–5] ill. N.Y., Kootz editions, 1948.

HARTUNG

67 BERLIN. HAUS AM WALDSEE. Karl Hartung, Ausstellung. 22 p. ill. Berlin, 1952. *Exhibit catalog, Sept. 2—Oct. 12; preface by K. L. Skutsch.*

HEILIGER

68 SKUTSCH, K. L. Bernhard Heiliger. ill. *Zeitschrift für Kunst* 4 nr. 2: 149–60 1950.

HEPWORTH

69 BROWSE, LILLIAN, ed. Barbara Hepworth, sculptress. 65 p. ill. London, Shenval press (by Faber & Faber), 1946. *Bibliography.*

KOLBE

70 BINDING, RUDOLPH G. Vom Leben der Plastik: Inhalt und Schönheit des Werkes von Georg Kolbe. 108 p. ill. Berlin, Rembrandt, 1933. *Supplemented by later Rembrandt edition: W. Pinder. George Kolbe, Werke der letzen Jahre. 84 p. ill. 1937.*

LACHAISE

71 KIRSTEIN, LINCOLN. Gaston Lachaise, retrospective exhibition. 29 p. ill. N.Y., Museum of modern art, 1935. *Bibliography.*

LAURENS

72 LE POINT (periodical). Henri Laurens. 48 p. ill. Lanzac, 1946. *Special no. 33, July 1946.*

73 VALENTIN, CURT, GALLERY. Henri Laurens, May 12–June 7. 16 p. ill. N.Y., 1952. *Includes statement by Laurens (XXᵉ Siècle, no. 2, Jan. 1952).*

LEHMBRUCK

74 HOFF, AUGUST. Wilhelm Lehmbruck. 120 p. ill. Berlin, Rembrandt, 1936.

75 MANNHEIM. STÄDTISCHE KUNSTHALLE. Wilhelm Lehmbruck. 34 p. ill. 1949. *Text by W. Passarge, J. Meier-Graefe. Also exhibited Düsseldorf. Bibliography.*

LIPCHITZ

76 PORTLAND ART MUSEUM. Jacques Lipchitz, an exhibition of his sculpture and drawings, 1914–1950. 32 p. ill. Portland, Oregon, 1950. *Bibliography. Quotes from J. J. Sweeney interview (Partisan Review no. 1, 1945).*

77 RAYNAL, MAURICE. Jacques Lipchitz. 17 p. ill. Paris, Bucher, 1947.

LIPPOLD

78 LIPPOLD, RICHARD. Variation number seven: Full moon. ill. *Arts & Architecture* 67: 22–23, 50 May 1950. *Additional commentary,* 64: 22–23 Aug. 1947.

LIPTON

79 LIPTON, SEYMOUR. Experience and sculptural form. *College Art Journal* 9 no. 1: 52–54 1949.

MAILLOL

80 RITCHIE, ANDREW C., ed. Aristide Maillol. 128 p. ill. Buffalo, Albright art gallery, 1945. *Bibliography.*

81 REWALD, JOHN. Maillol. 167 p. ill. London, Paris, N.Y., Hyperion, 1939. *Bibliography.*

MANZÙ

82 PACCHIONI, ANNA. Giacomo Manzù. 41 p. ill. Milano, Ed. del Milione, 1948. *Bibliography.*

MARCKS

83 KESTNER-GESELLSCHAFT, HANNOVER. Gerhard Marcks Ausstellung. 14 p. ill. 1949. *Preface by A. Hentzen. Autobiographical notes in Curt Valentin exhibition catalog, Oct. 16–Nov. 10 1951 (N.Y.).*

84 LINFERT, CARL. Gerhard Marcks, Grenzmale der Plastik. *Die Neue Rundschau* [35] p. June 1935. "*Sonderdruck aus der Monatsschrift, p. 616–50.*"

MARINI

85 CARRIERI, RAFFAELE. Marino Marini, scultore. 36 p. ill. Milano, Ed. del Milione, 1938. *Bibliography.*

MARTINI

86 BONTEMPELLI, MASSIMO. Arturo Martini. 32 p. ill. Milano, Hoepli, 1948. *Bibliography.*

87 MARTINI, ARTURO. La scultura, lingua morta: pensieri. 50 p. Verona, 1948.

MATISSE

88 BARR, ALFRED H., JR. Matisse: his art and his public. 591 p. ill. N.Y., Museum of modern art, 1951. *Bibliography.*

MODIGLIANI

89 SOBY, JAMES T. Modigliani: paintings, drawings, sculpture. 55 p. ill. N.Y., Museum of modern art, 1951. *Bibliography.*

MOORE

90 MOORE, HENRY. The sculptor speaks. ill. *The Listener* 18 no. 449: 338–40 Aug. 18, 1937. *Frequently reprinted.*

91 READ, HERBERT. Henry Moore, sculpture and drawings. 229 p. ill. N.Y., Valentin, 1944. *Bibliography.*

92 SWEENEY, JAMES J. Henry Moore. 95 p. ill. N.Y., Museum of modern art, 1946. *Bibliography.*

NICHOLSON

93 READ, HERBERT. Ben Nicholson: paintings, reliefs, drawings. 32 p. ill. London, Humphries, 1948. *Bibliography.*

NOGUCHI

94 Isamu Noguchi defines the enormous potential importance of sculpture—"the art of spaces." ill. *Interiors.* 108 no. 8: 118–23 Mar. 1949.

95 Isamu Noguchi—sculptor. *Index of Twentieth-Century Artists.* 2 no. 11: 167–68 Aug. 1935. *Bibliography.*

PAOLOZZI

96 MELVILLE, ROBERT. Eduardo Paolozzi. ill. *Horizon* 16 no. 92: 212–13 Sept. 1947.

PEVSNER

97 MASSAT, RENÉ. Antoine Pevsner. ill. *Cahiers d'Art* 25 pt. 2: 349–64 1950.

236

98 OLSEN, RUTH & CHANIN, ABRAHAM. Naum Gabo, Antoine Pevsner. 83 p. ill. N.Y., Museum of modern art, 1946. *Bibliography*.

PICASSO

99 BARR, ALFRED H., JR. Picasso: fifty years of his art. 314 p. ill. N.Y., Museum of modern art, 1946. *Bibliography*.

100 KAHNWEILER. DANIEL HENRY. Les sculptures de Picasso. 13 p. 216 plates. Paris, du Chêne, 1948. *Also English edition: London, Phillips, 1949*.

101 LIEBERMAN, WILLIAM S. The sculptor's studio: etchings by Picasso. 4 p. 25 plates. N.Y., Museum of modern art 1952.

RENOIR

102 HAESAERTS, PAUL. Renoir, sculptor. 43 p. ill. N.Y., Reynal & Hitchcock, 1947.

RODIN

103 CLADEL, JUDITH. Auguste Rodin, l'oeuvre et l'homme. 164 p. ill. Bruxelles, Van Oest, 1908.

104 MAUCLAIR, CAMILLE. Auguste Rodin, the man—his ideas—his works. 147 p. ill. London, Duckworth, 1909. *Bibliography*.

105 STOREY, SOMERVILLE. Auguste Rodin. N.Y. & London, Oxford, Phaidon, 1939. *Revised edition, 1951*.

ROSSO

106 PAPINI, GIOVANNI. Medardo Rosso. 41 p. ill. Milano, Hoepli, 1945. *Bibliography*.

SMITH

107 SMITH, DAVID. The language is image. ill. *Arts & Architecture*, 69 no. 2: 20–21, 33–34 Feb. 1952.

108 WILLARD, MARIAN, GALLERY. David Smith. 8 p. ill. [N.Y., 1946]. *Pamphlet prepared for American Association of University Women*.

VANTONGERLOO

109 VANTONGERLOO, GEORGES. Georges Vantongerloo: paintings, sculptures, reflections. 48 p. ill. N.Y., Wittenborn, Schultz, 1948.

VIANI

110 VIANI, ALBERTO. Sculture di Alberto Viani: testamonianze. . . . 29 p. ill. Milano, Spiga, 1946.

ZADKINE

111 RIDDER, ANDRÉ DE. Zadkine. 28 p. ill. Paris, Chroniques du jour, 1929.

ZORACH

112 WINGERT, PAUL S. The sculpture of William Zorach. 74 p. ill. N.Y., Pitman, 1938. *Bibliography*.

PHOTOGRAPH CREDITS

This book has been produced in December, 1952, for the Trustees of the Museum of Modern Art, New York by Thames & Hudson, Ltd., London.

SCULPTURE OF THE TWENTIETH CENTURY

PHILADELPHIA MUSEUM OF ART
FAIRMOUNT PARK ART ASSOCIATION
OCTOBER 11-DECEMBER 7, 1952

THE ART INSTITUTE OF CHICAGO
JANUARY 22-MARCH 8, 1953

THE MUSEUM OF MODERN ART
APRIL 29-SEPTEMBER 7, 1953

PUBLISHED BY THE MUSEUM OF MODERN ART NEW YORK

ACKNOWLEDGMENTS

On behalf of the Trustees of the Museum of Modern Art, New York, the Philadelphia Museum of Art, the Fairmount Park Art Association and The Art Institute of Chicago, I wish to convey my deepest gratitude to: Miss Margaret Miller for the preparation of the biographical notes in the catalogue and for her assistance in many other ways; Miss Alice Bacon, Miss Alicia Legg and Miss Jane Sabersky for research work in connection with the exhibition; my colleagues Alfred H. Barr, Jr., René d'Harnoncourt, Miss Dorothy C. Miller and Monroe Wheeler for their advice and assistance; the European and American collectors and museums, herein listed, who have graciously lent sculpture to the exhibition; and to the following for special assistance and counsel: Mr. R. Sturgis Ingersoll, Mr. Fiske Kimball, Mr. Henri Marceau, Mr. Daniel Catton Rich, Mr. and Mrs. Laurence P. Roberts, Mr. W. J. H. B. Sandberg, Mme. Roberta Gonzalez-Hartung, Mr. George Heard Hamilton, Mr. Philip James, Mr. Daniel Henry Kahnweiler, Dr. Alfred Hentzen, Mme. Gaston Lachaise, Mr. Marcel Duchamp, Mr. Pierre Matisse, and, for his extraordinary help in securing photographs and information, Mr. Curt Valentin.

ANDREW CARNDUFF RITCHIE
Director of the Exhibition

INTRODUCTION

One important feature of twentieth-century sculpture is the rôle the painter has played in it. Since the renaissance the painter has held a dominant position in the visual arts, for reasons too complex to examine here. This dominance was so great, in fact, between the seventeenth and nineteenth centuries, that sculpture, with few exceptions, was relegated to a very subsidiary position indeed and was all too often reduced to the making of dull portrait busts and insipid garden statuary. The revival of sculpture in the twentieth century has been largely the result of a healthy inter-action between it and painting. Sculptors have looked at painting and have been deeply influenced by every modern painting movement. Painters have looked at sculpture, and many have produced important sculpture themselves.

While these two arts have drawn closer together, modern architecture, Corbusier and the Bauhaus notwithstanding, has for the most part taken a reticent, even stand-offish, position towards them. Whether for aesthetic or economic reasons this unfortunate isolation of one major art from the others is to be deplored. It is to be hoped that before long a union can again be established.

Many modern painters in search of inspiration outside the traditional fields made sterile by the overgrazing of academic artists have turned to non-Western cultures, for example Africa, the Near and Far East, pre-Conquest South America and Oceania, and from these sources, largely represented by sculpture, have received suggestions for new formal experiments and for the extension and enrichment of their imagery. Following their example the modern sculptor has enormously increased the resources of his art as the diversity and complexity of twentieth-century sculpture proves at a glance.

Between the seventeenth and nineteenth centuries the Western sculptor was dependent upon the renaissance-derived, Greco-Roman tradition. Rodin, the father of modern sculpture, remained largely within that tradition but, by the force of his personality, and under the stimulation of revolutionary movements in painting, he gave this tradition a new life after it had practically died at the hands of academic formularizers. Rodin's rhetoric may be difficult for us to accept today, skeptical and inhibited as we are in the face of cataclysmic events. And even during the first decade of the century there was a reaction on the part of such sculptors as Maillol and Brancusi to the dynamic explosiveness of Rodin's forms and subjects. As Cézanne had endeavored to control and give substance to the evanescent light

3

effects of the impressionists, so Maillol tamed the fiery gestures of Rodin and in the closed, compact rhythms of his compositions, based almost wholly on the female nude, presented a contained and idealized version of the human figure which has influenced a great many modern sculptors. He was in love with Greece as Cézanne was with Poussin and in their different ways they can be called neo-classic in temperament as opposed to the expressionist abandon of Rodin.

Rodin has had his followers and those who have associated themselves directly or indirectly with him, for example Matisse and Picasso in their beginnings, and after a long cubist phase, Lipchitz. Brancusi also, the third of the great triumvirate of modern sculptors, came under Rodin's influence in his youth. However, he early took a contrary direction in a search for a control and purification of form which owes nothing to Rodin nor to the tradition from which he stems. Born in Rumania, one of the crossroads between Asia and Europe, Brancusi retains much of the Asiatic's love for the occult and the mysterious. The abstract treatment of form in certain prehistoric art, the geometrical refinement of some Oriental sculpture, the elementary grasp of formal relations in African sculpture appealed to him and from their example he set out to by-pass the traditional sculpture of the West. To release the image imprisoned in the stone or wood by a reduction of the material to its absolute essence was his intention. The removal of particularizing detail is an objective comparable to the neo-classic idealization of form. Both points of view look to a type rather than to an individual. Maillol's woman is a formal idea, not a portrait of a particular nude. The idea in his case is bound to a great Western tradition. Brancusi's *Bird in Space,* on the other hand, reaches out to a universal, transcendental idea of flight, an idea, whatever its non-Western origins, that had never been as completely expressed before.

If the first decade of the century is dominated by three great personalities: Rodin, Maillol and Brancusi, the second decade is marked by three movements: cubism, futurism and constructivism. Each follows a more or less abstract direction. Between 1908 and 1914 the cubist revolution took place, a revolution comparable to the discovery of perspective in the renaissance. Cubism was actually a new multi-focus perspective for the examination or analysis simultaneously of different views of an object or figure either at rest, as with the cubists proper, such as Picasso, Braque, Lipchitz and Laurens, or in motion, as with the futurist Boccioni or the futurist-derived Duchamp-Villon. Brancusi's abstract purification of the object, the cubists' and futurists' geometrical dissection of it in a static or kinetic state all had to do with the animal or human figure or the still life in relation to space. The most extreme of all the abstractionists were the so-called constructivists. Deriving some of their ideas from the cubists, first in Russia, later in Germany, Holland, France and England, they pushed abstraction to its extreme geometrical limit by divorcing their shapes or forms from any organic or human reference. Theirs was an effort above all to make space rather than mass the primary consideration in sculpture.

The surrealists, beginning in the twenties, reacted violently to what they considered was the sterile intellectualism of abstract art of whatever degree. As a corrective

they explored the world of subconscious experience and from this source created an imagery of fantastic, horrific dimensions. Arp, Gonzalez and Giacometti are, or were, the leading exponents of surrealist sculpture and their influence, particularly Arp's and Gonzalez', has been widespread.

While surrealism ceased being an organized movement before the beginning of World War II, its influence, together with that of the constructivists, has continued until today. By a sort of fusion of the two, in fact, there has been produced a new avant-garde movement now vaguely called abstract expressionism, whose principal practitioners are American. At the same time, during the last decade and a half there has been a return by some of the older sculptors to more naturalistic forms. Picasso, Lipchitz and Laurens and some of the younger Italians such as Marini and Manzù are examples of this tendency.

In short, modern sculpture, like all other aspects of the twentieth century, has been in a constant state of flux and at the present moment shows no signs of arriving at any final resolution. Herein perhaps is the secret of its extraordinary diversity and nervous vitality.

The present exhibition is designed to give the observer as comprehensive a view as possible of twentieth-century sculpture in all its richness and variety of expression. What has been attempted is to present a balanced picture of the giants of modern sculpture, including outstanding painter-sculptors, the various movements they represent, their followers or those who are stylistically related to them and, finally, a limited selection of work being done today. The latter section is suggestive rather than representative since, for reasons of space, many younger artists from abroad have had to be omitted.

ANDREW CARNDUFF RITCHIE

5

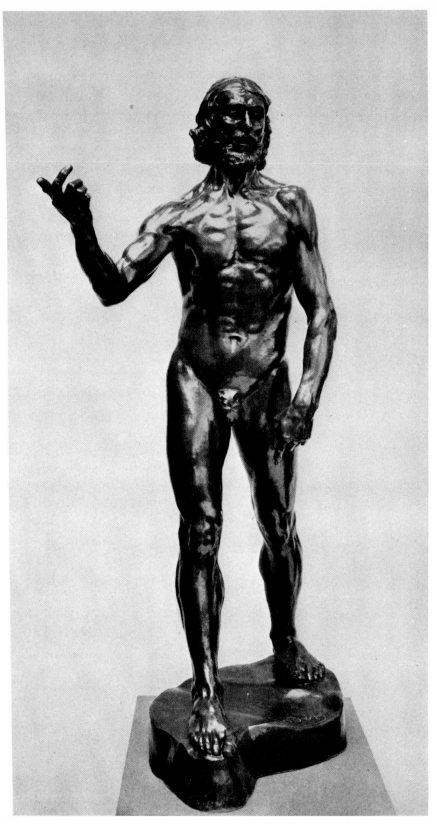

RODIN, AUGUSTE. FRENCH.
St. John the Baptist. 1878-80.
Bronze, 6'8½" high. Lent by the
City Art Museum of St. Louis

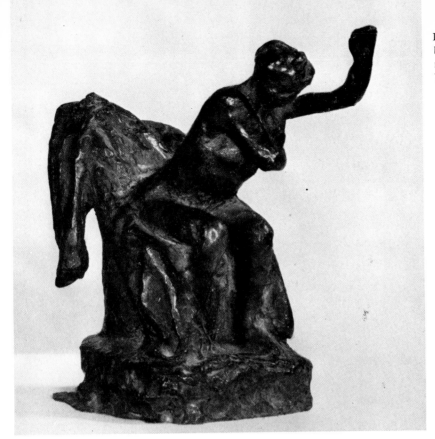

DEGAS, EDGAR. FRENCH.
Woman Seated in Armchair.
1896-1911. Bronze, 12½" high.
The Art Institute of Chicago

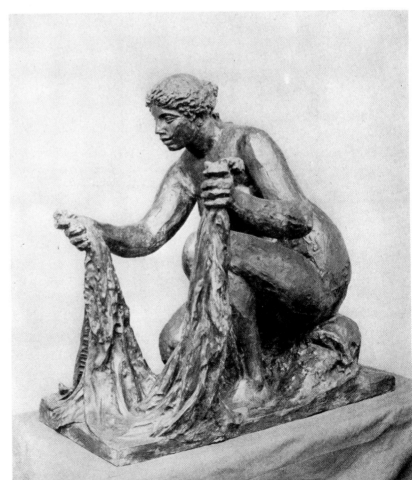

RENOIR, AUGUSTE. FRENCH.
Washerwoman. 1917. Bronze,
48" high. Lent by the
Curt Valentin Gallery, New York

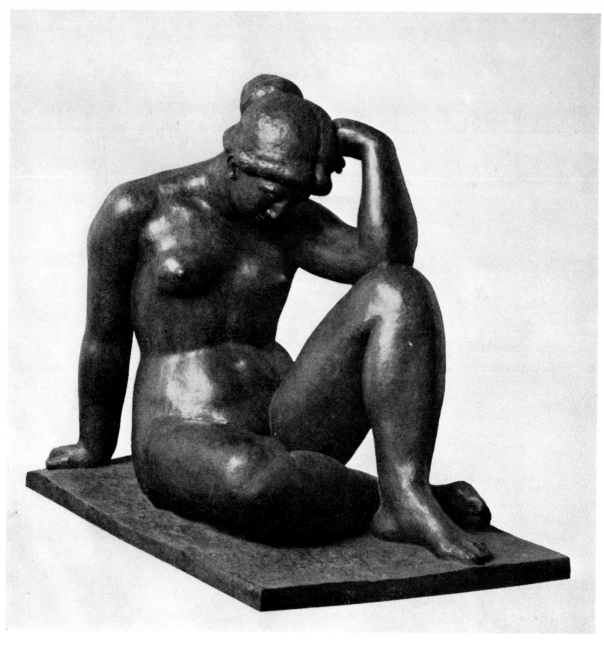

MAILLOL, ARISTIDE. FRENCH. *Mediterranean.* c. 1901. Bronze, 41″ high. Lent by Stephen C. Clark, New York

LACHAISE, GASTON. AMERICAN. *Floating Figure.* 1927. Bronze (cast 1935). 53″ high. The Museum of Modern Art. New York, given anonymously in memory of the artist

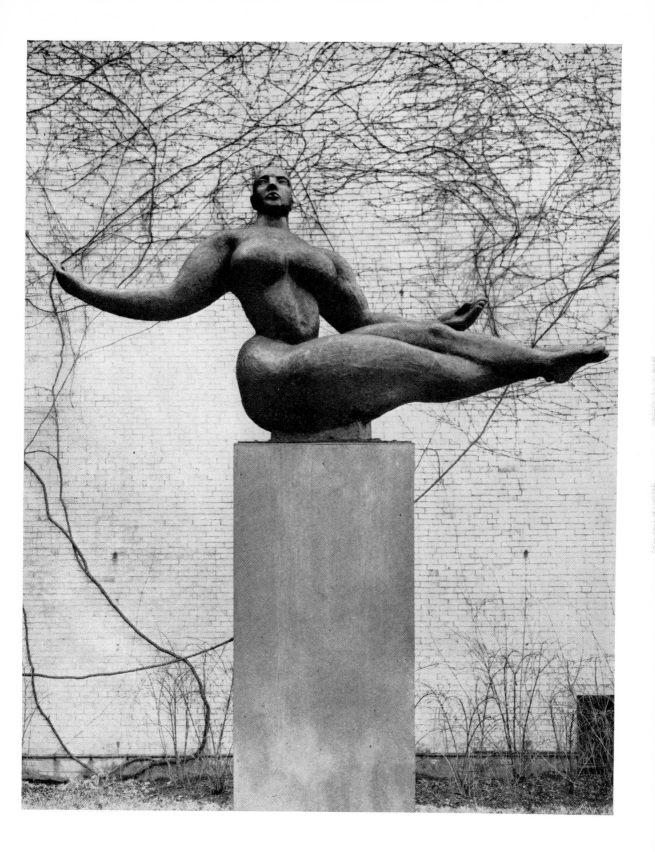

9

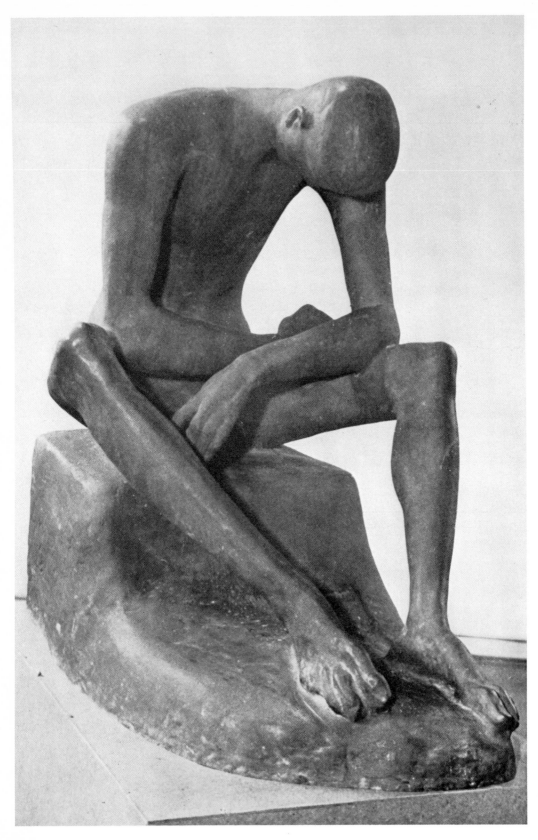

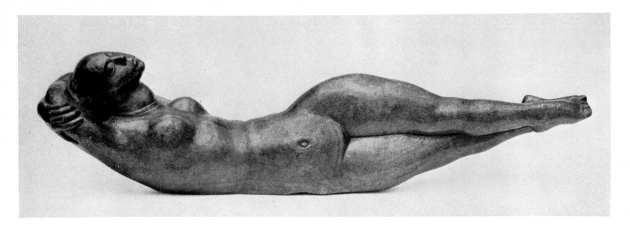

ZORACH, WILLIAM. AMERICAN. *Floating Figure*. 1922. African mahogany, 9″ high x 33¼″ long. Lent by the Albright Art Gallery, Buffalo, Room of Contemporary Art

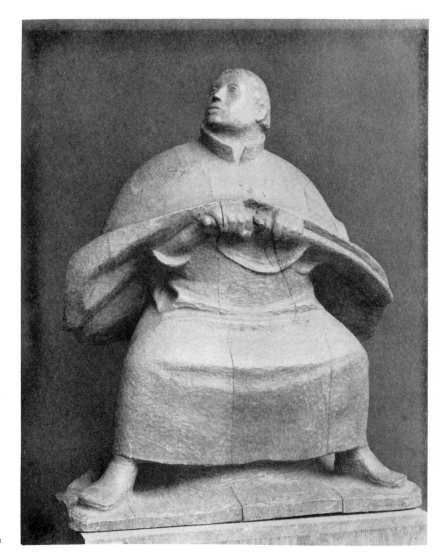

Opposite:
LEHMBRUCK, WILHELM. GERMAN. *Seated Youth*. 1918? Bronze, 41½″ high. Lent by the Kunstmuseum, Duisburg, Germany

BARLACH, ERNST. GERMAN. *Man Drawing Sword*. 1911. Wood, 31″ high. Lent by the Museum of Cranbrook Academy of Art, Bloomfield Hills, Michigan

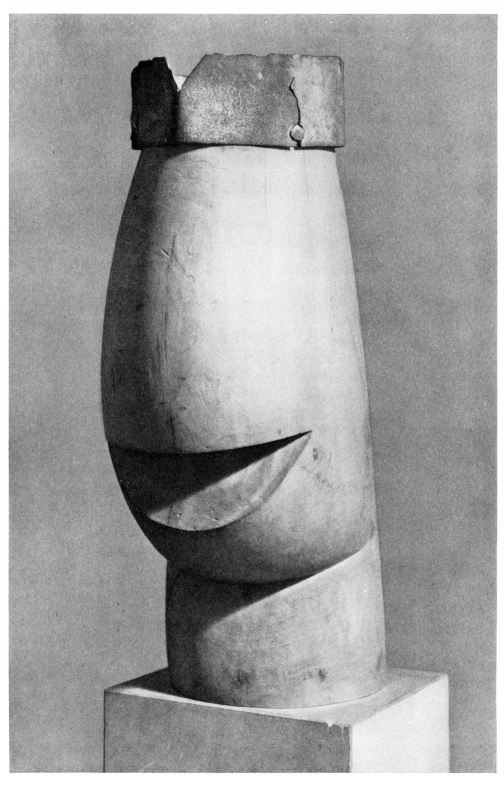

BRANCUSI, CONSTANTIN. RUMANIAN. *The Chief*. 1925. Wood, 20″ high (with base, 71½″ high). Lent by Mrs. Pierre Matisse, New York. (Exhibited in Chicago and New York)

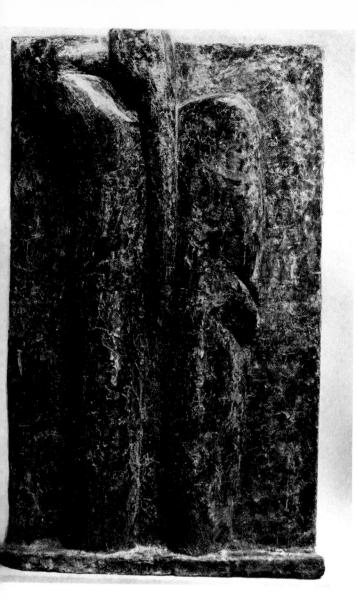

MATISSE, HENRI. FRENCH. *The Back, III.* 1929? Bronze, 6′2⅜″ high.
The Museum of Modern Art, New York, Mrs. Simon Guggenheim Fund

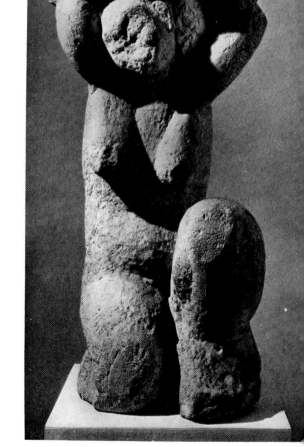

MODIGLIANI, AMEDEO. ITALIAN. *Caryatid.* c. 1914. Limestone, 36¼″
high. The Museum of Modern Art, New York, Mrs. Simon Guggen-
heim Fund

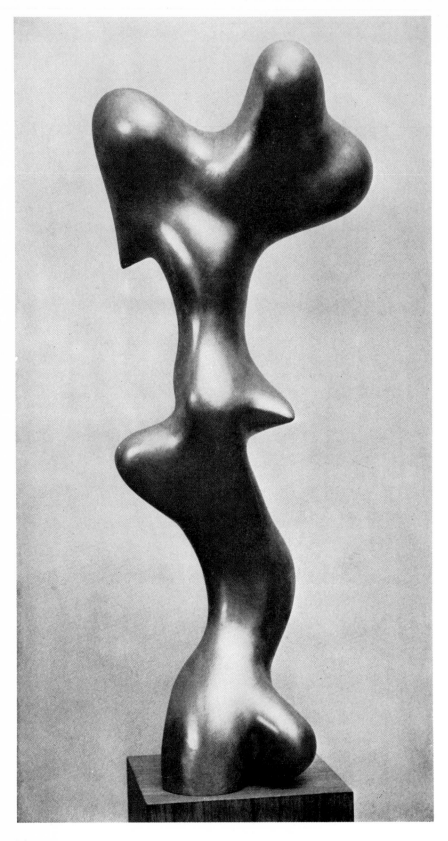

ARP, JEAN (HANS). FRENCH.
Growth. 1938. Bronze, 31½″ high.
Philadelphia Museum of Art

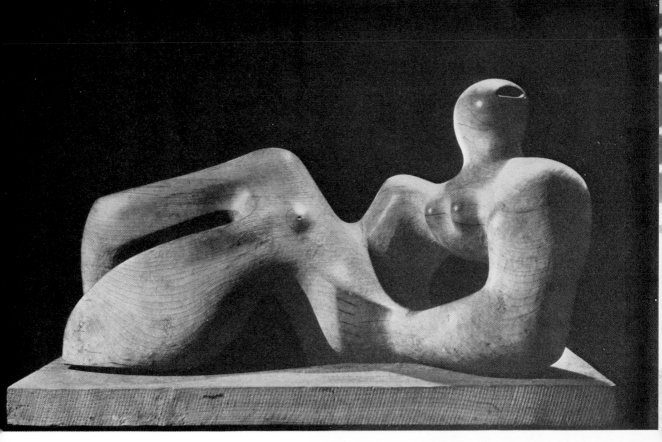

MOORE, HENRY. BRITISH. *Reclining Figure.* 1935. Elm wood, 19″ high, 35″ long. Lent by the Albright Art Gallery, Buffalo, Room of Contemporary Art

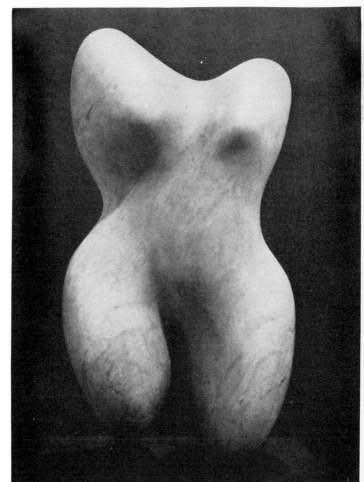

VIANI. ALBERTO. ITALIAN. *Torso.* 1945. Marble, 38″ high. The Museum of Modern Art, New York

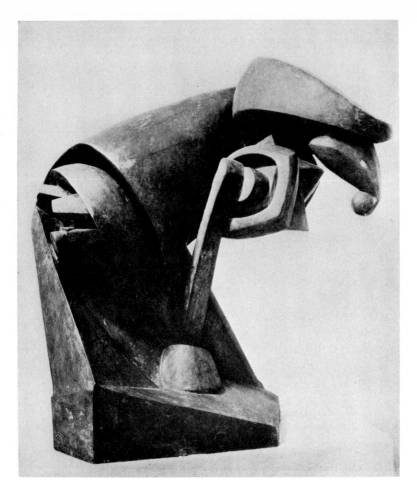

DUCHAMP-VILLON, RAYMOND. FRENCH. *The Horse*. 1914. Bronze, 40″ high.
The Museum of Modern Art, New York, van Gogh Purchase Fund

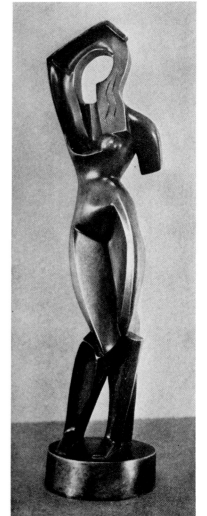

ARCHIPENKO, ALEXANDER. AMERICAN. *Woman Combing
Her Hair*. 1915. Bronze, 13¾″ high. Lent by Mr. and Mrs.
George Heard Hamilton, New Haven

16

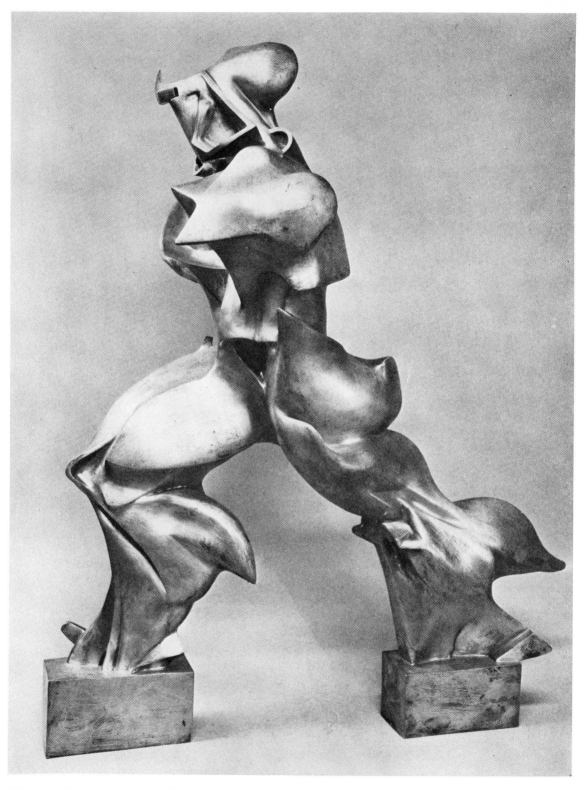

BOCCIONI, UMBERTO. ITALIAN. *Unique Forms of Continuity in Space*. 1913. Bronze, 43½″ high. The Museum of Modern Art, New York, acquired through the Lillie P. Bliss Bequest

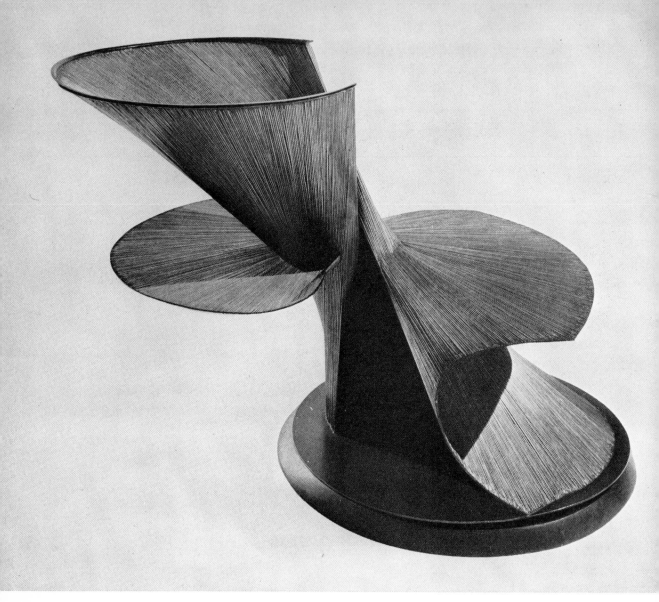

PEVSNER, ANTOINE. FRENCH. *Developable Column*. 1942. Brass and oxidized bronze, 20¾″ high. The Museum of Modern Art, New York

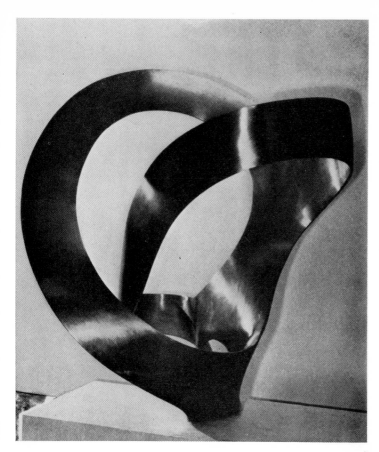

BILL, MAX. SWISS. *Tripartite Unity*. 1947-48. Chrome-nickel steel, 46″ high. Lent by the Museu de Arte Moderna, São Paulo, Brazil

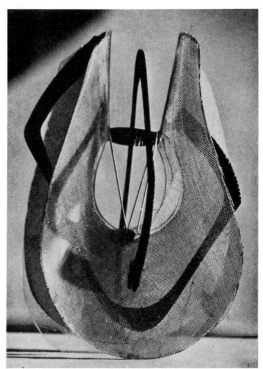

GABO, NAUM. AMERICAN. *Study for Constructi‹ Space*. 1951. Brass net, plastic and stainless wire, 6″ high. Owned by the artist

19

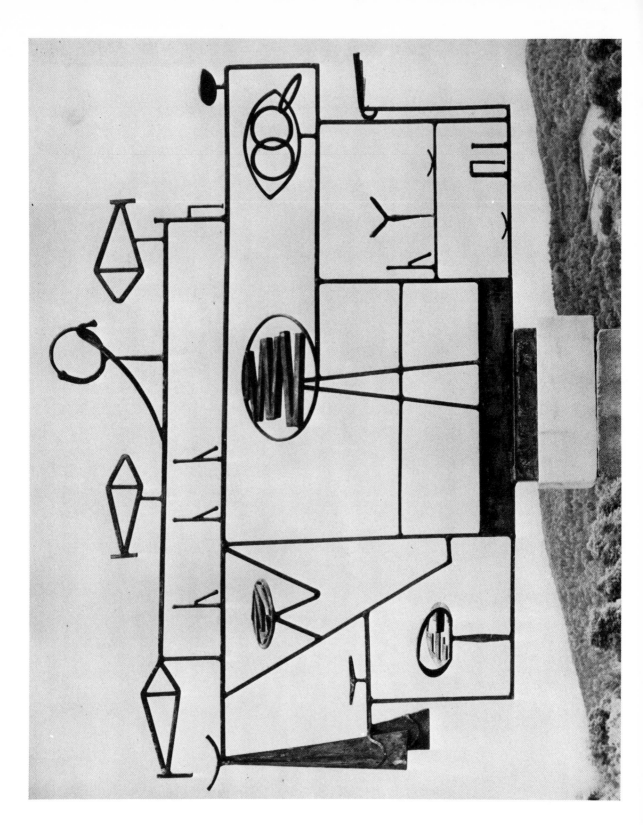

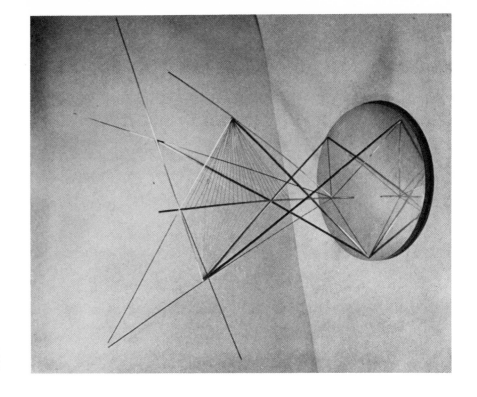

Above: SMITH, DAVID. AMERICAN. *The Banquet*. 1951. Steel, 53⅛″ x 6′11″. Lent by the Willard Gallery, New York

Left: LASSAW, IBRAM. AMERICAN. *Monoceros*. 1952. Bronze, 46¾″ high. Lent by the Kootz Gallery, New York

Below: LIPPOLD, RICHARD. AMERICAN. *Reunion*. 1951. Copper, brass, nichrome, enameled wires, 23½″ high. Lent by the Willard Gallery, New York

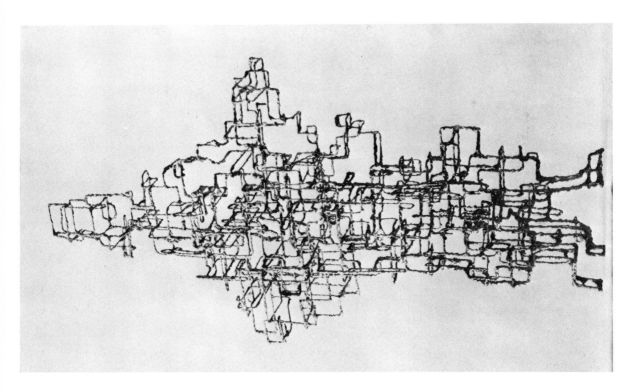

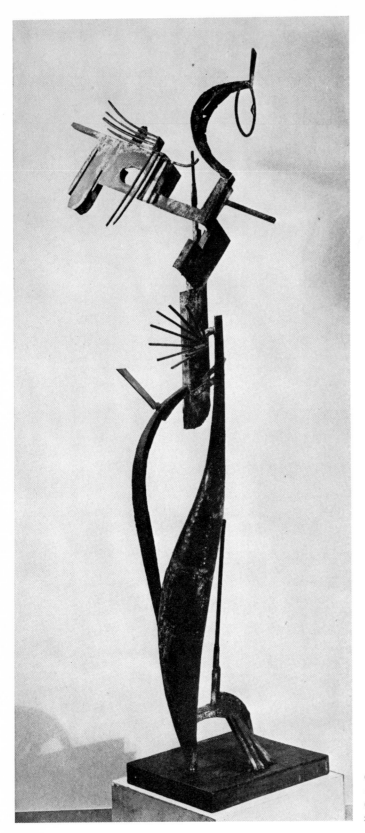

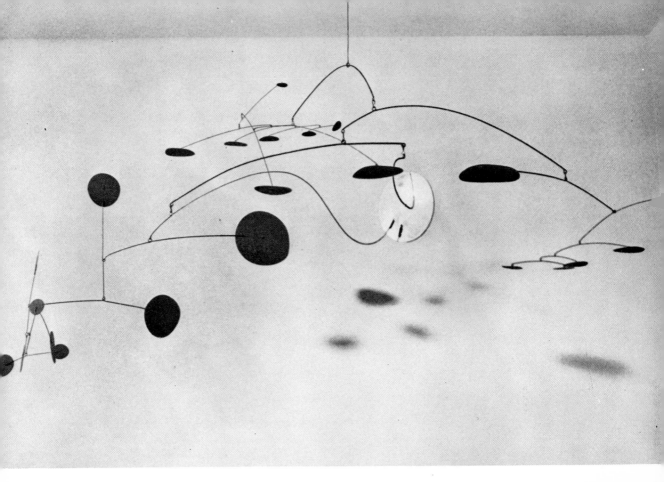

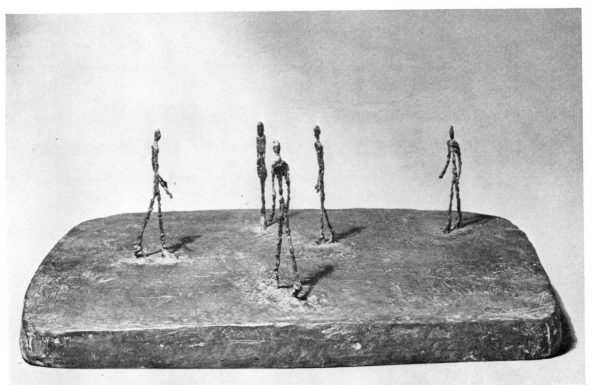

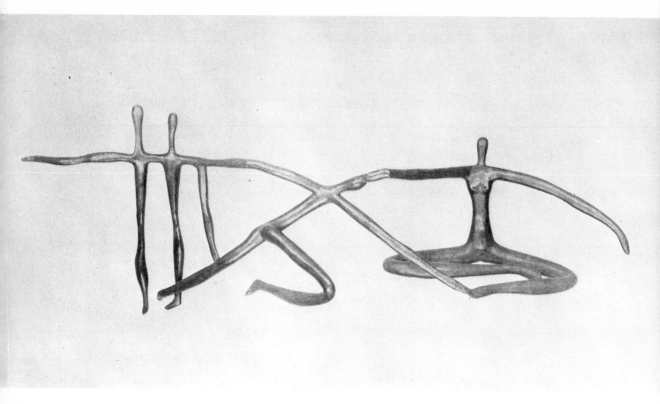

CALLERY, MARY. AMERICAN. *Mural Composition*. 1949. Bronze, 18″ high. 57″ long. Lent by Nelson A. Rockefeller, New York

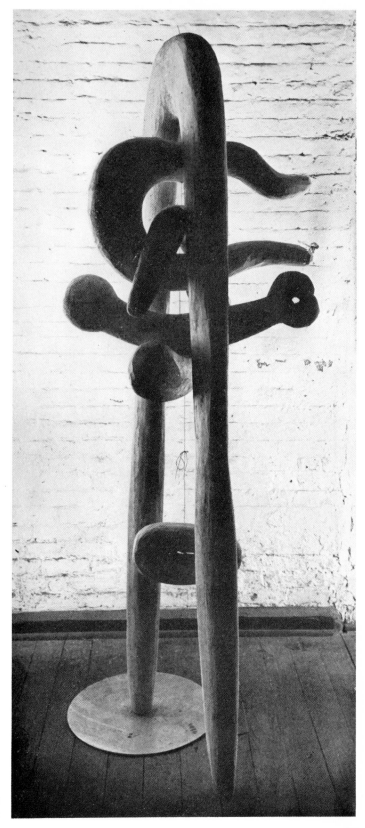

NOGUCHI, ISAMU. AMERICAN. *Cronos.* 1949. Balsa
wood, 76″ high. Lent by the Egan Gallery, N.Y.

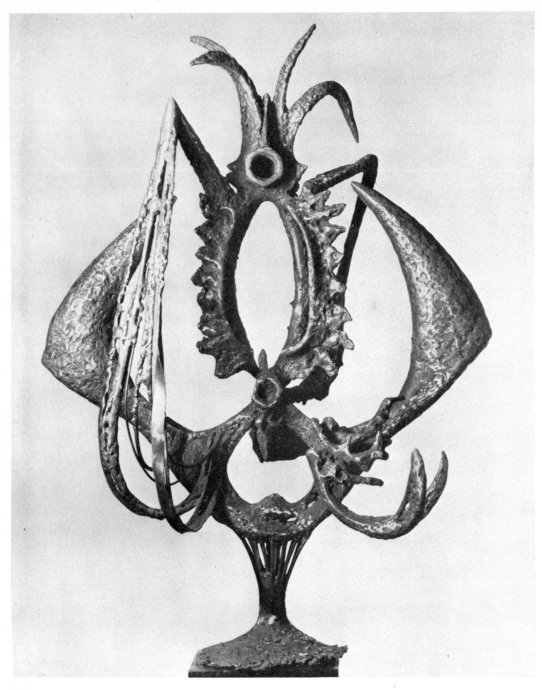

ROSZAK, THEODORE J. AMERICAN. *Invocation.* 1946-47. Steel, 30¼″ high. Lent by the Pierre Matisse Gallery, New York

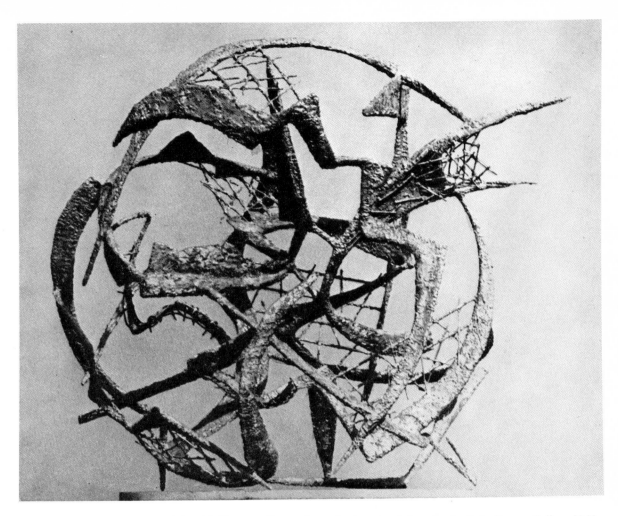

FERBER, HERBERT. AMERICAN. *Spheroid, II.* 1952. Copper, brass, lead, 33 x 47″. Lent by the Betty Parsons Gallery, N. Y.

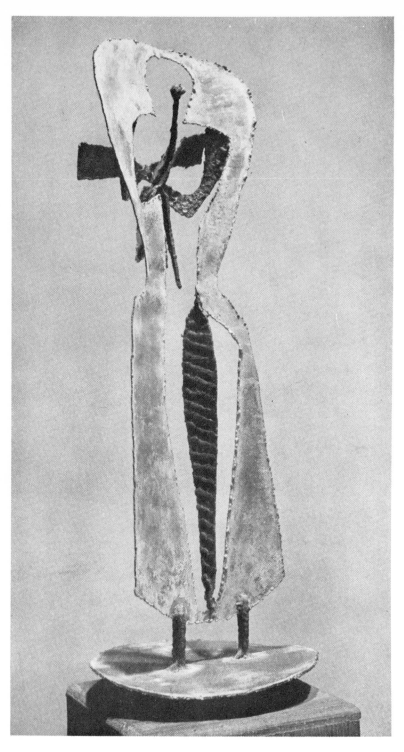

HARE, DAVID. AMERICAN. *Figure with Bird.* 1951. Steel and iron, 35″ high. Lent by the Kootz Gallery, New York

Opposite: ESHERICK, WHARTON. AMERICAN. *Reverence.* 1942. Wood, 12′ high. Fairmount Park Art Association, Philadelphia

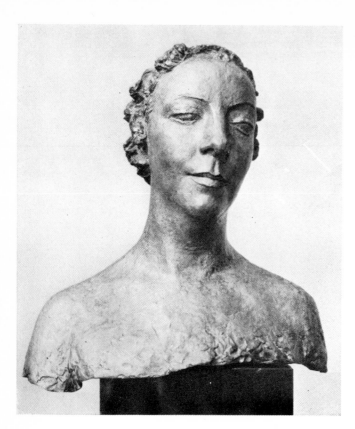

Opposite: EPSTEIN, JACOB. BRITISH.
Madonna and Child. 1927. Bronze,
67" high. Lent by Miss Sally Ryan,
Georgetown, Conn.

DESPIAU, CHARLES. FRENCH.
Antoinette Schulte. 1934. Bronze,
20" high. Lent by Miss Antoinette Schulte,
New York

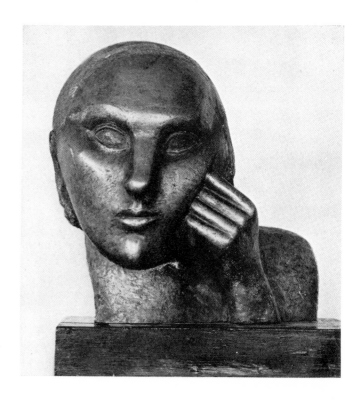

HARKAVY, MINNA. AMERICAN. *Woman in Thought.*
1929-30. Bronze, 17" high. Lent by the Midtown
Galleries, New York

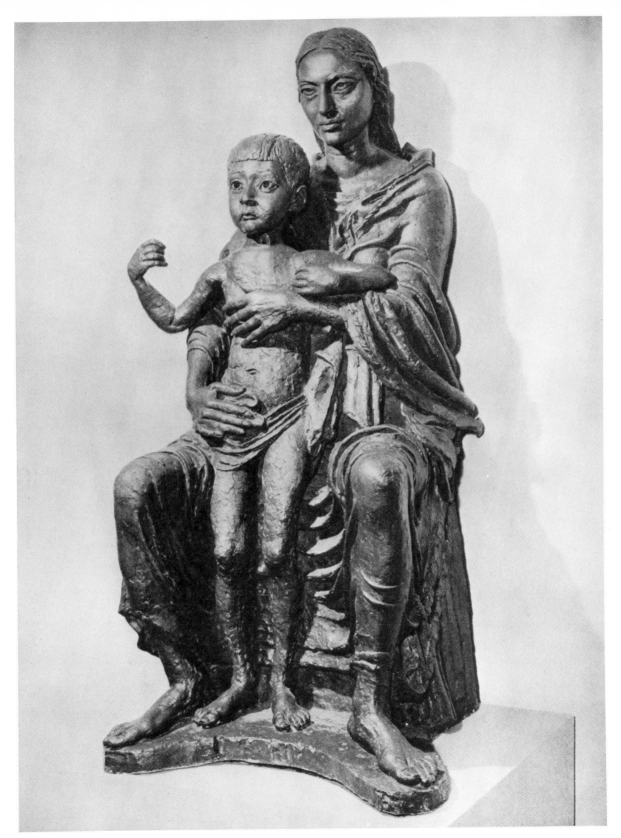

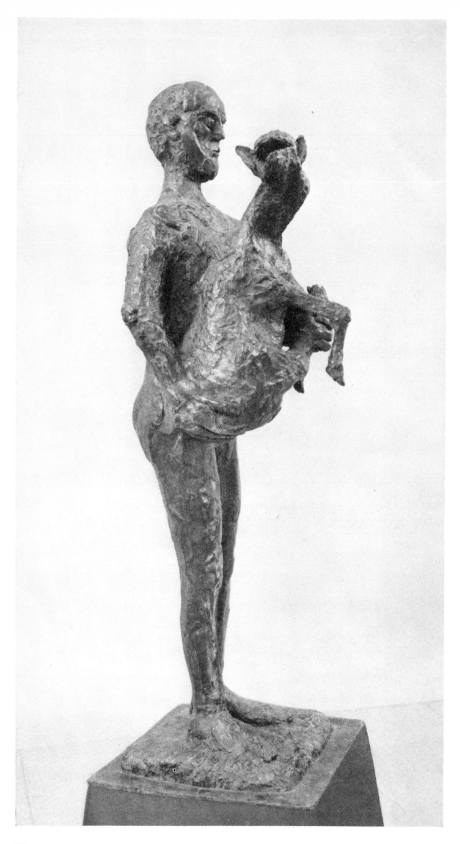

PICASSO, PABLO. SPANISH.
Shepherd Holding a Lamb.
1944. Bronze, 7′4″ high.
Lent by Mr. and Mrs.
R. Sturgis Ingersoll,
Penllyn, Pa.

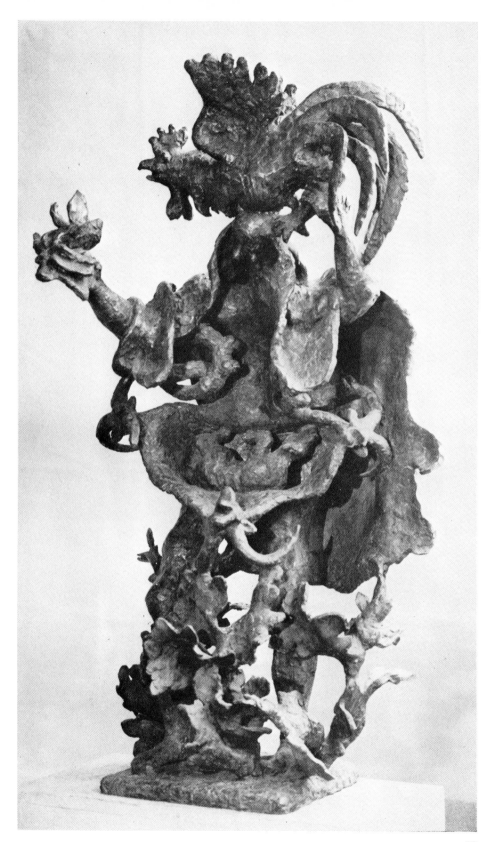

LIPCHITZ, JACQUES.
FRENCH. *Prayer*. 1943.
Bronze, 42½″ high.
Lent by Mr. and Mrs. R.
Sturgis Ingersoll,
Penllyn, Pa.

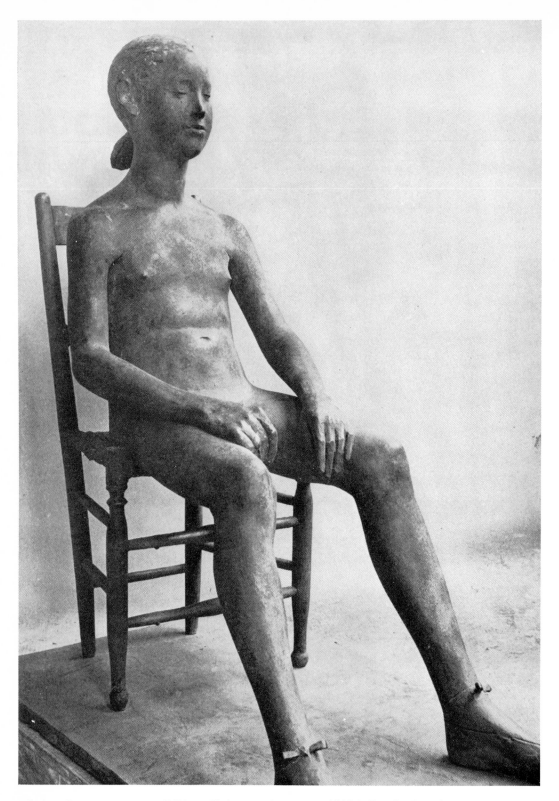

MANZU, GIACOMO. ITALIAN. *Child on Chair*. 1949. Bronze, 49¼" high. Lent by the artist

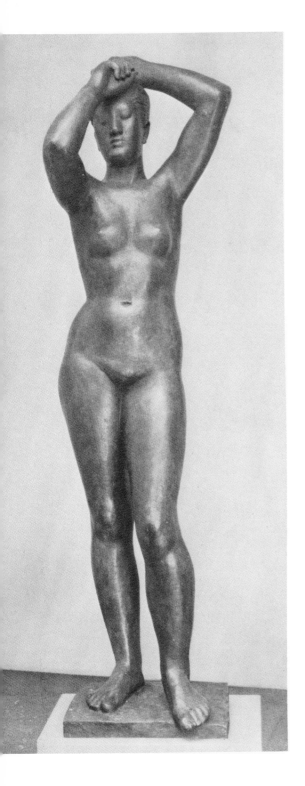

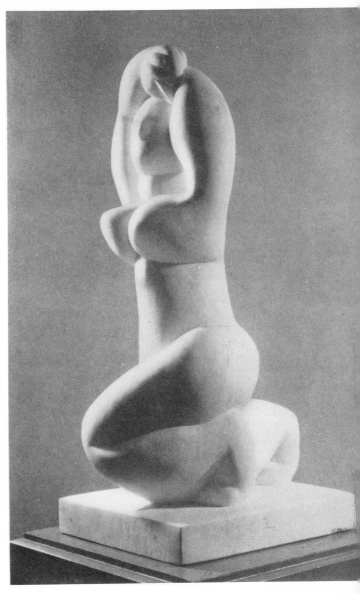

LAURENS, HENRI. FRENCH. *Luna.* 1948. Marble, 35¾″ high. Lent by the Curt Valentin Gallery, New York

MARCKS, GERHARD. GERMAN. *Maja.* 1942. Bronze, 7′ high. Fairmount Park Art Association, Philadelphia

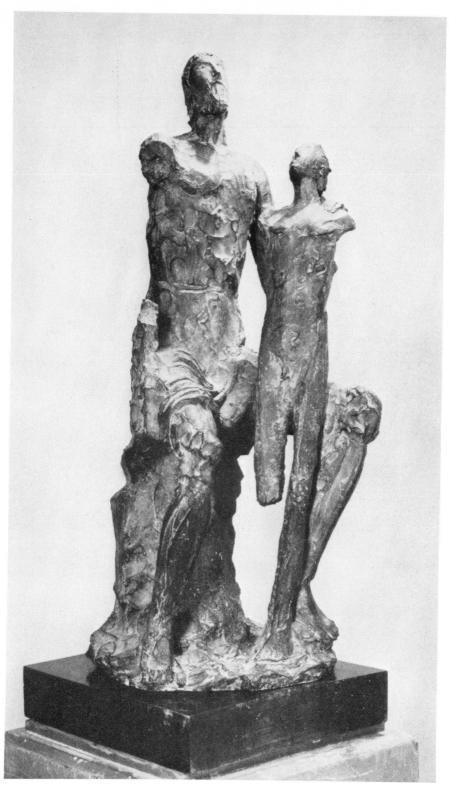

MARTINI, ARTURO. ITALIAN. *Daedalus and Icarus*. 1934-35. Bronze, 24″ high. The Museum of Modern Art, New York

36

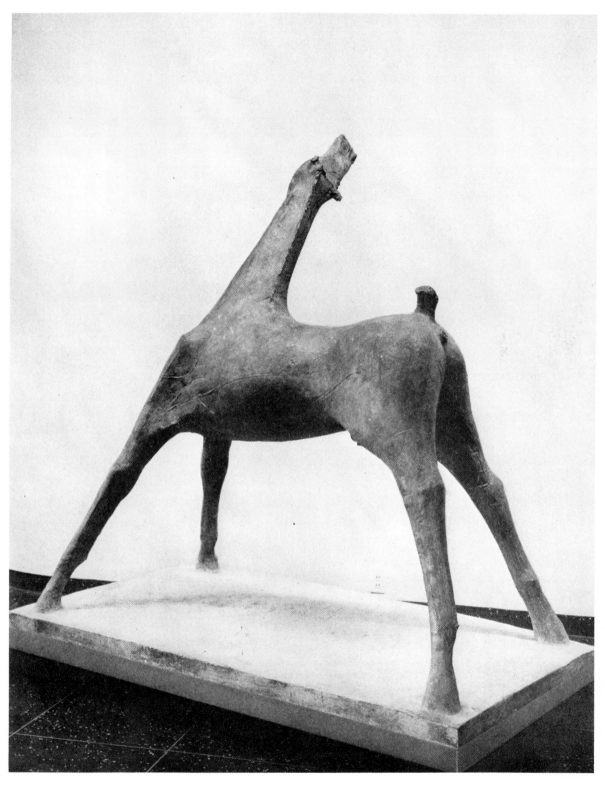

MARINI, MARINO. ITALIAN. *Horse*. 1951. Bronze, c. 7′3″ high. Lent by Nelson A. Rockefeller, New York

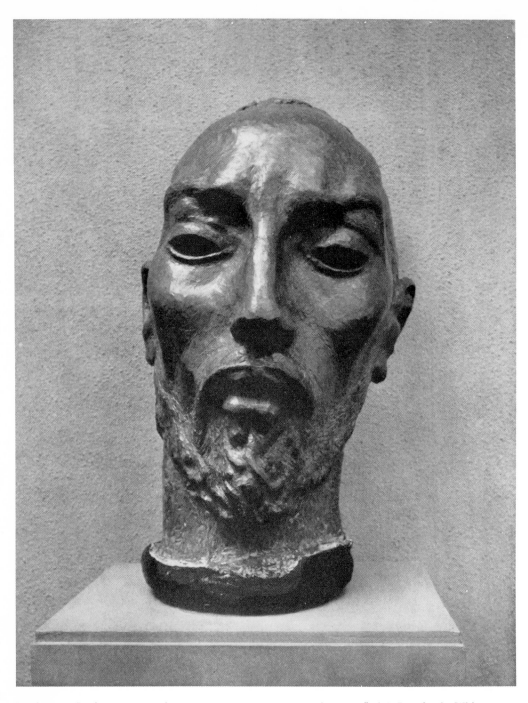

DE CREEFT, JOSÉ. AMERICAN. *Himalaya.* 1942. Beaten lead over plaster, 34″ high. Lent by the Whitney Museum of American Art, New York

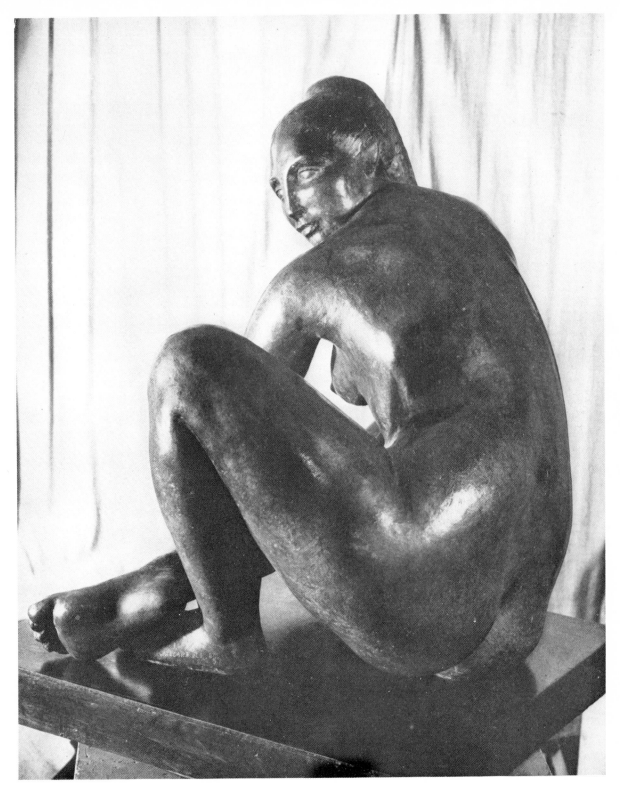

MALDARELLI, ORONZIO. AMERICAN. *Bianca, II.* 1950. Bronze, 28″ high. Lent by the Midtown Galleries, New York

CATALOGUE OF THE EXHIBITION

LENDERS

Mr. and Mrs. Alexander M. Bing; Mrs. Meric Callery; Mr. Stephen C. Clark; Mr. and Mrs. Erich Cohn; Dr. Maurice Fried; Mr. Naum Gabo; Mme Robèrta Gonzalez-Hartung; Mr. and Mrs. George Heard Hamilton; Mr. and Mrs. R. Sturgis Ingersoll; Mrs. T. Catesby Jones; Mr. Giacomo Manzù; Mr. and Mrs. Samuel A. Marx; Mrs. Pierre Matisse; Mrs. John D. Rockefeller, III; Mr. Nelson A. Rockefeller; Miss Sally Ryan; Miss Antoinette Schulte.

Stedelijk Museum, Amsterdam; City Museum and Art Gallery, Birmingham, England; Museum of Cranbrook Academy of Art, Bloomfield Hills, Michigan; Albright Art Gallery, Buffalo; The Art Institute of Chicago; The Arts Club of Chicago; Kunstmuseum, Duisburg, Germany; Yale University Art Gallery, New Haven; The Metropolitan Museum, New York; Whitney Museum of American Art, New York; Philadelphia Museum of Art; Fairmount Park Art Association, Philadelphia; City Art Museum of St. Louis; Washington University, St. Louis; Museu de Arte Moderna, São Paulo, Brazil.

Downtown Gallery, Egan Gallery, Kootz Gallery, M. Knoedler & Co., Pierre Matisse Gallery, Midtown Galleries, Betty Parsons Gallery, Paul Rosenberg & Co., Jacques Seligmann & Co., Curt Valentin Gallery, Willard Gallery, all of New York.

CATALOGUE

Works marked with an asterisk are illustrated

ARCHIPENKO, ALEXANDER. AMERICAN

Born Kiev, Russia, 1887. Studied 1902-08, first in Russia then Paris. Associated with cubists; experimented with unconventional materials; one of first to explore possibilities of concave surfaces and voids in three-dimensional sculpture. Berlin, 1921-23. Settled U.S., 1923. Lives in New York and Woodstock.

* 1 *Woman Combing Her Hair.* 1915. Bronze, 13¾" high. Lent by Mr. and Mrs. George Heard Hamilton, New Haven. *Ill. p. 16*

ARP, JEAN (HANS). FRENCH

Born Strasbourg, 1888. Studied painting, Weimar, 1907. Met *Blue Rider* group, Munich, 1912. One of founders of dada, Zurich, 1916. Began abstract wood reliefs executed by jigsaw about 1917. Settled in Meudon, France, 1926; participated in surrealist movement; worked increasingly

in sculpture in the round. Second only to Brancusi in influence on organic abstract sculpture. Lives in France and Switzerland.

2 *Configuration.* 1932. Wood, c. 27½ x 33½". Philadelphia Museum of Art, A. E. Gallatin Collection

* 3 *Growth.* 1938. Bronze, 31½" high. Philadelphia Museum of Art. *Ill. p. 14*

BARLACH, ERNST. GERMAN

Born near Hamburg, 1870. Studied Hamburg and Dresden, 1888-1895. Paris, 1895-6: impressed by the work of van Gogh. Visited South Russia, 1910. Style formed principally under influence of Russian folk carvings and Gothic sculpture. Worked principally in wood. Settled permanently Güstrow, North Prussia, 1910. During 20's executed memorials in Güstrow, Kiel and Magdeburg. Influential also as graphic artist. Died, 1938.

* 4 *Man Drawing Sword.* 1911. Wood, 31" high. Lent by the Museum of Cranbrook Academy of Art, Bloomfield Hills, Michigan. *Ill. p. 11*

BILL, MAX. SWISS

Born Winterthur, 1908. Studied Zurich School of Arts and Crafts, and Bauhaus, Dessau. Member of Paris *Abstraction-Création* group, 1932-36. Works in strictly geometrical abstract style. Lives in Zurich.

* 5 *Tripartite Unity.* 1947-48. Chrome-nickel steel, 46" high. Lent by the Museu de Arte Moderna, São Paulo, Brazil. *Ill. p. 19*

BOCCIONI, UMBERTO. ITALIAN

Born Reggio, Calabria, 1882. Studied with Balla in Rome and at Academy of the Brera in Milan. Met Marinetti, 1909. The most gifted of the futurists, he participated in the movement as painter, sculptor and theorist. *Technical Manifesto of Futurist Sculpture* published in 1912, advocated principally sculpture of movement, the opening up of forms and their fusion in space. Died Verona, 1916.

6 *Development of a Bottle in Space.* 1912. Bronze, 15" high. The Museum of Modern Art, New York, Aristide Maillol Fund

* 7 *Unique Forms of Continuity in Space.* 1913. Bronze, 43½" high. The Museum of Modern Art, New York, acquired through the Lillie P. Bliss Bequest. *Ill. p. 17*

BRANCUSI, CONSTANTIN. RUMANIAN

Born Craiova, Rumania, 1876. Attended local art school; trained also in cabinet making. Studied Bucharest academy until 1902. Settled permanently Paris, 1904. Studied Ecole des Beaux-Arts under Mercier, left 1906 at advice of Rodin. Early work influenced by Rodin. Pioneer in use of abstract forms; influenced by primitive art, principally in wood carvings. Style has been perfected and expanded, but virtually unchanged since about 1910. Has been a pervasive influence on 20th-century sculpture. Lives in Paris.

8 *The Prodigal Son.* 1914. Wood, 29⅝" high. Philadelphia Museum of Art, The Louise and Walter Arensberg Collection. (Exhibited in Philadelphia only)

9 *Bird in Space.* 1919. Bronze, 54" high. The Museum of Modern Art, New York. (Exhibited in New York only)

10 *Golden Bird.* 1919. Polished bronze, 37" high, stone pedestal 9", wood pedestal 39". Lent by The Arts Club of Chicago. (Exhibited in Chicago only)

11 *Mlle Pogany.* 1920. Polished bronze, 17" high. Lent by the Albright Art Gallery, Buffalo. (Exhibited in Chicago and New York)

12 *Bird in Space.* 1920-24. Bronze, 56¾" high (with base). Philadelphia Museum of Art, The Louise and Walter Arensberg Collection. (Exhibited in Philadelphia only)

13 *Yellow Bird.* c. 1922-24. Marble, 50½" high (with base). Philadelphia Museum of Art, The Louise and Walter Arensberg Collection. (Exhibited in Philadelphia only)

*14 *The Chief.* 1925. Wood, 20" high (with base, 71½" high). Lent by Mrs. Pierre Matisse, New York. (Exhibited in Chicago and New York.) *Ill. p. 12*

15 *Mlle Pogany.* c. 1928-29. Marble on stone base, 27½" high. Philadelphia Museum of Art, The Louise and Walter Arensberg Collection. (Exhibited in Philadelphia only)

16 *The Fish.* 1930. Marble, 71" long. The Museum of Modern Art, New York, acquired through the Lillie P. Bliss Bequest. (Exhibited in New York only)

17 *The Miracle.* 1938. Marble, 60" long. The Museum of Modern Art, New York, on loan from the artist

CALDER, ALEXANDER. AMERICAN

Born Philadelphia, 1898. Studied engineering, later painting. First sculpture wood carvings c. 1926-27. Wire portraits and figures, 1928-29. First *mobiles* (moving abstract constructions of wire and sheet metal) 1931. Painting of Mondrian and Miró principal influence. Since 1938 has worked also in stationary sheet metal constructions. Before World War II divided time between France and U.S. Lives in Roxbury, Conn.

18 *Black Thing.* 1942. Sheet steel, 31¼" high. Private collection, New York. (Exhibited in New York only)

19 *Constellation.* 1950. Wood and metal, 39" high. Lent by the Curt Valentin Gallery, New York

20 *Loop on Platform.* c. 1950. Sheet metal, 27¾" high. Lent by the Curt Valentin Gallery, New York

*21 *Streetcar.* 1951. Sheet metal, brass, wire, 9'8" long. Lent by the Curt Valentin Gallery, New York. *Ill. p. 23*

CALLERY, MARY. AMERICAN

Born New York, 1903. Studied U.S. and France. Lived in Paris, 1930-40. First American exhibition, 1944. Lives in New York.

*22 *Mural Composition.* 1949. Bronze, 18" high, 57" long. Lent by Nelson A. Rockefeller, New York. *Ill. p. 24*

DE CREEFT, JOSE. AMERICAN

Born Guadalajara, Spain, 1884. At 12 apprenticed in bronze foundry, Barcelona. To Paris, 1905. Studied Académie Julian; worked as stone cutter. Early in career became exponent of direct handling of materials. Settled in U.S., 1927. Lives in New York.

*23 *Himalaya.* 1942. Beaten lead over plaster, 34" high. Lent by the Whitney Museum of American Art, New York. *Ill. p. 38*

DEGAS, EDGAR. FRENCH

Painter-sculptor. Born Paris, 1834. Formal training in Paris supplemented by long sojourns in Italy, 1854-60. Met Manet, 1862. Active as painter in impressionist group from the beginning. About 1866 began modeling small figures in wax as studies for paintings. Exhibited costumed wax figure of dancer in impressionist exhibition, 1881. Sculpture not publicly exhibited again; continued modeling throughout his life. Died 1917.

*24 *Woman Seated in Armchair.* 1896-1911. Bronze, 12½" high. The Art Institute of Chicago. *Ill. p. 7*

25 *Study in the Nude for Clothed Dancer.* c. 1872. Bronze (cast c. 1919-21), 28¾" high. Lent by The Metropolitan Museum of Art, New York, H. O. Havemeyer Collection

DESPIAU, CHARLES. FRENCH

Born Mont-de-Massan, 1874. Father and grandfather master stuccoists. Decided on sculpture at 16. To Paris, c. 1891; studied Ecole des Arts Décoratifs and Ecole des Beaux-Arts. Learned stone cutting from an artisan. Began exhibiting 1902. From 1907-14 served as executant in stone for Rodin, reserving time for own work. Personal style, formed in opposition to prevailing taste c. 1904, virtually unchanged throughout career. By preference a modeler. Life-long interest in portrait heads, often uncommissioned. Died Paris, 1946.

*26 *Antoinette Schulte.* 1934. Bronze, 20" high. Lent by Miss Antoinette Schulte, New York. *Ill. p. 30*

DUCHAMP-VILLON, RAYMOND. FRENCH

Born Damville, 1876. Brother of Marcel Duchamp and Jacques Villon. Gave up medical studies for sculpture, c. 1898. Self-taught. Early work influenced by Rodin; cubism point of departure for work after 1912. Concerned also with architecture; designed exhibition house for Salon d'Automne, 1912. Served as army doctor in World War I. Died Cannes, 1918.

27 *Baudelaire*. 1911. Bronze, 15½" high. Lent by Mr. and Mrs. Alexander M. Bing, New York

*28 *The Horse*. 1914. Bronze, 40" high. The Museum of Modern Art, New York, van Gogh Purchase Fund. This cast was made after the sculptor's death by his brothers Jacques Villon and Marcel Duchamp, who enlarged the original model according to the artist's instructions. *Ill. p. 16*

EPSTEIN, JACOB. BRITISH

Born New York, 1880. Worked in bronze foundry 1901, studied evenings Art Students League with George Gray Barnard. Paris, 1902-06; attended Ecole des Beaux-Arts. Settled in England c. 1906, later becoming British subject. First important commission 1907, first portraits 1908. Paris 1912, knew Brancusi, Modigliani. Influenced by vorticism and African art. Has worked as carver in architectural sculpture and large-scale figure pieces, as modeler in portraits. Lives in London.

29 *Professor Albert Einstein*. c. 1933. Bronze, 20" high. Lent by M. Knoedler & Co., New York

*30 *Madonna and Child*. 1927. Bronze, 67" high. Lent by Miss Sally Ryan, Georgetown, Connecticut. *Ill. p. 31*

ESHERICK, WHARTON. AMERICAN

Born Philadelphia, 1887. Trained as a painter, Philadelphia Academy. Began carving in wood during 20's. Influenced principally by Oriental art. Lives in Paoli, Pa.

*31 *Reverence*. 1942. Wood, 12' high. Fairmount Park Art Association, Philadelphia. *Ill. p. 29*

FERBER, HERBERT. AMERICAN

Born New York, 1906. Studied dentistry and oral surgery; art training, Beaux Arts Institute of Design, New York. First sculpture show, 1937. Has since become one of the principal exponents of abstract expressionism in sculpture. Works in soldered metal. Executed large-scale relief construction for synagogue exterior, 1951-52. Lives in New York.

*32 *Spheroid, II*. 1952. Copper, brass, lead, 33 x 47". Lent by the Betty Parsons Gallery, New York. *Ill. p. 27*

FLANNAGAN, JOHN B. AMERICAN

Born Fargo, North Dakota, 1895. Studied painting 1914-17, Minneapolis Institute of Arts. Began carving in wood c.

1922 with encouragement of Arthur B. Davies. After 1928 worked exclusively as sculptor. Preferred direct carving as method, fieldstone as material. Gave up stone cutting in 1939 for reasons of health; turned to metal, working directly on unfinished bronze casts. Died by suicide, 1942.

33 *Triumph of the Egg*. 1937. Granite, 16" long. The Museum of Modern Art, New York

GABO, NAUM. AMERICAN

Born Briansk, Russia, 1890. Brother of Antoine Pevsner. Entered University of Munich, 1909: studied mathematics, physics, engineering. Norway, 1914-17 with Pevsner: compartmented reliefs influenced by cubism. Moscow, 1917-21: projects for monuments on constructivist principles; issued joint manifesto with Pevsner, 1920. Worked subsequently in Germany, 1922-32; Paris, 1932-37; London, 1937-46. To U.S., 1946. Lives in Woodbury, Conn.

34 *Column*. 1923. Glass, plastic, metal, wood, 41" high. Lent by the artist.

35 *Kinetic Stone Sculpture*. 1936. Portland stone, 14½" long. Lent by the artist.

*36 *Construction in Space*. 1952. Phosphor, bronze, aluminum, stainless steel, c. 42 x 30". Lent by the artist. *Study for, ill. p. 19*

GIACOMETTI, ALBERTO. SWISS

Born Stampa, Switzerland, 1901. Son of noted Swiss painter, Giovanni Giacometti. Studied sculpture 1919, Ecole des Arts et Métiers, Geneva. Italy, 1920-22. To Paris, 1922. Worked several years in studio of Bourdelle. After 1926 quasi-abstract constructions with quality of objects. Joined surrealists about 1930. Worked from model 1935-40, beginning of long series of elongated heads and figures. Lives in Paris.

37 *Slaughtered Woman*. 1932. Bronze, 34½" long. The Museum of Modern Art, New York

*38 *City Square*. 1948. Bronze, 8½" high, 25⅜" long. The Museum of Modern Art, New York. *Ill. p. 23*

39 *Chariot*. 1950. Bronze, 57" high. The Museum of Modern Art, New York

GONZALEZ, JULIO. SPANISH

Born Barcelona, 1876. Father and grandfather master goldsmiths. Instructed in metal-working from childhood by father; at 16 won gold medal Barcelona Exposition, 1892. Studied painting, Barcelona School of Fine Arts. Settled in Paris about 1900. Active principally as a painter until 1927. Worked thereafter in fantastic, forged iron constructions, returning from time to time to more realistic style. Instructed Picasso in metal techniques 1930-32. *La Montserrat* exhibited Spanish Pavillion, Paris Exposition, 1937. Died Arcueil, 1942.

40 *Sculpture*. 1932. Silver, 9" high. Philadelphia Museum of Art, A. E. Gallatin Collection

41 *Maternity.* 1933. Wrought iron, 55″ high. Lent by Mme Roberta Gonzalez-Hartung, Paris

42 *Head.* 1936? Wrought iron, 17¾″ high. The Museum of Modern Art, New York

43 *La Montserrat.* 1937. Sheet iron, 65″ high. Lent by the Stedelijk Museum, Amsterdam

*44 *Woman Combing Her Hair.* 1937. Wrought iron, 6′10″ high. Lent by Mme Roberta Gonzalez-Hartung, Paris. *Ill. p. 22*

HARE, DAVID. AMERICAN

Born New York, 1917. Worked first in color photography. First sculpture, 1942, with surrealist work of Giacometti as point of departure. France, 1951-52.

*45 *Figure with Bird.* 1951. Steel and iron, 35″ high. Lent by the Kootz Gallery, New York. *Ill. p. 28*

HARKAVY, MINNA. AMERICAN

Born Estonia, 1895. Studied Hunter College, and Paris, 1921-22, with Bourdelle. Passing influence of Brancusi. First one-man show, Galerie Bing, Paris, 1931. During 30's work oriented by social commentary. Lives in New York.

*46 *Woman in Thought.* 1929-30. Bronze, 17″ high. Lent by the Midtown Galleries, New York. *Ill. p. 30*

HEPWORTH, BARBARA. BRITISH

Born Wakefield, Yorkshire, 1903. Studied, 1919-23, Leeds School and Royal College of Art, London. Italy three years, turned from modeling to carving. First exhibition, 1929. Influenced by Moore and Arp. Worked in purely abstract forms from c. 1934-47. Lives in St. Ives, Cornwall.

47 *The Cosden Head.* 1949. Blue marble, 24″ high. Lent by the City Museum and Art Gallery, Birmingham, England

KOLLWITZ, KATHE. GERMAN

Graphic artist-sculptor. Born Königsberg, East Prussia, 1867. Grandfather noted Lutheran minister; father master stone mason. Studied Berlin and Munich, 1885-88. After 1890 concentrated on printmaking with social criticism of Zola and Hauptmann as point of departure. First sculpture, 1910; turned to sculpture again, 1923, under inspiration of Barlach, though graphic work remained major concern. Monument to German war dead, 1914, 1924-32. Considerable time devoted to small sculpture after 1938. Died 1945.

48 *Grief.* c. 1938. Bronze, 10½ x 10″. Lent by Mr. and Mrs. Erich Cohn, New York

LACHAISE, GASTON. AMERICAN

Born Paris, 1882. Studied Bernard Palissay craft and technical school, 1895-98, and Ecole des Beaux-Arts, 1898-1903. Began exhibiting, Paris salon at 16. Settled permanently in U.S., 1906. Until 1920 worked full time as sculptor's assistant, first in Boston with Kitson, later in New York with

Manship. First major work, *Standing Woman,* 1912-27. Portraits of contributors to the *Dial,* 1919-25. Figure style of unique vitality and power summarized in *Floating Woman* (1927) and *Woman* (1932). Architectural sculpture: reliefs for Rockefeller Center, 1931 and 1935. First public commission Fairmount Park Art Association, Philadelphia, 1935. Died October, 1935.

49 *Standing Woman.* 1912-27. Bronze, 70″ high. The Art Institute of Chicago. (Exhibited in Chicago only)

50 *Two Floating Figures.* c. 1925-28. Bronze, 12″ high. Lent by Dr. Maurice Fried, New York

*51 *Floating Figure.* 1927. Bronze (cast 1935), 53″ high. The Museum of Modern Art, New York, given anonymously in memory of the artist. *Ill. p. 9*

52 *Standing Woman.* 1932. Bronze, 7′4″ high. The Museum of Modern Art, New York, Mrs. Simon Guggenheim Fund. (Exhibited in Philadelphia and New York)

LASSAW, IBRAM. AMERICAN

Born Alexandria, Egypt, 1913. Studied Clay Club, and Beaux Arts Institute of Design, New York. Constructions since mid 30's. Has worked intensively in brazed metal. Lives in New York.

*53 *Monoceros.* 1952. Bronze, 46¾″ high. Lent by the Kootz Gallery, New York. *Ill. p. 21*

LAURENS, HENRI. FRENCH

Born Paris, 1885. Apprenticed as sculptor decorator; worked later as ornamental stone cutter. Introduced to cubism by Braque, 1911. Worked in cubist style, 1911-25; still-life constructions, reliefs and sculpture in the round, experiments in polychromy. After 1925 more direct contact with natural forms. Lives in Paris.

54 *Mermaid.* 1945. Bronze, 45¼″ high. Lent by the Curt Valentin Gallery, New York

*55 *Luna.* 1948. Marble, 35¾″ high. Lent by the Curt Valentin Gallery, New York. *Ill. p. 35*

LEHMBRUCK, WILHELM. GERMAN

Born Duisburg-Meiderich, Germany, 1881. Father a miner. Studied Düsseldorf Academy, 1901-07. Visited Italy, 1905. Paris, 1910-14: first influenced by Maillol. About 1911 began working in the elongated proportions which became characteristic of his style. First retrospective exhibition, Paris 1914. Berlin, 1914-17. Zurich, 1917-18. Died by suicide, Berlin, 1919.

56 *Standing Woman.* 1910. Bronze, 6′4″ high. The Museum of Modern Art, New York

57 *Dancer.* 1913-14. Artificial stone, 11½″ high. Lent by Nelson A. Rockefeller, New York

*58 *Seated Youth.* 1918? Bronze, 41½″ high. Lent by the Kunstmuseum, Duisburg, Germany. *Ill. p. 10*

LIPCHITZ, JACQUES. FRENCH

Born Druskieniki, Russia, 1891. Father building contractor. Made sculpture from age of 8. To Paris, 1909. Studied Académie Julian; learned stone cutting, modeling and casting in various commercial ateliers. Style changed radically about 1914 under combined influence of African Negro art and cubism. First "transparent" sculpture, 1927. After 1930 cubist iconography replaced by more violent, sometimes mythological themes. Style shows increasing concern with movement and relations of solids and voids. Settled in U.S., 1941. Major architectural commission, façade relief, Ministry of Education, Rio de Janeiro, 1944. Lives in Hastings-on-Hudson.

59 *Man with a Guitar.* 1915? Cast stone, 38¼" high. The Museum of Modern Art, New York, Mrs. Simon Guggenheim Fund

60 *Pegasus.* 1929. Bronze, 14½" high. Lent by Mrs. T. Catesby Jones, New York

61 *Mother and Child, II.* 1941-45. Bronze, 50" high. The Museum of Modern Art, New York, Mrs. Simon Guggenheim Fund

*62 *Prayer.* 1943. Bronze, 42½" high. Lent by Mr. and Mrs. R. Sturgis Ingersoll, Penllyn, Pa. *Ill. p. 33*

LIPPOLD, RICHARD. AMERICAN

Born Milwaukee, Wisconsin, 1915. Studied industrial design, school of Art Institute of Chicago, 1933-37. Worked as industrial designer, 1937-41. Began working as a sculptor, 1942. Wire constructions, geometric in form, evocative in feeling. Lives in New York.

*63 *Reunion.* 1951. Copper, brass, nichrome, enameled wires, 23½" high. Lent by the Willard Gallery, New York. *Ill. p. 21*

MAILLOL, ARISTIDE. FRENCH

Born Banyuls, 1861. To Paris; studied painting Ecole des Beaux-Arts with Gérôme and Cabanel. Influenced by Gauguin and Maurice Denis. About 1887 returned to Banyuls to set up tapestry workshop; made wood carvings as pastime. Threatened by blindness, gave up tapestry design c. 1899. Turned seriously to sculpture at age of 40. First one-man show Vollard, 1902. *Mediterranean* exhibited Salon d'Automne, 1905. Visited Greece, 1906. Classical repose and serenity of his figure style broke influence of Rodin's impressionism. Died 1944.

*64 *Mediterranean.* c. 1901. Bronze, 41" high. Lent by Stephen C. Clark, New York. *Ill. p. 8*

65 *Young Cyclist.* c. 1904. Bronze, 38¾" high (with base). Lent by the Curt Valentin Gallery, New York

66 *Seated Figure.* c. 1930? Terra cotta, 9" high. The Museum of Modern Art, New York, gift of Mrs. Saidie A. May

67 *The River.* c. 1939-43. Lead, 7'6" long, 53¾" high. The Museum of Modern Art, New York, Mrs. Simon Guggenheim Fund

MALDARELLI, ORONZIO. AMERICAN

Born Naples, 1892. To U.S., 1900. Studied Cooper Union, National Academy of Design, and Beaux Arts Institute of Design, New York. Europe, 1931-32: forms treated more abstractly. Now works in the tradition of Maillol. Lives in New York.

*68 *Bianca, II.* 1950. Bronze, 28" high. Lent by the Midtown Galleries, New York. *Ill. p. 39*

MANZU, GIACOMO. ITALIAN

Born Bergamo, 1908. Youngest in family of 12; father convent sacristan. Apprenticed at 11 to a carver and gilder; worked later as assistant to stucco worker. To Verona 1928 for military service; frequented academy, soon worked independently. Formative influences Maillol, Donatello, Medardo Rosso. Mature style dates from 1934. Crucifixion reliefs, 1939-43, criticized by both Fascists and Church. Now completing Stations of the Cross for Sant' Eugenio, Rome. Lives in Milan.

*69 *Child on Chair.* 1949. Bronze, 49¼" high. Lent by the artist. *Ill. p. 34*

MARCKS, GERHARD. GERMAN

Born Berlin, 1889. From 1907 worked in studio of Richard Scheibe. Director of ceramics, Bauhaus, Weimar, 1920-25. Traveled Greece, Italy, France. Settled in Mecklenburg, 1933. After World War II taught Hamburg (1946-50); important commissions Lübeck, Cologne, Hamburg. Lives in Cologne.

*70 *Maja.* 1942. Bronze, 7' high. Fairmount Park Art Association, Philadelphia. *Ill. p. 35*

MARINI, MARINO. ITALIAN

Born Pistoia, 1901. Studied Florence Academy under naturalist Trentacosta. Worked as painter and draftsman until 1928. Paris, 1928-29. Has traveled in Greece and many European countries, though not appreciably influenced by contemporary sculpture outside Italy. Won recognition in 30's for portraits and figures of wrestlers and acrobats. Worked in Switzerland, 1942-46. Primarily a modeler. Lives in Milan.

71 *Dancer.* 1949. Bronze, 68" high (with base). Lent by the Curt Valentin Gallery, New York

72 *Stravinsky.* 1950. Bronze, 9" high. Lent by the Curt Valentin Gallery, New York

*73 *Horse.* 1951. Bronze, c. 7'3" high. Lent by Nelson A. Rockefeller, New York. *Ill. p. 37*

MARTINI, ARTURO. ITALIAN

Born Treviso, 1899. Apprenticed in ceramic workshop; later studied sculpture in Treviso and Munich under Hildebrand. Visited Paris 1911 and 1914. Uninfluenced by cubism or other group movements. Works reproduced *Valori Plastici*, 1921. Subsequent work marked by restless changes of style. Influential as teacher, Venice Academy. Repudiated sculpture for painting at end of life; his rationale, *La Scultura Lingua Morta*, published posthumously. Died 1947.

*74 *Daedalus and Icarus.* 1934-35. Bronze, 24″ high. The Museum of Modern Art, New York. *Ill. p. 36*

MATISSE, HENRI. FRENCH

Painter-sculptor. Born Le Cateau, 1869. As leader of the fauves became decisive figure in French painting, c. 1905. First sculpture, 1899, under influence of Barye and Rodin. Studied briefly with Bourdelle, 1900. Exhibited 13 bronzes and terra cottas, Salon d'Automne, 1908. Has turned to sculpture frequently during subsequent career, working always as modeler. Lives in Nice.

75 *The Slave.* 1900-03. 36¼″ high. The Art Institute of Chicago, Edward E. Ayer Collection

76 *Reclining Nude, I.* 1907. Bronze, 13½″ high. The Museum of Modern Art, New York, acquired through the Lillie P. Bliss Bequest

77 *Jeannette, V.* 1910-11? Bronze, 22⅞″ high (with base). The Museum of Modern Art, New York

*78 *The Back, III.* 1929? Bronze, 6′2⅜″ high. The Museum of Modern Art, New York, Mrs. Simon Guggenheim Fund. *Ill. p. 13*

MODIGLIANI, AMEDEO. ITALIAN

Painter-sculptor. Born Leghorn, Italy, 1884. Studied painting in Italy. Settled in Paris, 1906. From about 1909-15 worked almost exclusively at sculpture, first with instruction from Brancusi. Influenced also by African Negro carvings. Died 1920.

*79 *Caryatid.* c. 1914. Limestone, 36¼″ high. The Museum of Modern Art, New York, Mrs. Simon Guggenheim Fund. *Ill. p. 13*

MOORE, HENRY. BRITISH

Born Yorkshire, England, 1898. Father coal miner. Trained first as school teacher. Studied Leeds School, 1919-21; Royal College of Art, London, 1921-25. Visited France and Italy, 1925. Writings of Roger Fry and African and pre-Columbian sculpture initial influences. First one-man show and first public commission, 1928. Work increasingly abstract during 30's; figure style built on fluid transitions from solids to voids. During World War II war artist: Underground shelter drawings. Post-war commissions: Church of St. Matthew, Northampton; Darlington Hall Memorial; Arts Council for Festival of Britain. Lives in Hertfordshire.

*80 *Reclining Figure.* 1935. Elm wood, 19″ high, 35″ long. Lent by the Albright Art Gallery, Buffalo, Room of Contemporary Art. *Ill. p. 15*

81 *Sculpture.* 1937. Bird's eye marble, 15½″ long. Lent by the Curt Valentin Gallery, New York

82 *Family Group.* 1945. Bronze, 9⅜″ high. The Museum of Modern Art, New York, acquired through the Lillie P. Bliss Bequest

83 *Family Group.* 1945-49. Bronze, 59¼″ high. The Museum of Modern Art, New York, A. Conger Goodyear Fund

84 *Double Standing Figure.* 1950. Bronze, 7′3″ high. Lent by the Curt Valentin Gallery, New York

NOGUCHI, ISAMU. AMERICAN

Born Los Angeles, 1904. Childhood, Japan. Abandoned pre-medical studies for sculpture, New York, 1924. Worked as assistant to Brancusi, Paris, 1927-29. To U.S., 1929; exhibited abstract metal constructions. China and Japan, 1929-31; studied terra-cotta techniques. Large-scale architectural sculpture: colored cement relief, Rodriguez Market, Mexico City, 1936; aluminum relief, Rockefeller Center, 1938. During 40's series of large interlocking constructions, principally in stone. Traveled Mediterranean and Far East, 1949-50. Now lives in Japan.

*85 *Cronos.* 1949. Balsa wood. 76″ high. Lent by the Egan Gallery, New York. *Ill. p. 25*

PEVSNER, ANTOINE. FRENCH

Born Orel, Russia, 1886. Brother of Naum Gabo. Studied Kiev, later St. Petersburg. Paris, 1911 and 1913-14; influenced by cubism. Norway, 1914-17. Moscow, 1917-22; active in Russian constructivist movement; issued joint manifesto with Gabo, 1920. Settled Paris, 1923. Worked principally in transparent and opaque plastics, turning to metal during 30's. Lives in Paris.

86 *Portrait of Marcel Duchamp.* 1926. Celluloid on zinc, 37⅛x25⅝″. Lent by the Yale University Art Gallery, New Haven. (Exhibited in New York only)

87 *Abstraction.* 1927. Brass. 23¾x24⅝″. Lent by Washington University, St. Louis

* 88 *Developable Column.* 1942. Brass and oxidized bronze, 20¾″ high. The Museum of Modern Art, New York. *Ill. p. 18*

PICASSO, PABLO. SPANISH

Painter-sculptor. Born Malaga, Spain, 1881. Carved, modeled and constructed sculpture occasionally during early career: 1899-1905, modeled heads and figures; "Negro" period, 1907, wood carvings; cubism, 1912-14, cubist still-life constructions. Turned again to sculpture, 1929-34, working in many directions, notably metal constructions with technical instruction from Gonzalez. Set up sculpture

studio at Boisgeloup, 1933, began working in larger scale. Since 1941 has again devoted considerable time to sculpture. Lives in Vallauris, France.

89 *Woman's Head.* 1909. Bronze, 16¼″ high. Lent by Mr. and Mrs. Samuel A. Marx, Chicago

90 *Figure.* 1931. Bronze, 23¾″ high. Lent by Mrs. Meric Gallery, New York

* 91 *Shepherd Holding a Lamb.* 1944. Bronze. 7′4″ high. Lent by Mr. and Mrs. R. Sturgis Ingersoll, Penllyn, Pa. *Ill. p. 32*

92 *Owl.* 1950. Bronze, 14¼″ high. Lent by Mrs. John D. Rockefeller, III, New York

RENOIR, AUGUSTE. FRENCH

Painter-sculptor. Born Limoges, 1840. Apprenticed to porcelain painter, later studied painting Ecole des Beaux-Arts. Active in organization of impressionist group, 1874. First sculpture, c. 1907, during visit of Maillol. Later more ambitious work executed by sculptor-assistant, c. 1915-16. Experiments in own kiln with colored terra cotta. Sculpture not exhibited until after painter's death. Died 1919.

93 *Judgment of Paris.* 1914. Bronze, 28¾ x 35½ x 6″. Lent by the Curt Valentin Gallery, New York

* 94 *Washerwoman.* 1917. Bronze, 48″ high. Lent by the Curt Valentin Gallery, New York. *Ill. p. 7*

RODIN, AUGUSTE. FRENCH

Born Paris, 1840. Began studying at age of 14, first at La Petite Ecole, later under Barye. Refused admittance three times to Ecole des Beaux-Arts. Worked over ten years in decorator's atelier executing architectural ornament; then as sculptor's assistant. Brussels, 1871-76: architectural sculpture, first recognition. Visited Italy to study Michelangelo. Germany to see Gothic cathedrals. Still unknown in France, returned to Paris, exhibited *Age of Bronze* in Salon of 1877. Accused of casting figure from model; three years of litigation to disprove charges. Second major work, *St. John the Baptist,* begun 1877. Competed unsuccessfully for monument to war of 1870 with *The Defense.* First public commission. 1880, portal for Musée des Arts Décoratifs *(Gate of Hell).* Reputation established within following decade. Principal monuments: *The Burghers of Calais,* 1884-86; *Balzac Monument,* 1892-96. Joint exhibition with Monet, 1889. Retrospective exhibition, Paris Exposition, 1900. Died Meudon, 1917.

95 *The Defense.* 1878. Bronze. 45″ high. Private collection, New York

* 96 *St. John the Baptist.* 1878-80. Bronze, 6′8½″ high. Lent by the City Art Museum of St. Louis. *Ill. p. 6*

97 *Les Trois faunesses.* 1882. Bronze, 9½″ high. Lent by the Curt Valentin Gallery, New York

98 *Study for Balzac Monument.* c. 1893. Bronze, 49½″ high. Lent by Jacques Seligmann & Co., New York

ROSZAK, THEODORE J. AMERICAN

Born Posen, Poland, 1907. Studied Columbia University, National Academy of Design and Art Institute of Chicago. Europe. 1929-31. Worked first as painter. Abstract constructions c. 1935-45, severely geometric in form, impersonal in finish. Marked change of style after 1945: molten forms in welded and brazed metal, violent or cataclysmic in theme. Lives in New York.

* 99 *Invocation.* 1946-47. Steel, 30¼″ high. Lent by the Pierre Matisse Gallery, New York. *Ill. p. 26*

SMITH, DAVID. AMERICAN

Born Decatur, Indiana, 1906. Attended Ohio, Notre Dame and George Washington Universities; worked one year Studebaker Factory, South Bend, Indiana. Studied painting Art Students League, work oriented by cubism, Mondrian and Kandinsky. Example of Gonzalez suggested use of iron and forge for sculpture. First steel sculpture, 1933; set up workshop in Terminal Iron Works, Brooklyn. Since 1941 has lived in Bolton Landing, New York.

*100 *The Banquet.* 1951. Steel, 53⅛″x6′11″. Lent by the Willard Gallery, New York. *Ill p. 20*

VIANI, ALBERTO. ITALIAN

Born Quistello, 1906. Studied Venice Academy, assistant in sculpture to Arturo Martini. 1944-47. Member of postwar *Fronte Nuovo delle Arti.* Now works in the tradition of Arp. Lives in Venice.

*101 *Torso.* 1945. Marble, 38″ high. The Museum of Modern Art, New York. *Ill. p. 15*

ZORACH, WILLIAM. AMERICAN

Born Eurburg, Lithuania. 1887. Family settled in Cleveland, 1891. Studied painting Cleveland School of Design, National Academy of Design, N.Y., 1908-10. Paris, 1910-12. Turned seriously to sculpture. c. 1922. An advocate of direct carving. Lives in New York.

*102 *Floating Figure.* 1922. African mahogany, 9″ high x 33¼″ long. Lent by the Albright Art Gallery, Buffalo, Room of Contemporary Art. *Ill. p. 11*

103 *Torso.* 1932. Labrador granite, 33″ high. Lent by the Downtown Gallery, New York

A FEW BOOKS ON SCULPTURE

CASSON, STANLEY. *Some modern sculptors.* London, Oxford, 1928. Supplemented by *XXth century sculptors.* London, Oxford, 1930.

GIEDION-WELCKER, C. *Modern plastic art.* Zurich, Girsberger, 1937. (A new edition of this important work will be issued in 1953 by Wittenborn, Schultz, New York.)

RAMSDEN, E. H. *Twentieth century sculpture.* London, Pleiades, 1949.

RITCHIE. ANDREW CARNDUFF. *Sculpture of the twentieth century.* N.Y., Museum of Modern Art, 1953 (to be published in April).

ROTHSCHILD, LINCOLN. *Sculpture through the ages.* N.Y., McGraw-Hill, 1942.

SEYMOUR, CHARLES, JR. *Tradition and experiment in modern sculpture.* Washington, D. C., American University Press, 1949.

VALENTINER, WILHELM R. *Origins of modern sculpture.* N.Y., Wittenborn, Schultz, 1946.

See also extensive list of catalogues and monographs published by the Museum of Modern Art, New York, on individual sculptors such as Alexander Calder, John B. Flannagan, Naum Gabo, Antoine Pevsner, Gaston Lachaise, as well as national and international exhibitions such as *Cubism and Abstract Art, German Painting and Sculpture, Twentieth-Century Italian Art, Abstract Painting and Sculpture in America, 14 Americans* and many others.

Museum of Modern Art Publications in Reprint

Max Ernst. 1961. William S. Lieberman

Fantastic Art, Dada, Surrealism. 1947. Barr; Hugnet

Feininger-Hartley. 1944. Schardt, Barr, and Wheeler

The Film Index: A Bibliography (Vol. 1, The Film as Art). 1941.

Five American Sculptors: Alexander Calder; The Sculpture of John B. Flannagan; Gaston Lachaise; The Sculpture of Elie Nadelman; The Sculpture of Jacques Lipchitz. 1935-1954. Sweeney; Miller, Zigrosser; Kirstein; Hope

Five European Sculptors: Naum Gabo—Antoine Pevsner; Wilhelm Lehmbruck—Aristide Maillol; Henry Moore. 1930-1948. Read, Olson, Chanin; Abbott; Sweeney

Four American Painters: George Caleb Bingham; Winslow Homer, Albert P. Ryder, Thomas Eakins. 1930-1935. Rogers, Musick, Pope; Mather, Burroughs, Goodrich

German Art of the Twentieth Century. 1957. Haftmann, Hentzen and Lieberman; Ritchie

Vincent van Gogh: A Monograph; A Bibliography. 1935, 1942. Barr; Brooks

Arshile Gorky. 1962. William C. Seitz

Hans Hofmann. 1963. William C. Seitz

Indian Art of the United States. 1941. Douglas and d'Harnoncourt

Introductions to Modern Design: What is Modern Design?; What is Modern Interior Design? 1950-1953. Edgar Kaufmann, Jr.

Paul Klee: Three Exhibitions: 1930; 1941; 1949. 1945-1949. Barr; J. Feininger, L. Feininger, Sweeney, Miller; Soby

Latin American Architecture Since 1945. 1955. Henry-Russell Hitchcock

Lautrec-Redon. 1931. Jere Abbott

Machine Art. 1934. Philip Johnson

John Marin. 1936. McBride, Hartley and Benson

Masters of Popular Painting. 1938. Cahill, Gauthier, Miller, Cassou, et al.

Matisse: His Art and His Public. 1951. Alfred H. Barr, Jr.

Joan Miró. 1941. James Johnson Sweeney

Modern Architecture in England. 1937. Hitchcock and Bauer

Modern Architecture: International Exhibition. 1932. Hitchcock, Johnson, Mumford; Barr

Modern German Painting and Sculpture. 1931. Alfred H. Barr, Jr.

Modigliani: Paintings, Drawings, Sculpture. 1951. James Thrall Soby

Claude Monet: Seasons and Moments. 1960. William C. Seitz

Edvard Munch; A Selection of His Prints From American Collections. 1957. William S. Lieberman

The New American Painting; As Shown in Eight European Countries, 1958-1959. 1959. Alfred H. Barr, Jr.

New Horizons in American Art. 1936. Holger Cahill

New Images of Man. 1959. Selz; Tillich

Organic Design in Home Furnishings. 1941. Eliot F. Noyes

Picasso: Fifty Years of His Art. 1946. Alfred H. Barr, Jr.

Prehistoric Rock Pictures in Europe and Africa. 1937. Frobenius and Fox

Diego Rivera. 1931. Frances Flynn Paine

Romantic Painting in America. 1943. Soby and Miller

Medardo Rosso. 1963. Margaret Scolari Barr

Mark Rothko. 1961. Peter Selz

Georges Roualt: Paintings and Prints. 1947. James Thrall Soby

Henri Rousseau. 1946. Daniel Catton Rich

Sculpture of the Twentieth Century. 1952. Andrew Carnduff Ritchie

Soutine. 1950. Monroe Wheeler

Yves Tanguy. 1955. James Thrall Soby

Tchelitchew: Paintings, Drawings. 1942. James Thrall Soby

Textiles and Ornaments of India. 1956. Jayakar and Irwin; Wheeler

Three American Modernist Painters: Max Weber; Maurice Sterne; Stuart Davis. 1930-1945. Barr; Kallen; Sweeney

Three American Romantic Painters: Charles Burchfield: Early Watercolors; Florine Stettheimer; Franklin C. Watkins. 1930-1950. Barr; McBride; Ritchie

Three Painters of America: Charles Demuth; Charles Sheeler; Edward Hopper. 1933-1950. Ritchie; Williams; Barr and Burchfield

Twentieth-Century Italian Art. 1949. Soby and Barr

Twenty Centuries of Mexican Art. 1940

Edouard Vuillard. 1954. Andrew Carnduff Ritchie

The Bulletin of the Museum of Modern Art, 1933-1963. (7 vols.)

This reprinted edition was produced by the offset printing process. The text and plates were photographed separately from the original volume, and the plates rescreened. The paper and binding were selected to ensure the long life of this library grade edition.